Brad,
Love, Beth,
Julie
Brenna
Allan .

The
Artist's
Palate

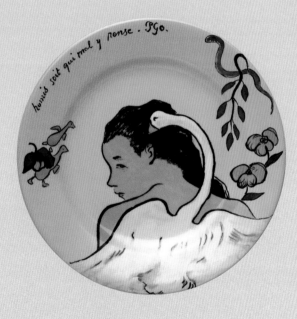

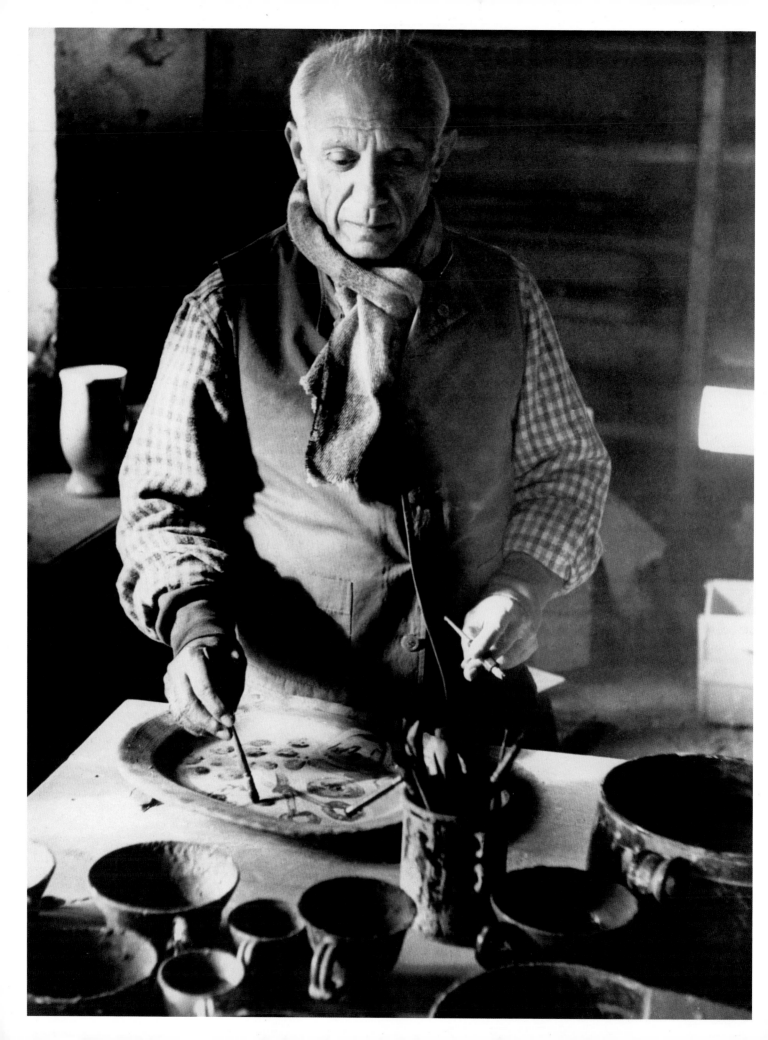

The Artist's Palate

Cooking with the World's Great Artists

Frank Fedele

DK Publishing

LONDON, NEW YORK, MUNICH,
MELBOURNE, and DELHI

DK PUBLISHING
Senior Editor Barbara Berger
Publisher Chuck Lang
Creative Director Tina Vaughan
Project Director Sharon Lucas
Art Director Dirk Kaufman
Production Manager Chris Avgherinos
DTP Designer Milos Orlovic
Recipe Development and Testing Wesley Martin
Contributing Writer Jennifer Williams
Editorial Assistant Katie Zien
Copyeditor Lucas Mansell

First American Edition, 2003
2 4 6 8 10 9 7 5 3 1
Published in the United States
by DK Publishing, Inc.
375 Hudson Street
New York, New York 10014

Editors note: Some of the recipes have been adapted from the originals
for today's kitchen

DK Publishing, Inc. offers special discounts for bulk purchases for sales
promotions or premiums. Specific, large-quantity needs can be met with
special editions, including personalized covers, excerpts of existing
guides, and corporate imprints. For more information, contact:
Special Markets Department,
DK Publishing, Inc.,
375 Hudson Street, New York, NY 10014
Fax: 212-689-5254

Cataloging-in-Publication data is available from
the Library of Congress

ISBN 0-7894-7768-8

Reproduced by ColourScan, Singapore
Printed and bound in China by Toppan Printing Co. (Shenzhen) Ltd.

See our complete product line at
www.dk.com

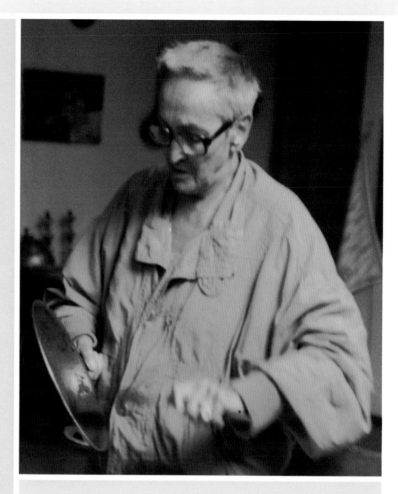

FOREWORD . 8

INTRODUCTION . 10

BREAKFAST . 12

Willem de Kooning | Traditional Dutch Breakfast 14

M. C. Escher | Milktoast . 16

Francis Picabia | Eggs Picabia . 18

Meret Oppenheim | Courtyard Garden Breakfast 19

Isamu Noguchi | Honey and Buttermilk Oatmeal
 by Chef Kevin Shikami . 20

Edgar Degas | Zoe's Brunch by Chef David Bouley 22

André Masson | The Soft-boiled Egg with Truffle 25

Bridget Riley | Robert's Egg Dish . 26

Contents

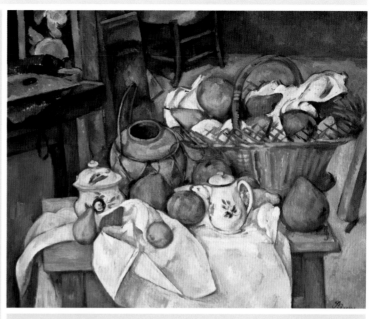

SOUPS & STEWS 28

Henry Moore | Lamb Stew 30

Marisol | Nabeyaki Udon 32

Wayne Thiebaud | Corn Soup 33

Robert Cottingham | Hearty Lamb Stew 34

Louise Bourgeois | Oxtail Stew 36

Howard Pyle | Philadelphia Pepper Pot 38

Henri Matisse | Soupe de poissons (French Fish Soup) 40

YuYu Yang | Hot & Sour Soup 42

Jasper Francis Cropsey | Fish & Pork Chowder
 by Chef Erin Horton 44

Christo & Jeanne-Claude | Tarator (Summer Soup) 47

Rufino Tamayo | Coloradito (Red Mole) 48

APPETIZERS, SIDES, & SALADS 50

Milton Glaser | Chinese Chicken Salad 52

Man Ray | Juliet's Potlagel (Romanian Style Eggplant) 54

Al Hirschfeld | Caviar with Rice Crackers 55

Paul Cézanne | Pommes de terres à l'huile (Potatoes in Oil)
 by Chef Mark Hix .. 56

Vincent van Gogh | Bread, Cheese & Absinthe 58

Francisco Zúñiga | Pickled Fish 60

Joan Miró | La calçotada (Grilled Spring Onions) 62

Paul Delvaux | Baked Oysters with Leeks 64

Edward & Nancy Kienholz | Hot-Cold Chinese Noodles 65

Victor Vasarely | Szilva Gombac (Sugared Plum Dumplings) 66

Gutzon Borglum | Mushroom Gravy 68

Jackson Pollock & Lee Krasner | Bread & Cheese
 Hominy Puffs ... 70

Wifredo Lam | Frijoles Negros (Black Beans) 74

Red Grooms | Confetti Egg Salad 76

Chaim Gross | Mamelige (Polenta) 77

Piet Mondrian & Harry Holtzman | Ambrosia &
 Pommes Frites ... 78

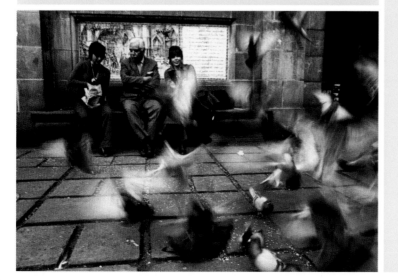

ENTRÉES 80

Horst Antes | Spaghetti alla Roberto Barni 82

Salvador Dalí | Mesclagne Landais, Mère Irma
(Liver & Chicken Cutlets) 84

Friedensreich Hundertwasser | Sashimi 101 by Chef Ming Tsai ... 86

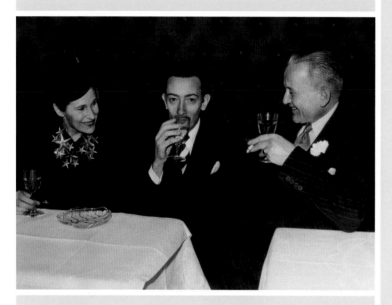

Pierre-August Renoir | Omelette au lard pour Monet
et Pour Deux .. 89

Henri de Toulouse-Lautrec | Lobster à l'Américaine 90

Amedeo Modigliani | Triglie alla Livornese (Stewed Red Mullet)
by Chef Mary Ann Esposito92

Pablo Picasso | Matelote d'Anguille (Eel in Brandy Sauce)
by Chef Antonio Cabanas 94

Will Barnet | Linguini with Garlic and Oil 97

Alex Katz | Salmon Coulibiac (Salmon in Pastry) 98

Arman | Alternating Slices of Marinated & Cooked Tuna 99

Romare Bearden | Artist's Meal 100

Stuart Davis | Finn an' Haddie (Cod Stew) 102

Roy Lichtenstein | Spaghetti with Broccoli Rabe 103

Beverly Pepper | Spaghetti al Limone 104

Helen Frankenthaler | Poached Stuffed Striped Bass 106

Sam Francis | Smoked Salmon & Jicama Maki Sushi
by Chef Ming Tsai 108

Josef & Anni Albers | Himmel und Erde (Apple & Potato Mash) ... 110

Robert Motherwell | Late Supper 111

Sandro Chia | Vegetarian Lasagne 112

Diego Rivera | Two Hot Mexican Chiles 114

Tom Wesselman | Almost Fat-Free Chili con Carne 117

DESSERTS 118

Yozo Hamaguchi | Cherries Jubilee 120

Charles Burchfield | Dumplings 122

Philip Pearlstein | Banana Splits 123

Jeff Koons | Apple Raisin Dumplings 124

Mark Rothko | Apple Pie 126

Ben Nicholson | Brown Bread Ice Cream 127

Mary Cassatt | Chocolate Caramels 128

Alphonse Mucha | Cokoladovna Bublanina
(Chocolate Bubble Cake) 130

Charles Demuth | Spice Cake 132

Norman Rockwell & Grandma Moses | Oatmeal Cookies
& Old-Fashioned Macaroons 134

Hans Richter | Crème Caramel 136

Larry Rivers | Mrs. Delicious's Rugelach 137

Grant Wood | Strawberry Shortcake 138

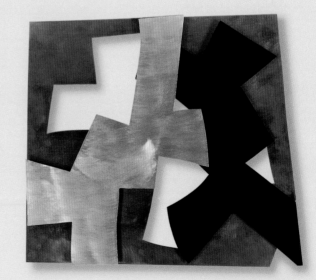

MENUS & SPECIAL MEALS140

Edward Hopper | My Lunch with Edward Hopper142

Paul Klee | Taschenkalender Menu144

James Rosenquist | Three Meals and a Bottle of Wine146

Michelangelo | Grocery List by Chef Mario Batali148

John James Audubon | A Perfect Meal151

Bernard Buffet | Buffet's Buffet154

Max Beckmann | Plaza Feast by Chef Robert Hasche156

Andy Warhol | Thanksgiving Dinner158

Frédéric-Auguste Bartholdi | Lady Liberty Banquet
 by Chef David Féau160

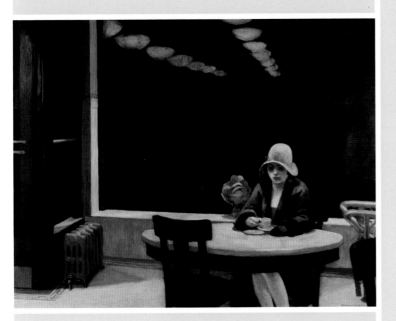

Alan Sonfist | Natural Dinner166

Le Corbusier | Two Feasts for Ozenfant by Chef André Soltner168

Alexander Calder | Flying Colors Menu
 by Chef Jean-Georges Vongerichten176

Paul Gauguin | Tahitian Feast by Chef James Babian183

Leonardo da Vinci | The Last Supper by Chef Mario Batali184

PARTICIPATING CHEFS' BIOGRAPHIES188

INDEX ...189

PHOTO CREDITS ..191

ACKNOWLEDGMENTS192

(Page 1) Paul Gauguin, plate illustrated with Tahitian motifs, c. 1892; collection The Musée Gauguin, Tahiti

(Page 2) Pablo Picasso painting decorations on a plate in his pottery studio, at his villa on the French Riviera, 1948.

(Page 4) Meret Oppenheim cooking in the kitchen at Casa Costanza, Corona, Switzerland, 1985; courtesy Dr. Burkhard Wenger-Reister.

(Page 5, bottom left) Rufino Tamayo and two friends feeding pigeons in Barcelona, Spain, 1973.

(Page 5, top right) Paul Cézanne, *Still Life with a Basket,* c. 1888

(Page 6, top left) Salvador Dali drinking champagne with his wife, Gala, and Jacques Bollinger, the champagne magnate, at a party in New York, 1939

(Page 6, bottom right) Hans Richter, *Dymo,* 1974, Courtesy Hans Richter Archives

(Page 7, center left) Edward Hopper, *Automat,* 1927

(Page 7, top right) From left to right: Poet Gerard Malanga, Andy Warhol, and composer John Cage at a champagne breakfast at the Automat, New York, following a premiere of the James Coburn film, *Our Man Flint,* 1966.

(Page 8) Vincent van Gogh, *Café Terrace,* 1888

(Page 11) Alexander Calder in his kitchen at Saché, France, stocked with pots and pans that he made himself, c. 1970.

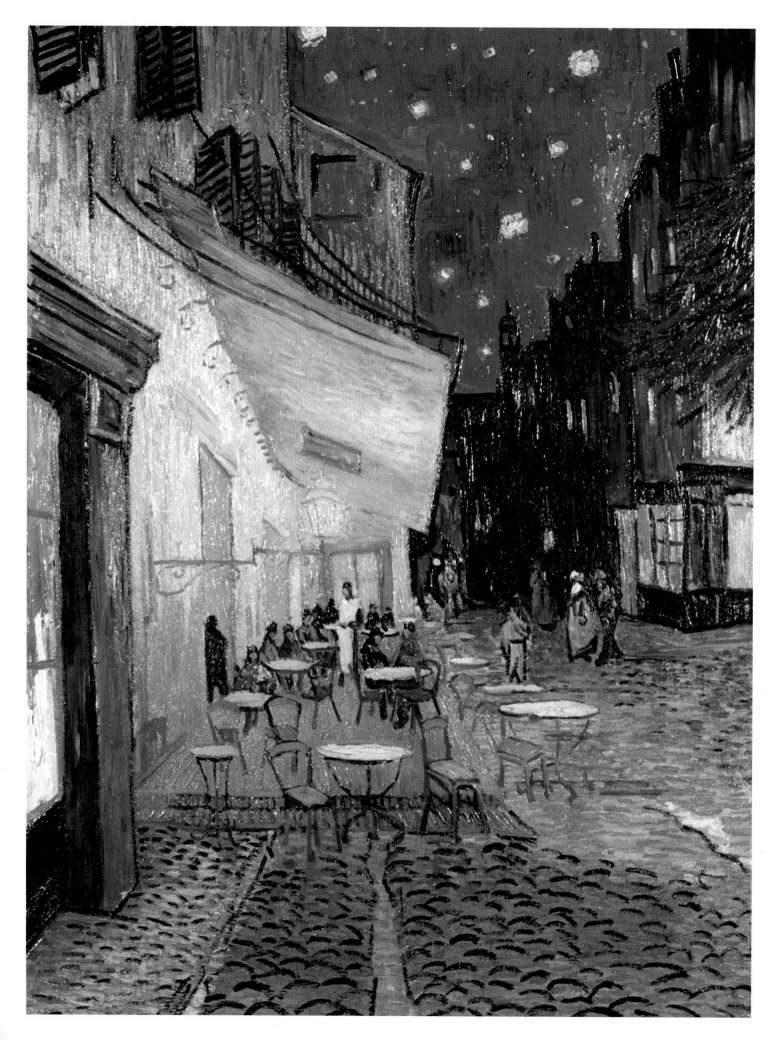

The Artist's Palate is a true celebration. Not only does each profile commemorate a great artist and his work, but the collection itself pays homage to a connective power that is unique to food and art. Frank Fedele has compiled a remarkable group of insights, all of which attest to the humanizing influence of food. Each tasty glimpse into the culinary intimacies of the artist is an ode to the myriad personalities and habits that people chew in everyday life. In each of the artists' rapports with food—sometimes quirky, sometimes indulgent, often restrained—the reader finds a gem of palate memory and the thought of the meaning of food and all of its correlation with the rest of our basic needs. We recognize food as we all explore and understand it; as an invitation to friends, an evocation of a lost homeland, a means by which to seduce beautiful women, and sometimes merely sustenance. Food, even more than art, allows an admirer to relate to the artist on common ground.

I can't think of a better way to come to appreciate and understand an artist than through his appetite. With his exceptional knowledge of artists and their world, Frank gives readers the means to approach the artist as something beyond just the visually familiar, something more tangy and more visceral. Some of the recipes here are irresistible and some are questionable. But each page, each anecdote, is touching, thoughtful, and rare.

It's food and art at its best, as that which can unite even the most seemingly separate minds and worlds. Bravo, Frank.

—Mario Batali

Introduction

While our scientists develop ever more powerful microscopes and telescopes, the process of creation in all its forms, both large and small, continues to unfold before our eyes. As living human beings, we are also a continuation and a product of this ongoing creative process. Under certain circumstances, some of us are able to tap into this magical process—to the amazement of others. When this level of creativity is achieved, we call the messenger an artist and inspect his or her markings with fascination and curiosity. The artist projects a vision, and we use our own subjective experiences to interpret what we are given in order to achieve a personal translation of that vision.

The way humans learn involves both linking bits of information to form a chain of understanding and breaking down large concepts into comprehensible parts. However, in terms of viewing human creations, or what we call "art," we are relegated to the role of an inquisitive guest, who can only peep into the windows of the artist's creative mind. We search for emotional hints in the gestural drippings of Jackson Pollock or in the sweeping, windblown rhythms of Van Gogh. But, alas, we have arrived too late for the party, and the artist has already completed the task, leaving us only the remnants of the creative process to analyze and interpret. How, I wondered, could we, as an audience, gain access to the inner chambers of the artist's creative mind? How could we experience something directly, just enough for us to digest some of what the artist is experiencing? The culinary arts are closely linked to the visual arts in this sense: they incorporate elements of color, form, and texture, while weaving in the sensory preceptors of taste and smell to achieve their effects. In the shared appreciation of food, the artist's genius—and some of his or her own experience— leaks out. *This* is the chamber that we can enter: the artist's dining room. Here we can gather clues to better understand the person behind the work.

It was with these thoughts in mind that I began working on *The Artist's Palate* in the summer of 1995. I have to admit that this compilation of recipes and personal accounts was made easier by my having been a Manhattan art dealer for the past thirty-six years: in this capacity I have curated, exhibited, and befriended some of today's most influential artists. On many occasions, while I was viewing their work in an atelier or loft, I could smell the delicious fragrance of a culinary fantasy bubbling away on a back burner. When I began researching this book, I was sure that many of the artists would have mouth-watering recipes to share. At the time, I thought the book could only include living artists, since I didn't have a clue as to where or how I could locate recipes from past masters. However, the project soon grew into a global undertaking: what had started out as a collection of thirty recipes evolved into a canon of one hundred and twenty. Although I didn't know it at the time, this book would take over six years to complete!

This artistic and culinary journey into the private lives, tastes, and habits of these great men and women has been an extremely interesting, enlightening, and fruitful adventure for me, as I hope it will be for you. I have met great artists and their families, friends, lovers, and dealers from all over the world, as well as art publishers, biographers, historians, assistants, agents, photographers, representatives from artists' estates, museum curators, and chefs. In these encounters, I have made a great many new friends. All have given me a deeper insight into the world's great artists and their culinary preferences through the personal stories and recipes contained in this book. I thank them all.

Let us now part the curtains and step into the kitchens of our most prized messengers of creation. The recipes here sparkle with personal anecdotes, idiosyncrasies, and other fascinating manifestations of the artists' unique styles and tastes. Inside these pages, you will find Leonardo da Vinci sitting at the kitchen table, slowly sipping his favorite chickpea soup, la Minestra, before it gets cold; or you'll discover the Dada and Surrealist masters, Man Ray and Marcel Duchamp, drinking wine and feasting on Man Ray's favorite Romanian eggplant spread, Juliet's Potlagel, while engrossed in a game of chess. Or perhaps from the kitchen doorway Grandma Moses will offer you a selection of goodies from her tray of Old-Fashioned Macaroons, still warm from the oven. This book is a culinary experience enhanced by the touch of these monumental creative figures. With *The Artist's Palate*, cooks and art-lovers from around the globe can now break bread and share in the creative magic of the world's great artists.

—Frank Fedele

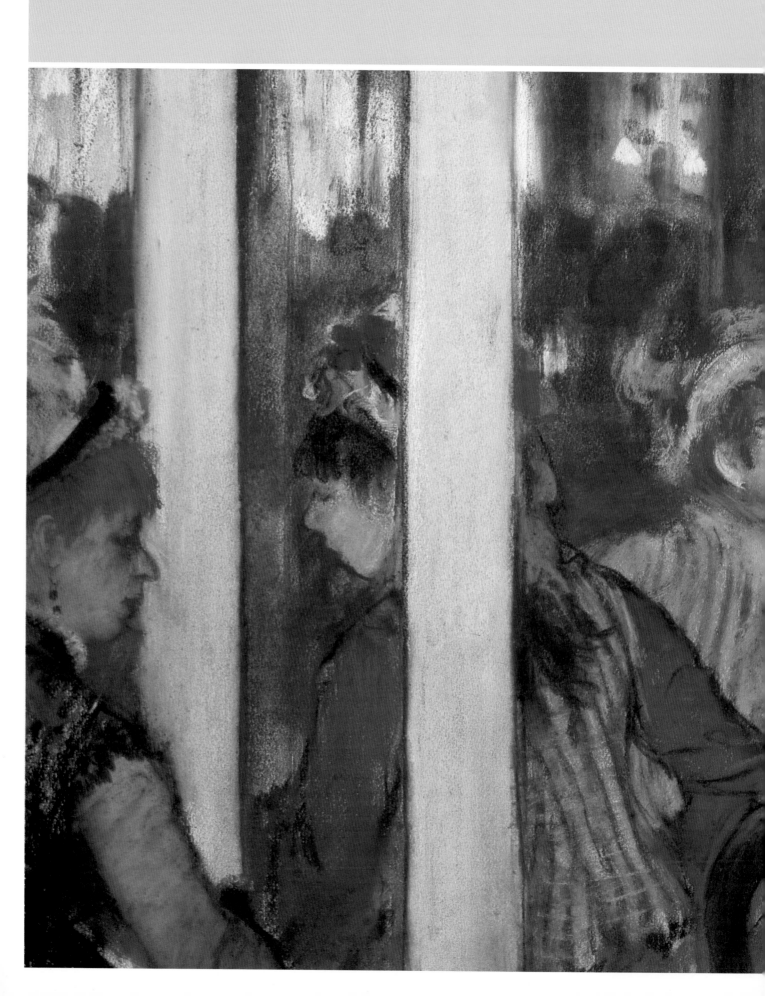

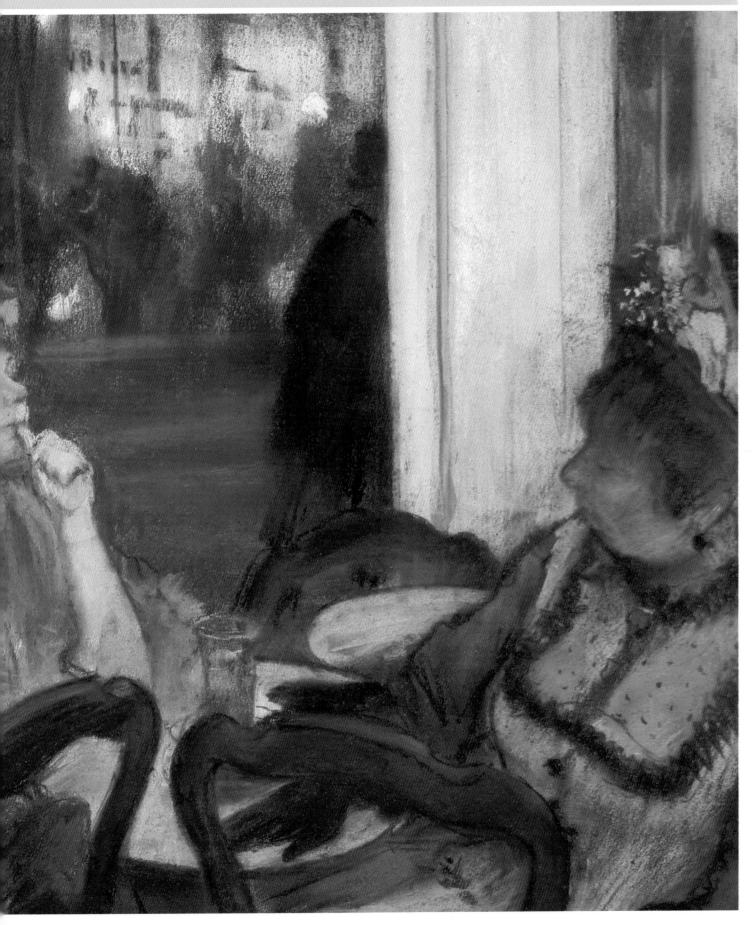

Willem de Kooning Traditional Dutch Breakfast

The great Abstract Expressionist Willem de Kooning is renowned for his paintings of the female nude, whose form he abstracted and reinvented to create a powerful new vocabulary. The following recollections by the artist's daughter, Lisa de Kooning, and her mother, Joan Ward, were compiled by Amy Schichtel, collections curator of The Willem de Kooning Foundation.

"Willem de Kooning came to New York from Rotterdam in 1926. He considered himself a New Yorker yet never gave up his homeland entirely. His morning ritual began here as it likely did during his youth, with a traditional Dutch breakfast: Gouda cheese, ham, a huge cup of tea with milk and sugar, and a thick piece of hard bread. His daughter, Lisa, smiled as she recalled, 'He would hold his big cup with both hands and make a loud rolling *sslluuurrp* as he drank up the steaming hot tea and read the morning paper spread out at the end of the kitchen table.'

"Curiously, the hearty and unadorned Dutch food that he liked so much shared the table and his heart with its extreme opposite, everyday American convenience food. Indeed, de Kooning was an extraordinary artist who relished the ordinary. One of his favorite meals? Fried chicken TV dinners with extra butter on the chicken, made expressly by his daughter, and, of course, followed by TV. 'This is VERY good,' he would say, 'You're a very good cook!' Did he cook? According to Lisa's mother, Joan Ward, 'Bill didn't cook. He loved eating, but he didn't cook. He liked ugly foods—boiled foods, boiled meats, boiled potatoes. He didn't like anything creamed or elaborate.' Yet, always the practical man and contrary to this recollection, for dinner he was known to place a frozen minute steak right on the kitchen grill. He would turn with a shrug, 'Works just as well, you know.'"

Traditional Dutch Breakfast

Serves 2

Wedge of Gouda cheese
1/2 lb (225 g) sliced deli ham
Crusty dark grainy bread,
 such as pumpernickel
4 poached eggs (optional)
2 cups (470 ml) tea
Milk and sugar to taste

• Place poached eggs and ham on a plate. Place the wedge of cheese on a board with a knife. If the bread is sliced, arrange on a plate or serve whole with bread knife.

• Serve tea with milk and sugar.

(Previous page) Edgar Degas, *Women on the Terrace of a Cafe,* 1877

(Right) Willem de Kooning in his Hamptons studio, 1982, Long Island, New York.

M. C. Escher Milktoast

Dutch artist Maurits Corneille (M. C.) Escher is one of the most well-known graphic artists of the 20th century. Strongly influenced by his training in architecture and mathematics, Escher's woodcut prints and drawings of "impossible" structures and patterns use repetition and multiple perspectives to challenge our sense of reality. Escher employed mathematic formulas to divide his picture areas, which he called "filling the plane." A family friend recalled how when Escher was a boy, he would carefully "select the shape, quantity, and size of his slices of cheese, so that, fitting one against the other, they would cover as exactly as possible the entire slice of bread. This particular trait never left him." According to Muldoon Elder, owner of Vorpal Gallery in New York and San Francisco and Escher's dealer, Escher had stomach problems and milktoast was the most delicious of his easily digestible recipes. He also recalled Escher's playful nature in a story about one of his clients meeting Escher for the first time.

"Escher was a very proper and formal person, but within that formality, he was very whimsical, even capricious. I once sent a client of mine to meet Escher when he was living in Larne, Holland. My client knocked on Escher's door and asked the gentleman who opened the door if he was Mr. Escher. The gentleman replied 'No, I'm the butler.'... 'Is Mr.Escher in?'... 'Do you have an appointment?'... 'No!'... 'Mr. Escher never sees anyone without an appointment!' and the door slammed in my client's face. A few hours later he telephoned Escher and made an appointment for the next day. When my client arrived and the door opened, the same gentleman replied in a most cordial manner, 'I'm Mr. Escher, won't you come in?' They spent two hours in lively conversation, but not a word was mentioned about the previous episode of the day before."

—Muldoon Elder

Milktoast

Serves 2

4 slices of bread
Cold butter, thinly sliced
1 1/2 cups (350 ml) of steaming milk
Salt

• Toast bread and cover with slices of butter so they "fill the entire plane" of bread, then place in a large soup bowl. Sprinkle with salt. Pour steaming milk over the toast.

(Far left) M. C. Escher, undated portrait, courtesy Vorpal Gallery, San Francisco

(Left) M. C. Escher, *Sky and Water I*, 1938; courtesy Cordon Art, Holland

Francis Picabia Eggs Picabia

The Parisian-born artist Francis Picabia was a key member of the Cubist, Dadaist, and Surrealist movements; he also loved shocking the established art world and public opinions of good taste and acceptable behavior. He was a connoisseur of elegant nightclubs, deluxe trains, high-powered cars, beautiful women, and a rich egg dish, which he allowed Alice B. Toklas to include in her now-famous eponymous publication, *The Alice B. Toklas Cookbook,* reproduced here as she described it.

Eggs Picabia

Serves 3–4

8 eggs
Salt to taste
16 tablespoons/1 cup (230 g) butter
 or more if desired

• Break all eggs into a bowl and mix them well with a fork, add salt. Pour them into a saucepan —yes a saucepan, not a frying pan. Put the saucepan over a very low flame, keep turning them with a fork while very slowly adding in very small quantities of butter—not a speck less, rather more, if you can bring yourself to it. It should take 1/2 hour to prepare this dish. The eggs of course are not scrambled but with the butter, no substitute omitted, produce a suave consistency that perhaps only a "gourmet" will appreciate.

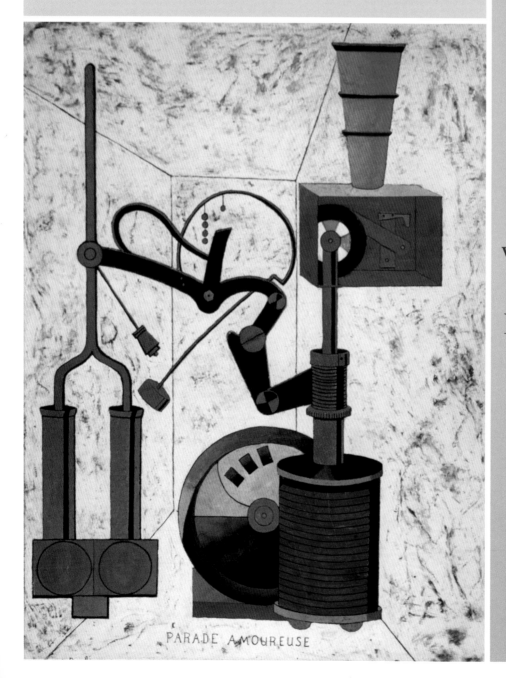

PARADE AMOUREUSE

"The only painter who ever gave me a recipe was Francis Picabia and though it is only a dish of eggs, it merits the name of its creator."

—Alice B. Toklas, *The Alice B. Toklas Cookbook*

(Left) Francis Picabia, *Parade Amoureuse,* 1917

Meret Oppenheim Courtyard Garden Breakfast

One of the few women artists to take part in the Surrealist movement of the 1930s, German-born Swiss painter and sculptor Meret Oppenheim moved to Paris as a young woman. She became entrenched in the art scene there, meeting important artists such as Pablo Picasso, Max Ernst, and Hans Arp. Her famous fur-lined teacup and saucer created a stir at the 1936 International Surrealist Exhibition in London, and remains today an iconic image of the Surrealist movement.

The artist's brother, Dr. Burkhard Wenger-Reister, sent a letter that shared some of the favorite dishes that Meret loved to cook.

"I am sending you a photograph taken in summer of 1983 showing Meret at breakfast in the courtyard/garden of our family house at Corona in southern Switzerland. She is with a friend, Mr. Henry Alexis Baatsch, who translated a great part of her literary artwork from German to French, and Mr. Baatsch's little daughter.

"Meret loved minestrone, and risotto of her own making with oil and butter. She also loved *rosti* [a Swiss dish similar to hash browns, with cheese], which she prepared carefully and 'scientifically.' I believe however, that Meret's 'table ethics' were mainly to prepare a savory Swiss/German breakfast with bread and butter, meat and sausage, confiture with honey with milk coffee. This she took around 9 or 10 in the morning, so as to avoid lunch in order to have the rest of the day free."

Courtyard Garden Breakfast

Serves 2

4 slices crusty white bread
2 slices ham
4 breakfast sausages
2 cups coffee
Milk
Butter
2 jams (strawberry and orange)
Honey

• Cook the sausages until well done. Heat the ham (if you like). Serve two slices of bread, two sausages, and one slice of ham on each plate.

• Butter the bread, or add jam, honey, or all if you wish. Pour the coffee and add milk as desired.

This breakfast should only be served from 9–10 in the morning for best results.

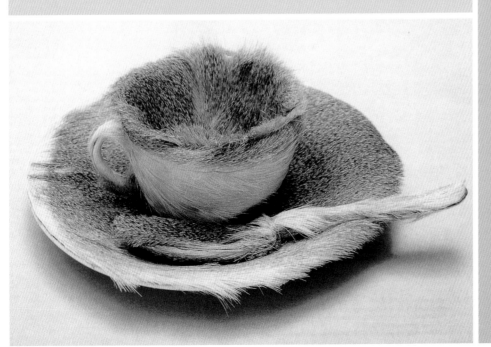

(*Above*) Henry Alexis Baatsch and his daughter, with Meret Oppenheim in her garden, Corona, Switzerland, 1983.

(*Left*) Meret Oppenheim, *Object (Fur-Covered Cup, Saucer, and Spoon)*, 1936, collection Museum of Modern Art, New York; both courtesy Dr. Burkhard Wenger-Reister.

Isamu Noguchi Honey & Buttermilk Oatmeal Re-created by **Chef Kevin Shikami**

American sculptor and designer, Isamu Noguchi, created a prolific body of public work, which included outdoor sculptures, monuments, fountains, architectural projects, gardens, furniture designs, and stage sets. The Isamu Noguchi Foundation reported that there was only one dish they knew of that the artist prepared—oatmeal, which he ate every morning with cream and honey. Acclaimed chef, Kevin Shikami, of Kevin restaurant, Chicago, has created a version here that Noguchi would have savored.

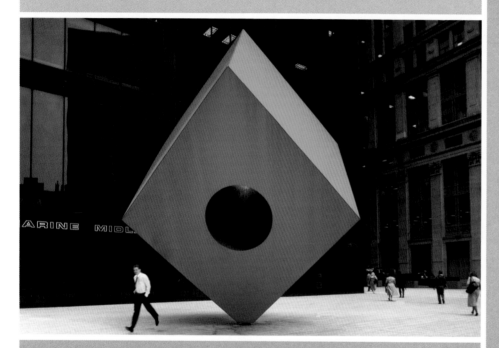

- Remove mixture and place a thin layer on a parchment-covered baking sheet. Bake at 375°F (140°C) until golden brown. Remove and let cool. Place the crumble in a covered container and use for this and future oatmeal breakfasts.

Honey Tuile
- In a mixer, cream butter and honey. Add the sugar and flour and mix until smooth. Add the egg whites and mix until smooth. Remove and let rest 1 hour. On a Silpat Mat (silicone pan liner) placed on a baking sheet, spread the batter in a thin layer into rectangle shapes, 4 x 2 inches (10 x 5 cm). Bake at 300°F (149°C) until golden brown.

Oatmeal
- Bring the water to a boil. Add the oatmeal and stir. When the oatmeal starts to thicken reduce the heat. When the oatmeal begins to thicken and soften (approximately 30 minutes) add honey and buttermilk. Stir. When desired thickness is achieved spoon into a bowl and top with crème frâiche, sprinkle with the crumb mixture, and stick the honey tuile on top.

Honey and Buttermilk Oatmeal with Crème Frâiche, Ginger, Lavender, Orange Crumble, and Honey Tuile

Serves 2

For the Crumble:
1 cup (120 g) flour
2/3 cup (125 g) brown sugar
1/4 cup (50 g) sugar
1 1/2 tablespoons minced ginger
1/4 teaspoon lavender leaves
1/2 teaspoon grated orange zest
6 tablespoons cold cubed unsalted butter

For the Honey Tuile:
4 tablespoons unsalted butter
4 tablespoons honey
1 cup (100 g) powdered sugar
1 cup (100 g) flour
3 oz (84 g) egg whites [3 eggs]

For the Oatmeal:
1 cup (230 g) McCann's Irish Oatmeal
4 cups (950 ml) water
2 tablespoons honey
3/4 cup (175 ml) buttermilk
Pinch of salt
1 rounded tablespoon crème frâiche

Crumble
- In a food processor place the flour, sugars, lavender, ginger, orange zest, and salt. Pulse to mix ingredients. Add the cubed butter and pulse until just combined.

(Top Left) Isamu Noguchi, *Red Cube,* 1968, New York

(Right) Isamu Noguchi, c. 1947, with his sculptures *Metamorphosis* and *The Queen;* courtesy The Isamu Noguchi Foundation, Inc., New York.

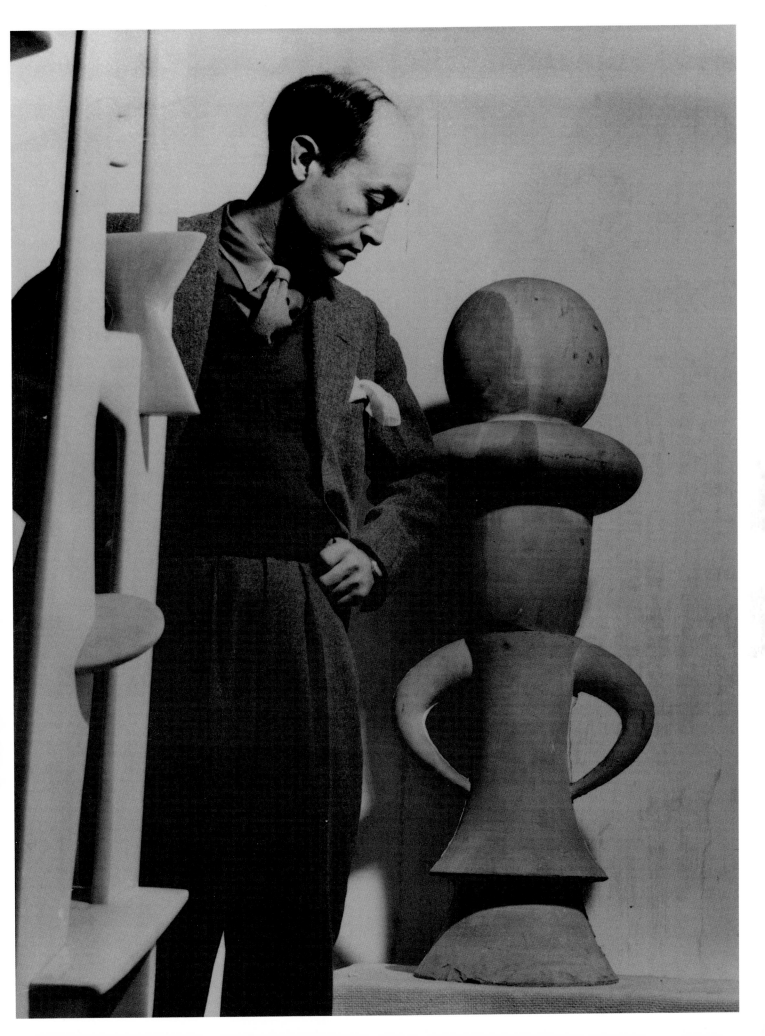

Edgar Degas Zoe's Brunch Re-created by **Chef David Bouley**

Born on the Rue St. George, Paris, in 1834, Edgar Degas left his classical legal background to study art at the École des Beaux Arts under the great Neoclassic painter Jean-Auguste Dominique Ingres. Degas's artworks explored contemporary 19th-century Parisian day-to-day life, art, and sport—women and men at work, ballet dancers and cabaret singers, horse races and polo players—and he eventually became a leading force in the Impressionist movement. A man of regimented habit, Degas could be found on any given day at the Café Guerbois with other Impressionists Manet, Pissaro, Renoir, and Monet. At other times he would be at Montparnasse studying the gestures and movements of the laundresses or milliners, or on occasion viewing past masters along with his good friend Mary Cassatt at the Louvre. But most often he would be found at his studio, freezing life's movements in oils or soft, delicately layered pastels, or observing his models, which he described as seeing "through a keyhole."

"Unfortunately, Degas does not seem to be much of a gourmet/gourmand. In fact, his friends occasionally complained about the mediocre cuisine found at the elderly Degas apartment."

—Dr. Rebecca A. Rainbow, Department of European Paintings,
Metropolitan Museum of Art, New York

There were, of course, occasional breaks for breakfast and lunch. Homemade marmalade with freshly baked brioche (which the artist described as the best in Paris) were served to him by his maid Zoe on a daily basis, as was a lunch consisting of a meat cutlet and two hard-boiled eggs, often with a salad dressed in oil and vinegar. These same two meals were habitually eaten by Degas every single day for over 20 years. There is no known written recipe of how Zoe cooked or prepared these meals, so I have appealed to the culinary artist David Bouley, of Bouley and Danube restaurants, in New York.

Zoe's Brunch

Marmalade of Apricots, Vanilla, and Orange Rind

Serves 2–3

1 lemon
3 navel oranges
1/4 cup (60 ml) Cointreau or Grand Marnier
1/2 cup (125 g) sugar
1/2 cup (120 ml) water
1 star anise
2 lbs (900 g) apricots or peaches
2 tablespoons butter
2 Tahitian vanilla beans

• Squeeze the lemon juice and then the orange juice into two separate small bowls, and reserve. Slice the orange rind thinly with a knife, making sure there are no bits of white inner skin, then blanch for 30 seconds in boiling water. Soak the rind in a bowl with Cointreau.

• Add the sugar to a heavy saucepan and heat over medium heat until medium brown. Turn off the heat and add water to make a light caramel. Add the star anise and lemon and orange juices and simmer until thick again. Set mixture aside.

• Cut the apricots or peaches in half and place on a baking sheet. Melt the butter in a small pot. Split the vanilla beans and scoop out seeds. Then, add the vanilla beans and seeds to the melted butter and blend well. Brush the apricots with the butter-vanilla mixture, then bake slowly for 2 hours at 175°F (80°C). When the apricots are very tender and have lost most of their moisture, place them in a Cuisinart with the caramel mixture. Blend with 10 one-second pulses. Remove and place in a preserving container and fold in the orange zest. Chill and allow to marinate for 2 days before using.

(Left) From left to right: Edgar Degas, Madame Strauss, Monsieur Cave, and Leon Gauderax at the Bibliotheque Nationale, Paris, undated.

Edgar Degas Zoe's Brunch Re-created by **Chef David Boul**ey

Brioche

Makes 2 brioche loafs | Adapted

4 cups (440 g) all-purpose flour

1/4 cup (60 g) sugar

1 teaspoon salt

1 1/2 teaspoons instant yeast

1/2 cup (60 g) cold butter, cut into chunks

3 eggs

1/2 cup (120 ml) milk

1/3 cup (120 ml) water

1 egg yolk, mixed with 2 tablespoons
 milk, beaten

• Combine the flour, sugar, salt, and yeast in a food processor, and pulse with a steel blade for 5 seconds. Add the butter and eggs and process for 12 seconds. Add the milk and water while processor is on, and pulse for 35 seconds. Scrape the batter into a greased bowl, cover, and allow to rise until doubled, 2–3 hours.

• Punch down the dough and divide into 2 loaves. Place each loaf in a greased loaf pan, cover, and let rise for 1 hour. Brush the tops of the loaves with the egg yolk mixture and bake in a preheated 400°F (200°C) for about 30 minutes until golden brown. Remove the brioche from the oven and cool it in the pan for 10 minutes. Turn brioche out of the pan, and cool completely on a rack before serving.

Rack of Lamb, Roast Potato in a Lemon Verbena Prune Crust with Ginger Flageolet Beans

Serves 2–3 | Adapted

3 tablespoons olive oil

2 garlic cloves,
 chopped fine

2 bunches scallions cut into
 1-inch (2.5 cm) pieces

3/4 cup (175 g) flageolet beans

3 bay leaves

1 branch rosemary

Sea salt and fresh ground pepper
 to taste

4 tablespoons lemon verbena

6 large California or Italian prunes

2 1/4 cups (350 g) fingerling potatoes cut into
 1-inch (2.5 cm) slices

1 rack of lamb, 12–14 oz (375 g), prepared French-
 style (butcher removes meat from top of bones)

1 tablespoon chopped thyme

3 tablespoons grated ginger

7 tablespoons chopped parsley

1 tablespoon sweet butter

• Heat 1 1/2 tablespoons of the olive oil in a deep, heavy, oven-proof saucepan. Add the garlic and scallions and slowly sauté until scallions are soft. Add the beans, 1 bay leaf, 1/2 branch of the rosemary, and salt and pepper to taste. Add water until it reaches double the height of the mixture and simmer slowly on low heat for about 30 minutes. Then put pan in oven and bake mixture at 275°F (135°C) for 40 minutes. Add water as needed if the beans become dry or remain firm while cooking. When finished, the beans should have a soft, smooth texture.

• In a large pot, add the lemon verbena to 3 cups (710 ml) of water and bring to a light boil. Then add the potatoes and simmer for 5 minutes. Remove the potatoes from the water and reserve. Next, add the prunes to the lemon verbena water and simmer for about 15 minutes until water is absorbed by the prunes.

Remove the prunes, clean away the lemon verbena leaves, and pass the prunes through a sieve or tea strainer to make a purée. Reserve the purée.

• Season the lamb with thyme, needles from the remaining rosemary, and 2 bay leaves. Heat remaining olive oil in a large sauté pan. Sear lamb in the oil for 3–5 minutes over low heat and then place it in an uncovered roasting dish in a 225°F (100°C) oven. After first 5 minutes, add potatoes all around the lamb and cook for 15 more minutes. Then add the prune-verbena purée, mixing well with the potatoes. Continue coating the potatoes periodically with purée so they completely absorb the prune flavor. When the lamb reaches an internal temperature of 140–150°F (60–65°C), remove it from the oven, but leave the potatoes to continue roasting until soft. Let the lamb rest for 5–8 minutes. While the lamb is resting, finish cooking the potatoes by raising the oven temperature to 400°F (200°C). Remove after 8 minutes, or when a crust has formed.

• Presentation should be simple. Place lamb on serving dish and surround with potatoes. Slice lamb into chops. Add ginger and chopped parsley to flageolets. Add butter and salt and pepper as needed. Serve with lamb.

(Below) Degas's painting palette

André Masson The Soft-boiled Egg with Truffle

The Parisian Surrealist legend André Masson created fantastic images that explored the hidden desires and emotions of his subconscious mind. His son, Luis Masson, shares here a rare and magnificent gift, his father's favorite cosmological recipe. Obtaining the exact ingredients may prove difficult, but when the dish is complete you can savor a true Surrealist artwork, and as the artist writes: "You will have, in three spoons, absorbed the world." The recipe has been translated by Gregoire De Cleen.

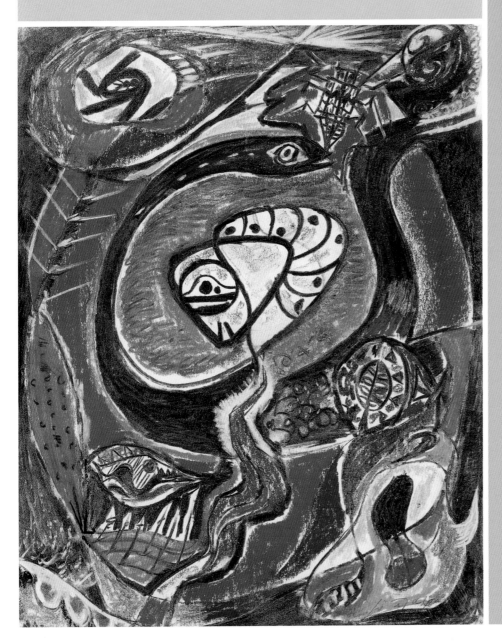

The Soft-boiled Egg with Truffle

Serves 1

1 fresh black truffle, preferably from Haute-Provence [the French Alps]
1 warm, new-laid egg
A few grains of salt of Guerande [in Brittany], if possible

• Go to the henhouse and get a new laid-egg, still warm from the hen heat and net straw. Put the egg and the truffle on the kitchen wooden table and cover them with a bowl turned upside down for 24 hours.

• Then simply boil the egg for 3 minutes precisely. Savor it at once, using a teaspoon, seasoned with a few grains of salt of Guerande. The egg, symbol of the cosmos, will have absorbed all the perfumes of the earth womb in which the truffle was hiding.

• You will have, in 3 spoons, absorbed the world.

• Furthermore, the truffle, from which you stole the perfumes, still retains so much that it will be of use in any other recipe. (Try simply to cook it wrapped in Silver Paper, in your chimney ashes.)

"Here is the favorite recipe of Masson and the drawing that strongly reminds of this Gastronomic Pleasure."

—Luis Masson

(Left) André Masson, *L'Oeuf Cosmique,* c. 1941, courtesy ADAGP Rue Berryer, Paris

Robert's Egg Dish

Serves 2 | Adapted

1 tablespoon olive oil or 1 tablespoon butter,
 or 1/2 tablespoon of both, combined
4 thick slices Canadian or Irish bacon
4 eggs
6–8 thin slices Camembert cheese
Pinch of paprika
1 banana, sliced
Curry powder to taste
About 1/2 cup (50 g) grated nutty cheese,
 such as Emmentaler
Half a medium onion, sliced into rings
1 large ripe tomato, sliced
Salt and pepper to taste
3/4 cup (45 g) Italian parsley, chopped

Note: Prepare all ingredients in advance, as the cooking time should not last longer than 15 minutes. The dish consists of 7 layers, which are stacked up successively.

• Melt olive oil and/or butter in a large frying pan. Fry the bacon lightly on both sides over medium high heat. Crack an egg on top of each of 4 slices of the bacon.

• Place pieces of Camembert onto the egg whites and put a pinch of paprika on each egg yolk.

• As the Camembert begins to melt, layer the banana slices evenly on top of the melting cheese. Sprinkle curry powder, to taste, over the banana slices. Sprinkle grated cheese over the banana layer.

• Add tomato slices to the top of each stack and season with salt and pepper.

• Place the onion rings on top and sprinkle the entire dish with fresh chopped parsley.

• Serve with white wine and fresh white bread.

(Top left) Bridget Riley, *Rêve*, 1999

(Right) Bridget Riley, undated; both courtesy Bridget Riley

One of the leading abstract painters of her generation, London artist Bridget Riley contributed this breakfast treat, which she says "Looks very pretty, smells delicious, and tastes wonderful." The artist explained the origins of Robert's Egg Dish:

"In the spring of 1972, I went to see a friend who had just completed his studies at Tübingen University in Southern Germany. Tübingen is in a part of a medieval town and one of the oldest universities in the country. As it was a beautiful day, we walked along beside the river before lunch. . . . My friend made me a meal in his room, which was extremely simple—the cooking facilities ran only to a single gas ring. As he explained, one of the charms of the Egg Dish was that it's ingredients were easily obtained virtually anywhere, and that you only need a frying pan, a gas ring, a knife and the smallest preparation area. Added to that it is easy, quick, it looks pretty, smells delicious and tastes wonderful. Robert's Egg Dish has always seemed to me the perfect young person's recipe. With a little white wine and fresh bread you can serve it up to any guest with absolute confidence. They may even want to join in the preparation as a chopper-upper, and it is almost as fun as it is to eat."

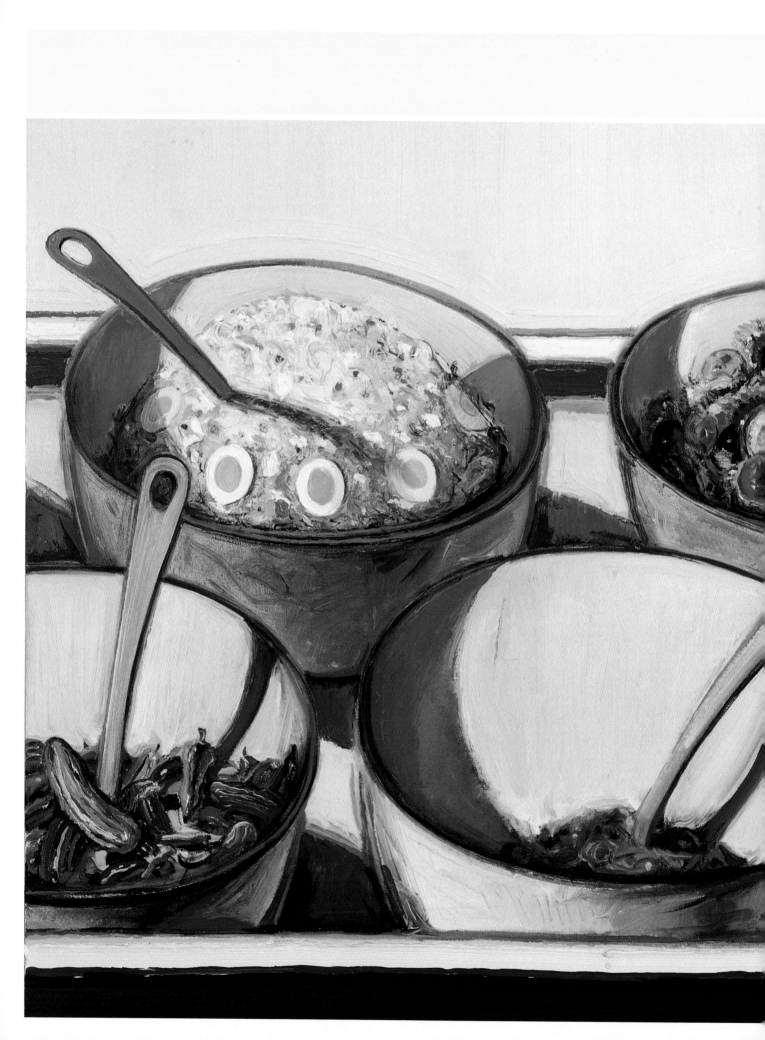

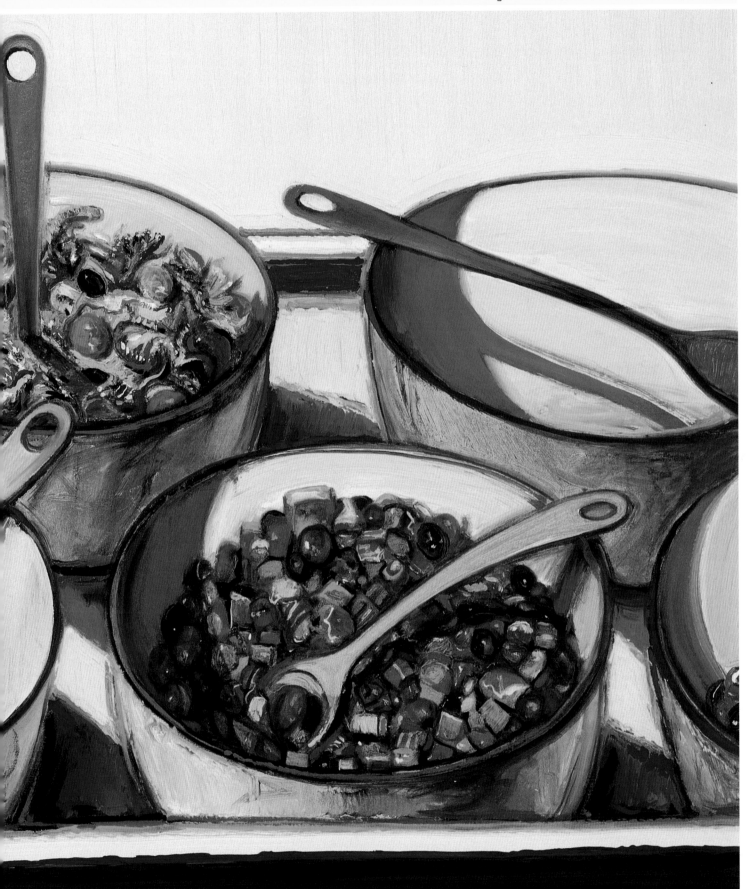

Henry Moore Lamb Stew

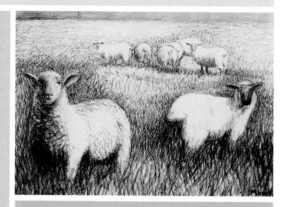

The monumental sculptures of Henry Moore, an English coal miner's son, are a breathtaking synthesis of classical and primitive sculptural traditions, pure abstraction and organic form. Margaret Reid, assistant curator of the Henry Moore Foundation, researched the acclaimed artist's culinary interests and also provided Moore's favorite recipe, Lamb Stew.

"In the 1980 publication of his *Sheep Sketchbook*, Moore describes how his initial perception of the sheep which grazed outside his studio as 'rather shapeless balls of wool with a head and four legs' gave way to an increased understanding of their form as he observed that 'underneath all that wool was a body, which moved in its own way.' . . . Returning from summer in Italy, Moore was sorry to discover that these 'balls of wool' had been shorn, finding them pathetically forlorn, naked, skinny, and guessing they must be as miserable as they looked. But his sympathy for the animals was tempered with a strong sense of realism; sheep were not only part of the Yorkshire landscape of his boyhood but also an essential ingredient in childhood meals of mutton stew. . . . Meals remained an important part of Moore's daily routine throughout his life. He would stop work punctually at 1:00 PM for an hour's lunch as well as taking a morning break at 11:00 AM and tea at 4:00 PM. His appetite did not diminish in later life. In his introduction to the *Royal College of Arts Artists Cookbook*, published after his death in 1987, he commented that 'I'm afraid I can't agree with the idea that, in order to be truly creative, an artist has to be underfed.'

"I have spent my life making sculptures . . . all the time fueled by thoughts, at least of the meals my mother cooked in native Yorkshire—fine English fare like mutton stew and rabbit pie."

—Henry Moore

"Emma Stower began cooking for the Moores at Hoglands in 1985, so that the cook, Mrs. Darby, could take the weekends off. In addition to the mutton stew and rabbit pie that he praises in the *Artist's Cookbook*, Moore enjoyed Emma's macaroni and cheese on Saturdays and steak and kidney pudding on a Sunday. . . . The supply of fruit in the Hoglands garden made stewed pears a regular favorite. However, Emma recalls that she was not entrusted with cooking a full roast dinner, which was postponed until Monday, when Mrs. Darby was back in charge of the kitchen."

Lamb Stew

Serves 4

8 lamb chops
4 tablespoons butter
1 1/2 lbs (675 g) small potatoes (halved)
4 oz (100 g) small button onions
8 oz (200 g) mushrooms (chopped)
1/2 cup plus 2 tablespoons (145 ml) white wine
1 cup (225 ml) white (veal) or chicken stock
8 tablespoons (50 g) bread crumbs
1/2 cup (125 g) sour cream
Salt and pepper
1 bay leaf
1 sprig thyme
1 sprig parsley
1 sprig rosemary
Chopped parsley to garnish

• In a large frying pan, fry the chops in butter, then remove. Put the potatoes, onions, and mushrooms in the pan and cook for 5 minutes. Lift out the vegetables, drain the fat from the pan, then add the white wine, white stock, bread crumbs and cream. Stir thoroughly and season to taste.

• Return the vegetables and chops to the pan with the herbs. Cover and simmer for about 1 hour or until tender. Remove the bay leaf, sprinkle chopped parsley over top and serve.

(*Previous page*) Wayne Thiebaud, *Deli Bowls,* 199

(*Above*) Henry Moore, *Sheep Grazing in Long Grass,* 1981

(*Right*) Henry Moore with his sculpture, *Sheep Piece,* 1971–72, Zurich; both photographs courtesy The Henry Moore Foundation, Hertfordshire, UK.

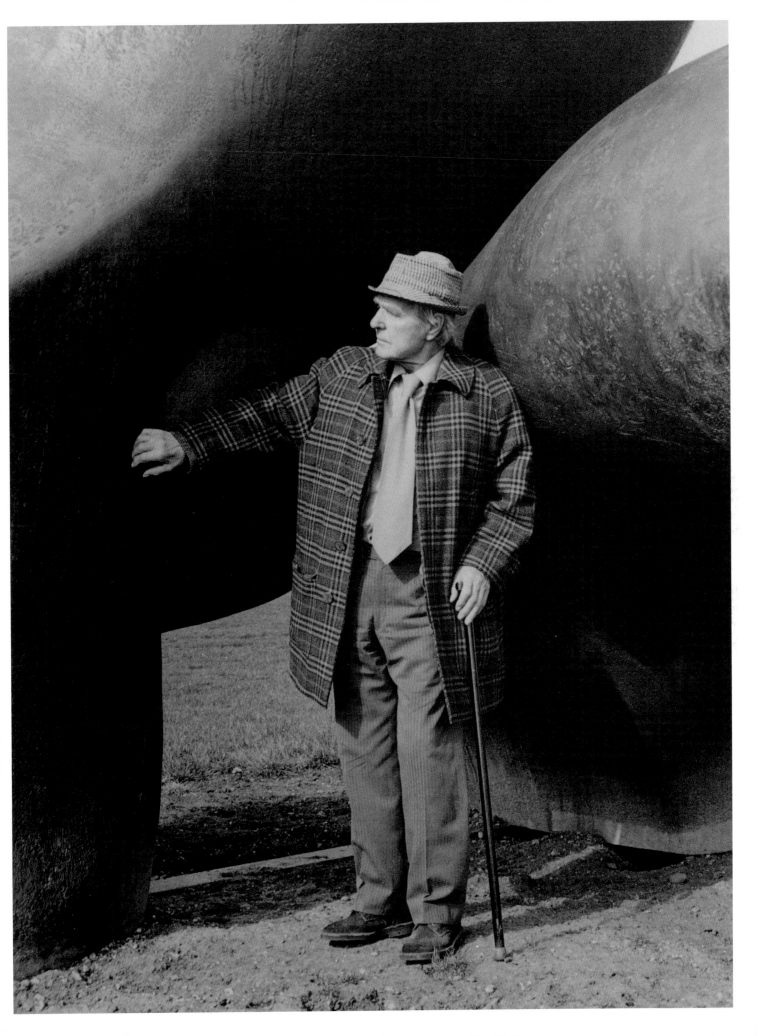

Marisol Nabeyaki Udon

Nabeyaki Udon (Japanese Noodles)

Serves 4 | Adapted

1 lb (450 g) dried udon noodles
4–6 cups (1–1.5 l) noodle stock (see Note)
4 large prawns, cleaned, shelled, and deveined
1 cake fish paste *(kamaboko)*, thinly sliced,
 or 4 oz (100 g) crabstick, chopped
4 shiitake mushrooms, sliced
12 small sprigs watercress or young spinach
 leaves, cleaned
4 small eggs

Note: Japanese noodle stock is traditionally made of kelp and bonito flakes (found in Asian markets) added to hot water. Light chicken, fish, or vegetable stock can be substituted.

• Boil noodles in a large pot of salted water according to package directions. Bring the stock to a boil, and add the shrimp. Cook shrimp for 3 minutes, remove, and bring the stock back to a rolling boil.

• Drain the noodles and divide among 4 large soup bowls, making a well in the center of each. Arrange the fish cake or crabstick, mushrooms, watercress, and shrimp in each bowl. Gently crack an egg into the center of each noodle well. Carefully pour boiling stock into each dish and cover for 3—5 minutes, until egg is set.

Born in Paris in 1930 to Venezuelan parents, Marisol Escobar (known as Marisol) has been internationally recognized for over 30 years for her free-standing sculptural portraits of her artworld friends, historic figures, royal families, and herself. Marisol's favorite dish is Nabeyaki Udon. Traditionally, this hearty winter soup is prepared and served in individual earthenware casseroles. It is essentially a one-portion version of a noodle sukiyaki.

(Above) Marisol posing with one of her sculptures, 1985

(Top right) Marisol, *Mimi,* 1997

Wayne Thiebaud Corn Soup

One of the most well-known American artists from the West Coast, Wayne Thiebaud introduced Pop Art to California. However, instead of employing mechanized techniques—like screen printing—to depict the ephemera of modern consumer culture, Thiebaud utilized the painterly manner of the Bay Area Figurative School. His images of neatly arrayed toys, lipstick tubes, pastries, cafeteria goodies, and other neon-lit foodstuffs are brought to life with luscious, rich paint and luminous California colors. Thiebaud is also acclaimed for his cityscapes and bird's-eye depictions of American highways. Here he speaks of his art as if he were "cooking on canvas":

" I am interested in what happens when the relationship between paint and subject matter comes as close as I can get—white gooey, shiny, sticky oil painting, spread on top of a painted cake to 'become' frosting. It is playing with reality-making, an illusion which grows out of an exploration of the propensities of materials."

Corn Soup

Serves 4 | Adapted

3 strips bacon
1 yellow or white onion, diced
1/2 green pepper, diced
2 cups (500 ml) chicken broth
2 red potatoes, peeled and boiled
3 ears sweet corn kernels
1 1/2–2 cups (375–500 ml) milk
Salt and pepper, to taste

• Fry the bacon in a skillet until crispy, then remove, allow to cool, and crumble. Add the onion and peppers to the bacon grease, and sauté over medium heat until softened, about 5 minutes.

• Add the chicken broth, potatoes, and corn kernels, bring to a boil, and cook for 10 minutes. Purée the mixture in a food processor until smooth, then pour into a saucepan, place over medium-low heat, and add milk to the desired consistency. Season with salt and pepper. Serve hot.

(Right) Wayne Thiebaud, *Deli Bowls,* 1995

Robert Cottingham Hearty Lamb Stew

The American Pop artist Robert Cunningham is noted for his vivid, photo-realistic paintings of old-fashioned machines, urban signs, and storefronts, which immortalize these icons of our recent past. While living in London, the artist enjoyed cooking leg of lamb for Sunday family meals. Now residing back in the United States, Cottingham's current favorite dish is one he calls Hearty Lamb Stew.

"In the early seventies my wife, Jane, and I moved from Los Angeles to London with our two daughters, Reid and Molly. We bought a house in Fulham, which was then a working-class neighborhood off the King's Road near Chelsea, and began acclimating ourselves to our new environment. Jane and I became accustomed to the huge soup-to-nuts supermarkets of Southern California where one visit would supply us with a week's worth of food. In London, however, we found that food shopping was a daily ritual. Our neighborhood, like others all over the city, had its own cheese shop, bakery, greengrocer, butcher, and fish monger. We would make the rounds of these local specialty shops almost every day, buying fresh food for the day's meals. On Sundays we'd enjoy a big leg of lamb, roasted potatoes, Brussels sprouts, and sometimes Yorkshire pudding. It became a weekly event to sit down to this big meal with our children and friends.

"Eventually we moved back to a temporary house in Bridgehampton, New York, and finally settled on an old dairy farm in Connecticut where we still live. Our third daughter, Kyle, was born a month after we moved in. In the chaos of unpacking and caring for a new baby our Sunday lunches were soon forgotten. As the kids got older, we wanted to reestablish the weekend lunch we had enjoyed so much in London. It offered an opportunity to catch up on the week's news and family gossip. The girls vetoed leg of lamb, so I proposed lamb stew, adding a Moroccan flavor and couscous as a side dish. We all like this spicy recipe, a hearty, colorful meal that still brings our family together. Now that two of our daughters are vegetarians, they take the lamb out and still have an interesting dish."

Hearty Lamb Stew

Serves 4 | Adapted

2 lbs (900 g) boneless lamb, cut into 1-inch (2.5-cm) cubes
2 tablespoons butter
1 tablespoon olive oil
1 large onion, chopped
2 carrots, diced
3 medium tomatoes, chopped
1 turnip, peeled and cut into cubes
2 tablespoons flour
Salt and pepper to taste
1 cup (250 ml) hearty red wine
1 cup (250 ml) beef broth
1 garlic clove, finely chopped
1 bay leaf
1 teaspoon chopped fresh rosemary
1 teaspoon caraway seeds

• Brown the lamb in a large skillet with butter. In a separate saucepan, slightly brown the onions, carrots and turnip in the olive oil. Add the flour to the lamb and mix well. Add the tomatoes and browned vegetables to the meat. Add the remaining ingredients, except the caraway seeds, cover and cook for 3 hours or bake at 325°F (170°C) for 3 hours. When meat is tender, add the caraway seeds and serve over wide noodles, with a dollop of sour cream.

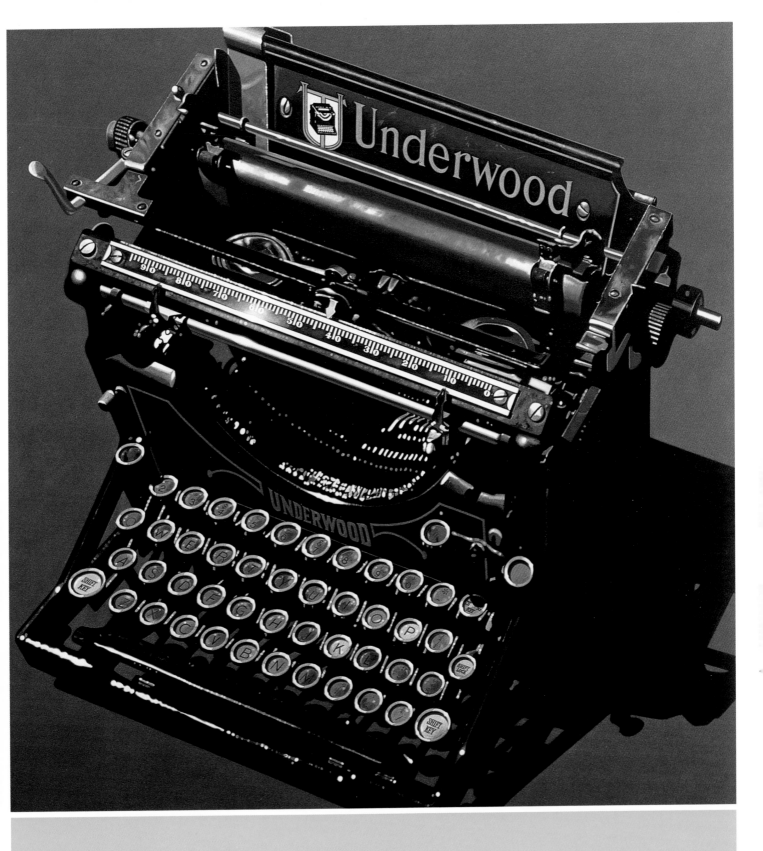

(*Above*) Robert Cottingham, *Underwood,* 1998

(*Top left*) Robert Cottingham, undated;
both courtesy Forum Gallery, New York

Louise Bourgeois Oxtail Stew

The installation artist and sculptor Louise Bourgeois is the Grande Dame of American sculptors. In 1995, she gave me her favorite recipe—with very careful instructions and a related anecdote—for oxtail stew:

"To be personal, I will bore you with what happened to me some time ago. Just for the sake of being smart, I went to the wholesale meat market on 14th Street in New York, and bought two packets of [whole] oxtails. . . . I got them home and realized I had to cut them into about five pieces per tail. Being a sculptor, I put them on my band saw. The bones were so hard the band saw blades snapped. I went to my corner butcher to ask him to do it with his rotary disk saw; he said 'I would do this for a customer, too bad you went behind my back.' I learned my lesson and since then I rely on my local butcher."

Seven years later, I visited the artist in her studio on a November Sunday and there met Pouran Esrafily, a filmmaker and Louise's assistant. Pouran, who was filming Louise at one of her Sunday gatherings, told me that she cooks for Louise every Sunday and always makes the same meal: well-cooked linguini with American cheese, served in a frying pan, with a soda. Dessert is coffee ice cream, which is served in the same frying pan.

(*Above*) Louise Bourgeois, *Untitled,* 1968–69

(*Right*) Louise Bourgeois eating her Sunday meal, 2003, courtesy Louise Bourgeois.

Oxtail Stew

Serves 6–8 | Adapted

4 lbs (2 kg) oxtails, cut into 2-inch (5-cm) segments
2 tablespoons lard or oil
1 bay leaf
10 sprigs fresh thyme
10 stems fresh parsley
3–4 cups (830 ml) beef stock
3 turnips, peeled, quartered, and sliced

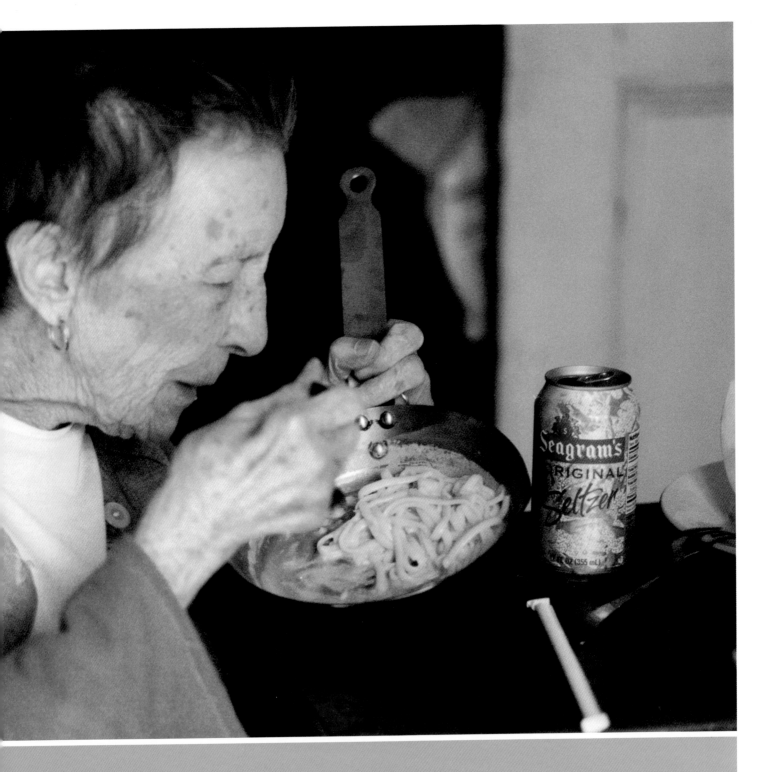

3 carrots, quartered lengthwise and cut into
 2-inch (5-cm) pieces
1 onion, cut into wedges
Salt and pepper to taste

Gravy:
1 lb (2.2 kg) mushrooms, finely chopped
1 lb (2.2 kg) raisins
1 lb (2.2 kg) pears or apples, peeled,
 cored, and chopped
Salt and pepper to taste

• Rinse the oxtails in cold water and pat dry. Season generously with salt and pepper. In a large heavy-bottomed pot or Dutch oven, heat the lard or oil over high heat. Sear the oxtails on all sides until browned. Tie the bay leaf, thyme, and parsley into a bundle with kitchen twine. Add the stock to the pot, stirring to scrape up the browned bits in the bottom of the pan. Add the herbs and vegetables. Cover and simmer over low heat for at least 2 hours, until meat is tender and falling off the bones.

• To prepare the gravy, put the mushrooms, raisins, and fruit in a large saucepan over medium-low heat. Cook, covered, stirring frequently until fruit is completely broken down and mushrooms are very soft, about 1 hour.

Serve the oxtails on a bed of greens with the "gravy" alongside. Squeeze fresh lemon over all, and serve with crusty bread. Ms. Bourgeois adds, "Sucking the meat from the bones keeps you from eating too much and making a pig of yourself."

Howard Pyle Philadelphia Pepper Pot

The 19th-century artist Howard Pyle is considered "the Father of American Illustrators." His illustrations and articles for *Harper's Weekly* and other publications of the time brought him wide fame, and in 1900 he established his own illustration school in Delaware. Pyle's biographer, Mr. Ian Schoenher, shares the culinary excursions and lifestyle of this remarkable artist:

"When Howard Pyle landed his first important commission, he rewarded himself by immediately taking a friend to Delmonico's, where they 'had a lunch of all the delicacies in season, and out of season.' Thereafter, as his success and circle of friends grew, dinners at Delmonico's and other such eateries were regular events in Pyle's life. He was invited to a number of lunches and dinners at the White House, and attended banquets honoring the likes of Mark Twain and other such luminaries. The menus at these grand feasts were nearly as remarkable as the guest-lists. Pyle's taste for food has its limits, however; when served truffles in Italy, he said that 'they taste like sewer gas smells.'

"By and large, the food Pyle is known to have enjoyed is of the comfort variety: ice cream, roasted chestnuts, popcorn, cake, pretzels, lager beer, dried fruit, chocolates, apple cider, ginger ale, waffles, turkey, and pie. He once offered to send some terrapin to a sick friend, saying "tis good and invalid food.' While teaching at the Drexel Institute in Philadelphia, Pyle occasionally invited some of his students to lunch. He liked to expose them to new dishes, but he also knew the power of food as an inducement to work, or as a reward for work well done. Once, at the Bartram Hotel, he said to a waiter, 'I want to introduce these boys and girls to the famous Philadelphia Pepper Pot. Bring them a large dish, with a large quantity of his famous Philadelphia Pepper Pot, for I want them to know it, and because I expect a great deal of work from them this afternoon.' On hot days, Pyle's penchant for lemonade spurred him to lead his summer school students on long bicycle trips from Chadsford to one restaurant in Wilmington, that made it especially with Appolinaire's water.

"Pyle peppered his pictures and prose with scenes of eating and drinking. The *Merry Adventures of Robin Hood* in particular is full of jolly feasts. The activities of Robin Hood and his men whet their appetites, and they satisfy themselves by 'roasting juicy steaks of venison, pheasants, capons and fish from the river,' by devouring 'fresh pastries compounded of juicy meats and onions being mingled with good rich gravy, and washing it all down, with pots of "humming ale" or a

Philadelphia Pepper Pot

Note: This standard pepper pot recipe was provided by one of the oldest restaurants in Philadelphia, Old Original Bookbinder's, founded in 1865.

Serves 4–6

1 lb (450 g) honeycomb tripe
6 cups (1.4 l) beef stock
1 medium green pepper, diced
1/4 cup (25 g) diced celery
1/4 cup (50 g) diced onion
1 cup (100 g) stewed tomatoes
1 cup (150 g) diced, uncooked potatoes or
 1 cup (125 g) cooked shell pasta
1/4 teaspoon thyme
1 small clove garlic, mashed
Dash Tabasco
Salt and pepper
1/4 cup (11 g) bacon fat
1/4 cup (11 g) flour

• Pour the stock into a large pot, then add the tripe in one piece to the stock and simmer about 3 hours, or until tender. Drain, reserving liquid in a separate container in the refrigerator. Cool and refrigerate the tripe until just chilled (about 15–20 minutes) then cut into strips.

• Pour the liquid back into a large pot—if it does not measure 4 cups (1 l) of liquid, add extra beef stock. Add the green pepper, celery, onion, tomatoes, and potatoes or pasta, together with the seasonings, and simmer on medium-low heat until vegetables and are done (about 20 minutes).

• Melt the bacon fat in a small skillet and add flour, stirring mixture until a smooth roux. Add the roux to the soup and stir until thickened. Add tripe and heat through. Correct seasoning.

(Top right) Howard Pyle, *January and May,* published in *Scribner's Magazine,* 1893

(Bottom right) Howard Pyle, *It was a very gay dinner,* c. 1880s; both courtesy Illustration House, Inc., New York

goatskin full of stout March beer.' In one memorable passage, Robin fantasizes about his ideal meal: 'Firstly, I would have a sweet brown pie of tender larks, mark ye, not dry, cooked, but with a good sop of gravy, to moisten it withal. Next, I would have a pretty pullet, fairy boiled with tender pigeons' eggs, cunningly sliced, garnishing the platter around. With these I would have a long, slim loaf of wheaten bread that hath been baked upon the hearth; it should be warm from the fire, with glossy brown crust, the color of the hair of mine own maid, Marian, and this same crust should be as crisp and brittle as the thin white ice that lies across the furrows in the early winter's morning. These will do for the more solid things; but with this I must have three bottles, fat and round, full of Malmsey, one of Canary, and one brimming full of mine own dear lusty sack.' Doubtless, these delicious descriptions reflected Pyle's own palate."

Henri Matisse Soupe de poissons

The very name Matisse is synonymous with great art. For almost a century, the Fauvist's magnificently colored canvases have dazzled the public. Matisse was an immensely prolific artist who structured his days with discipline. He rose early to take advantage of the light, and had only one large meal— at midday—followed by a siesta. This fish soup recipe must have been one of his favorites; he shared it in a 1938 letter to the French writer Marie Dormoy.

(Above) Matisse in his studio at the Hotel Regina in Nice, France, c. 1950, drawing sketches for murals he painted in the Chapel of the Dominicans, in nearby Venice.

(Top left) Recipe for Soupe de poissons in a letter written by Henri Matisse to Marie Dormoy, while he was staying at the Hotel des Thermes Vittel in France, 1938.

(Bottom left) Henri Matisse, *Still Life on Table,* 1925

Soupe de poissons (Fish Soup)

Serves 4 | Adapted

3 tablespoons olive oil

2 leeks, white part only, finely chopped

2 medium onions, finely chopped

2 cloves garlic, minced

2 tomatoes, finely chopped

Pinch of fennel seeds

1 bay leaf

Large piece of orange peel

3 lbs (1.25 kg) assorted shellfish

1 teaspoon salt

32 oz (950 ml) water

Pinch saffron

1/4 lb (125 g) large dried noodles

• Heat the olive oil in a large, deep sauce pan over medium heat. Add the leeks, onions. and garlic and cook until softened, about 5 minutes. Add the tomatoes and cook until broken down,

about 5 minutes more. Add the fennel, bay leaf, orange peel, half of the shellfish, water, and salt. Bring to a boil, cover, and cook for 15 minutes.

• Remove from heat and strain through a fine mesh strainer. Use back of a spoon to press all liquid out of the solids, and discard the solids. Return the broth to the pot and bring to a boil over medium-high heat. Add the remaining shellfish, saffron, and noodles and cook until tender, about 8 minutes. Serve immediately.

YuYu Yang Hot & Sour Soup

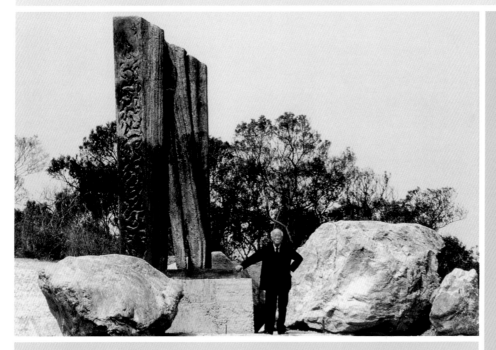

YuYu Yang is considered one of the world's preeminent sculptors and the "dean" of Taiwan's artistic community. The mutual friendship and artistic respect between the renowned architect I. M. Pei and YuYu Yang was evident when the architect commissioned YuYu to create *Advent of the Phoenix,* a sculpture for the Taiwan Pavilion at the 1970 World Expo in Osaka and the *East-West Gate* (1973) in front of Pei's Orient Overseas Building in New York. Other works by YuYu are also in the collections of the Smithsonian Institute and the Vatican. YuYu gave me this spicy soup recipe, which I consider to be a dish of complex flavors that guests would greatly enjoy (in China, it would be slurped—an accepted Chinese practice that signifies praise for the chef). YuYu told me, though, that to the Chinese, Hot and Sour Soup is considered more of an everyday dish:

"This is one of the most popular Chinese recipes, which is served at almost every Chinese restaurant. What makes this soup so sour is the vinegar, and what makes it so hot is black pepper. However, you won't see this soup served at banquets in China, because the ingredients are considered too ordinary."

(Above) YuYu Yang poses with one of his sculptures, undated.

(Left) YuYu Yang at work in his studio; his wife and daughter are in the foreground, c. 1950s; both courtesy YuYu Yang Lifescape Sculpture Museum, Taipei.

Hot & Sour Soup

Serves 6 | Adapted

1/2 cup (35 g) dried enoki mushrooms
 (soaked in 2 cups (470 ml) hot water for
 15 minutes and drained)
1/4 cup (25 g) dried wood ear mushrooms
 (soaked in 2 cups (470 ml) hot water for
 15 minutes and drained)
1/4 cup (32 g) corn starch
1/2 cup (70 g) shredded lean pork
1 8-oz can (260-g) can bamboo shoots
2 14-oz cans (880 ml) chicken broth
2 tablespoons soy sauce
2 tablespoons vinegar
1 teaspoon black pepper
3/4 cup (190 g) shredded firm tofu (bean curd)
1 egg, beaten
2 teaspoons sesame seed oil
2 tablespoons scallions, thinly sliced
Salt and pepper to taste

• Cut off the stems from the enoki, and then cut them in half. Cut the wood ears into 1/2-inch (13-mm) pieces. Rinse and drain the mushrooms, gently pressing out excess liquid.

• Stir the pork and 1 teaspoon of cornstarch together in a bowl. Stir the enoki, wood ears, and bamboo shoots together. Set aside.

• Dissolve the remaining cornstarch in 1/2 cup (120 ml) of water. Also set aside.

• Combine chicken broth and 3 cups (710 ml) of water in a large saucepan and bring to a boil. When the water is boiling, add the enoki, wood ears, pork mixture, and bamboo shoots. Bring back to a boil, for a third time, then add soy sauce, vinegar and pepper. Add cornstarch mixture and stir. Gently add the tofu. Pour a stream of beaten egg into the hot soup while stirring constantly.

• Remove from heat immediately and pour soup into serving bowls. Add salt to taste and garnish with sesame oil and scallions. Serve hot.

Jasper Francis Cropsey Fish & Pork Chowder re-created by **Chef Erin Horton**

The 19th-century American painter Jasper Francis Cropsey was a member of the Hudson River School, a group of Romantic Realist landscape painters founded in the 1820s. Kenneth W. Maddox, Art Historian at the Newington-Cropsey Foundation, discusses a letter written by Cropsey to his wife, Mary, in 1852, where he recounts the adventure of dining in the great outdoors:

"Jasper Francis Cropsey's recipe for a fish and pork chowder is contained in a letter written from Niagara Falls to his wife in 1852. In August that year, Cropsey had journeyed to the falls where he was soon joined by fellow Hudson River School artist John F. Kensett, whose friend and patron was Peter A. Porter. Porter's father had purchased Goat Island, which separates the American falls from the Canadian, and in 1817 had built a bridge connecting the island with the American shore. Porter points out that Cropsey had an unusual viewpoint—not previously known to artists—from an island of rocks below the American falls. The site was almost inaccessible, especially for the ladies, which pleased the artist, as it meant he could work undisturbed. Later he employed some boys to lay stepping-stones, and was able to avoid wading through the river to his island sketching grounds. The only disadvantage to his oasis, which he named 'Cropsey Rock,' was its closeness to the mist of the falls. Shifting winds would cover the artist with a dense spray, falling like a shower on the study he was working on, and often ruining it. From his sketches that survived, the artist painted the following year a 48 x 71-inch (122 x 180 cm) canvas, which he exhibited at the National Academy of Design in New York. It is now considered one of his most important paintings.

"The artist did not spend his entire time sketching and painting the falls. . . . he joyously described to his wife his participation in an unsuccessful fishing excursion upon Niagara River with Kensett, Porter and his friend Mr. Force: 'We passed entirely around Navy Island, and about 3 o'clock we landed and cooked our fish (which we didn't catch, but bought). Made a kind of chowder of flour, pork and fish, and darling you ought just to have peeked at us from behind the trees and bushes, and have seen this operation of fish cleaning, fire making, cooking and eating, a merrier set of fellows you could not have met with anywhere.' Unfortunately, a torrential downpour interrupted their festivities, and the jovial group was soaked to the skin. Cropsey's recipe for chowder of course, leaves much to be desired. Did it include onions or potatoes, how much milk and cream were added, was it seasoned with pepper or salt? Rarely do his letters, however, ▷

Jasper Francis Cropsey, *Niagara Falls,* 1853, collection Newington-Cropsey Foundation, Hastings-on-Hudson, New York

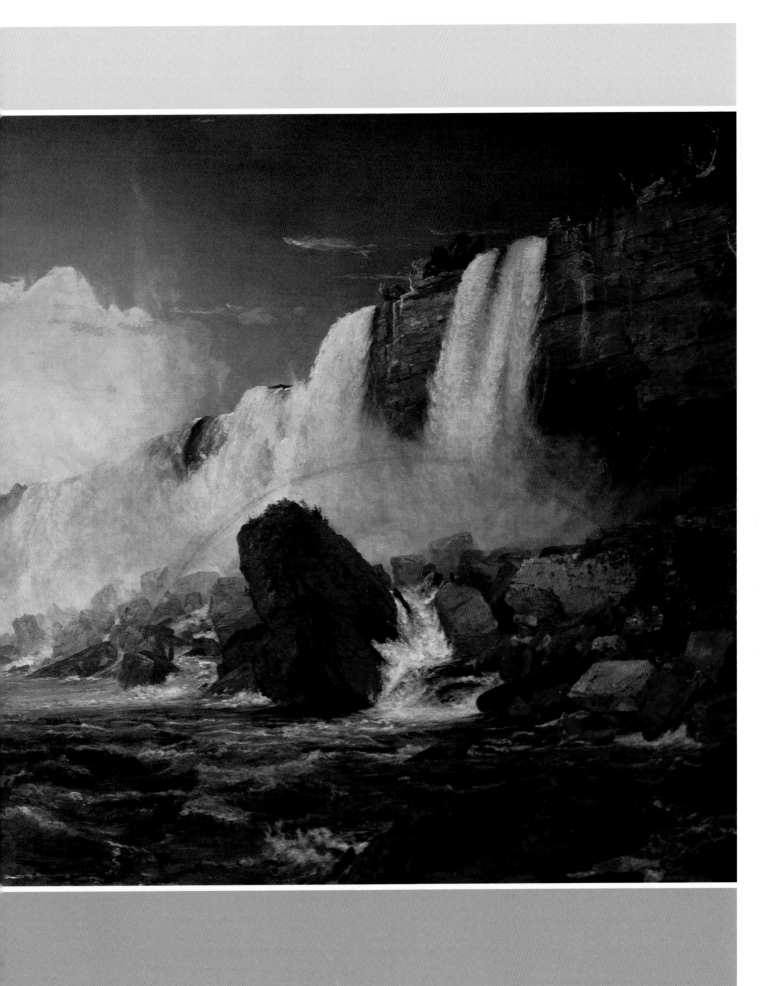

Jasper Francis Cropsey Fish & Pork Chowder re-created by Chef Erin Horton

mention the food he eats, and we are perhaps fortunate that the description is as detailed as it is. In a letter written on his journey to the falls, Cropsey expressed his dislike of the place where he had stopped, simply describing the food as 'scarcely done, or it is not very good.' He appreciated not only an excellent meal, but also an ample one, as a letter written the following year describing a meal at his parents' home in Staten Island makes clear. He had 'fared sumptuously' that morning, he related to his wife, for he had 'beef steak and chicken for breakfast.'"

"Darling you ought just to have peeked at us from behind the trees and bushes, and have seen this operation of fish cleaning, fire making, cooking and eating, a merrier set of fellows you could not have met with anywhere."

—Jasper Francis Cropsey

(*Above*) Edward L. Mooney, *Portrait of Jasper Francis Cropsey,* c. 1847, collection Newington-Cropsey Foundation, Hastings-on-Hudson, New York

Chef Erin Horton has recreated an authentic old-style chowder; like Cropsey, she has a good view of the waterfall from her restaurant, Top of the Falls, at Niagara Falls.

Fish and Pork Chowder

Note: Blue Pike, walleye, smallmouth bass, catfish, or trout would have been the most-likely fish used for this chowder. Haddock is also a reasonable possibility especially since the fish was purchased. Depending on how the fish was bought (whole or partially cleaned and boned), it is questionable if a fish stock would have been made; the alternative being Niagara River water. The most likely dairy product used was whole or powdered milk.

Serves 6–8

1/4 lb (100 g) salt pork, small dice
4 lb (1.8 kg) haddock or cod, cut into
 bite-size pieces (bones reserved for
 stock, recipe to follow)
1 small onion, small dice
1 celery stalk, small dice
1 carrot, small dice
2 tablespoons flour
1 quart (950 ml) fish stock
2 cups (480 ml) scalded half-and-half
2 large potatoes, medium dice
Salt and pepper to taste

• Render salt pork in heavy-bottomed pan until crispy. Remove pork and drain. Add onion, cook until tender. Drain excess fat. Add celery and carrot. Add flour to make a blonde roux. Whisk in hot fish stock and half-and-half. Add potatoes, simmer until just tender. Add fish pieces and crisp pork pieces; simmer until fish starts to flake. Taste, adjusting seasoning if necessary.

For the Fish Stock:
Bones, head, and tail of 1 haddock
1/2 cup (120 ml) white wine
2 quarts (1.9 l) cold water (approximate)
2 onions, thinly sliced
4 celery stalks, thinly sliced
2 carrots, small dice
1 bouquet garni (parsley and thyme
 stems and 1 bay leaf)
2 tablespoons black peppercorns
2 tablespoons kosher salt

• Chop and rinse fish bones. Combine all ingredients and enough cold water to cover them. Bring to a boil and skim all foam. Reduce heat and simmer until liquid is reduced by half. Add water whenever needed to ensure all ingredients are covered.

• Simmer for about 20 minutes more.

• Allow to steep off the heat for 15 minutes. Using a ladle, hold back the bones, and strain through a fine sieve, leaving any "sludge" behind.

Christo & Jeanne-Claude Tarator

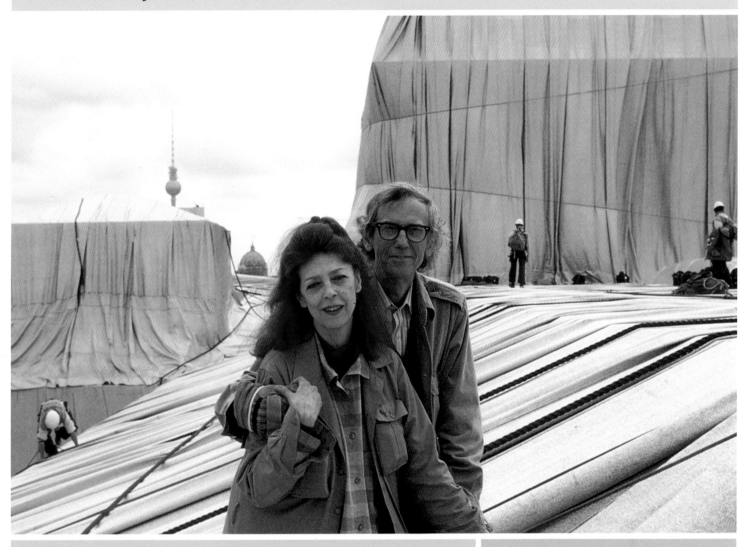

Since the 1960s, the astounding conceptual installations of two American artists have transformed some of the largest man-made and natural structures on Earth. The husband-and-wife team of Bulgarian-born Christo Javacheff, and Moroccan-born Jeanne-Claude de Guillebon—known as Christo and Jeanne-Claude—have temporarily wrapped or adorned public buildings, museums, trees, parks, fountains, floors, stairways, bays, coastlines, monuments, Roman walls, islands, and even the Pont Neuf in Paris. The artists have a refreshing Bulgarian recipe that was once prepared by Christo's mother, Tzeveta. This healthy dish makes a great appetizer or a light meal, and Jeanne-Claude often prepares it for summer guests.

(Above) Jeanne-Claude and Christo on the roof of the *Wrapped Reichstag*, Berlin, 1971-75, courtesy Christo and Jeanne-Claude.

Tarator (Summer Soup)

Serves 6 | Adapted

Four 8-oz (946-ml) containers plain lowfat yogurt
1 cup (450 g) walnuts, coursely chopped
1/2 cup (225 g) fresh dill, chopped
2 tablespoons olive oil
2 tablespoons vinegar
3 large cucumbers (peeled, seeded, and diced as small as possible)
2 teaspoons salt

• Simply mix all ingredients together in a large bowl and refrigerate for at least 3 hours before serving. Serve with bread if desired.

Rufino Tamayo Coloradito

During the early 20th century, painter, muralist, and sculptor Rufino Tamayo became the first Mexican artist to interweave the cultural traditions of his heritage with European Modernism. Tamayo transformed ancient pre-Columbian geometric forms, symbols, and rich colors; Mexican themes; Cubist composition; and classical structure into a universal language that transcended politics and still resonates today.

Maria Eugenia Bermudez, the niece of Rufino Tamayo's wife, Olga, tells us about the great Mexican master's culinary interests, and his favorite recipe of *coloradito,* the signature spicy Mexican sauce also known as red *mole.*

"Rufino Tamayo, a painter who expressed his concern for man and the universal culture through his work, was also an enthusiast of fine cuisine. He was fond of condiments and was always open to tasting any dish of his native Mexico, as well as dishes of the many countries he traveled to during his lifetime. I remember whenever he returned from a trip, he was always enthusiastic about sharing the exotic recipes he had tasted while abroad.

"As far as his preferences, the Mexican and Chinese cuisines, in which he found similarities, seduced him the most. The pleasure he experienced through eating, especially home-cooked meals, prompted his wife, Olga, to take cooking lessons to satisfy his palate. With the passing of years, Olga became a consummate cook. She enjoyed giving her husband the pleasure of not only preparing Mexican dishes, but also organizing the decoration of luncheons and dinners that were enjoyed by the frequent guests that shared their table. Tamayo's strict work schedule was only interrupted by the festival of colors and tastes that appeared daily in their dining room. Tortillas with any kind of salsa or stuffing, and white or red rice. Some of his favorite dishes were *mole*—every kind and color—*enchiladas, enfrijoladas,* hen with *hierba santa,* and *chiles poblanos* stuffed with ground meat. Without doubt, Tamayo's weaknesses were desserts, sherbets, and ice cream. This is the simple version of *Coloradito,* one of the seven moles of Oaxaca, that was prepared in the Tamayo kitchen. The recipe came from his mother-in-law's handwritten cookbook."

(Right) Rufino Tamayo with one of his paintings, undated, courtesy Fundación Rufino Tamayo.

Coloradito (Red Mole)

Serves 4 | Adapted

1 lb 4 oz (575 g) pork loin cut in cubes
 or 1 whole chicken cut in quarters
1 head of unpeeled garlic, halved crosswise
2 teaspoons salt
5 oz (150 g) dried ancho chiles
3 tomatoes
8 whole peppercorns
1/2 teaspoon oregano
1 whole clove
1 medium onion, roughly chopped
2-inch (5-cm) piece of cinnamon stick
2 tablespoons lard

• Place the pork in a medium pot. Add the salt, garlic and enough water to cover. Cook until tender, about 40 minutes. Set aside to cool in the broth.

• Gently warm the chiles on both sides in a non-stick skillet over low heat until soft but not browned. Let cool, remove seeds and veins, and soak the chiles in 2 cups (470 ml) of hot water. Add the tomatoes to the skillet and roast them over medium heat until charred and quite soft.

• Transfer the chiles, with 1 cup (240 ml) of the soaking water, the tomatoes, and the rest of the ingredients (except the cinnamon) to the blender. Blend to a smooth paste, adding a little pork broth if necessary. Strain to remove any stray seeds.

• Remove the meat from the broth. Reserve about 1 cup (240 ml) of the remaining broth. Melt the lard in a large pot until quite hot and fry the meat lightly. Remove the meat and set aside. Reduce the heat to medium. Add the blended ingredients and the cinnamon stick, cook for about 5 minutes, stirring continuously.

• Return the meat to the saucepan and cook for 15 minutes. The consistency of the sauce should be thick; if too thick add a little of the reserved broth. Add salt to taste. If desired, a small amount of sugar can be added to enhance the flavor. Serve with white rice and corn tortillas.

Chinese Chicken Salad

Serves 2–4 (depending on if it is served as an appetizer or a meal) | Adapted

1 chicken breast
2 tablespoons soy sauce
1 tablespoon dry sherry
1 tablespoon sugar
3–4 slices fresh ginger
1 clove garlic, crushed
Black pepper, fresh ground
Oil for frying
2 oz (50 g) bean thread (see Note)
1/2 head lettuce, finely chopped
3 scallions, chopped
2 tablespoons chopped cilantro
1/2 teaspoon dry mustard
1 tablespoon salad oil
1 tablespoon brown sesame oil
2 tablespoons vinegar
2 tablespoons sesame seeds

Note: Bean thread is a thin Japanese pasta made of soybean, available in Oriental markets. It can be substituted with rice flour pasta if desired.

• Marinate breast of chicken for several hours in 1 tablespoons of soy, the sherry and sugar, the ginger (you do not have to peel it), the crushed garlic, and a dash of black pepper.

• Bake chicken at 350°F (175°C) for 30 minutes. Allow to cool, and then shred by hand into bite-size strips.

• Take the bean thread and immerse in a deep pot of very hot oil. The bean thread should deep-fry instantly. Remove quickly and drain.

• Combine chicken with 3/4 of the bean thread with the lettuce, scallions, and cilantro. In a separate bowl, mix mustard, salad oil, sesame oil, remaining soy sauce, and vinegar.

• Mix everything together and top with the remaining bean thread and the sesame seeds. Serve at room temperature.

In 1954, American artist and designer Milton Glaser became cofounder and president of the venerable Pushpin Studios and went on to found *New York Magazine* along with Clay Felder in 1968. His well-known graphic and architectural commissions include the "I♥NY" logo, the redesigning of the Grand Union Supermarket chain, the graphics program for the Rainbow Room complexes at Rockefeller Center, in New York, and designing the International AIDS symbol for the World Health Organization. In 1975, his work was exhibited in a one-man show at the Museum of Modern Art in New York, and in 1977 he was honored with a one-man show at the Centre Georges Pompidou in Paris.

Mr. Glaser has selected his favorite recipe for Chinese Chicken Salad, as well as an illustration of a fizzing bottle of seltzer with which to wash it down.

(Previous page) Lee Krasner, Stella Pollock, and Jackson Pollock, in the Pollock kitchen at The Springs, East Hamptons.

(Above) Milton Glaser, undated.

(Right) Milton Glaser, *Experience Uncoated,* from a campaign for Fraser Papers, undated.

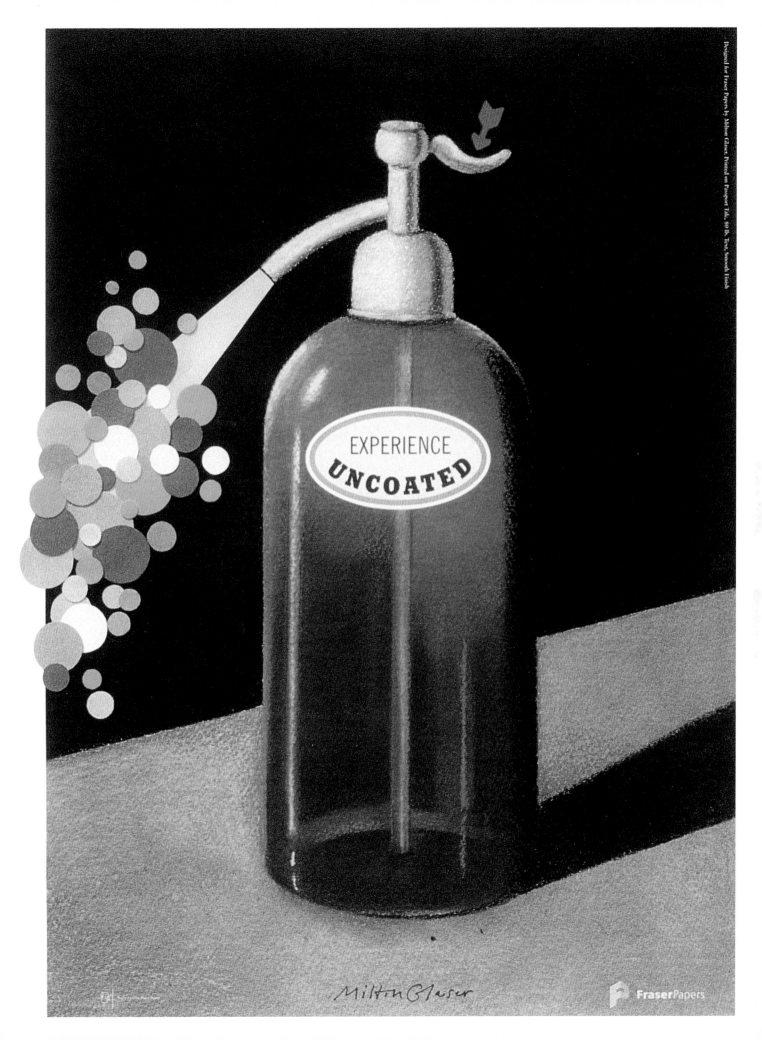

Man Ray Juliet's Potlagel

The American artist Man Ray and the French-born artist Marcel Duchamp met in New York in 1915. This noteworthy meeting not only led to a lifelong friendship, but also precipitated the founding of the New York Dada group in 1917, and the Surrealist movement of the 1920s. Eric Browner, Man Ray's brother-in-law and and administrator of the Man Ray Trust, recalls the great artists' friendship, and their love of wine, chess, and eggplant.

"Man Ray had a favorite food prepared by his wife (my sister), Juliet: Romanian style eggplant (*potlagel*). . . . When [Marcel] Duchamp and Teeny [Duchamp] came over to Man Ray's atelier to play chess, Juliet and Teeny would set out the baguettes and the potlagel. The men chose their favorite wines, and the women left to walk through Jardin du Luxembourg, and [have] a drink at Alexander's on the way back to the atelier."

Juliet's Potlagel
(Romanian-style Eggplant Spread)

Serves 4

2 large eggplants
1/2 medium onion
5 cloves of garlic
1 tablespoon olive oil
Salt and pepper to taste
French baguette, rye bread, or Russian
 black bread

• Wash the eggplants and pierce them with a knife. Place them in a microwave (that's new) and cook for 8–9 minutes (for best results cook on a barbecue).

• Place the cooked eggplants in a bowl and cool for several minutes, then split them lengthwise and scrape out the pulp with a large spoon. Put the pulp in a small Oscar (blender) or grinder, along with onion, garlic, and olive oil, with salt and pepper to taste. Pulse, do not purée.

• Chill the mixture in the refrigerator. This makes a great spread on French baguettes, sliced rye, or Russian black bread.

(*Left*) Man Ray eating spaghetti, c. 1960, courtesy Man Ray Trust.

Al Hirschfeld Caviar with Rice Crackers

Caviar with Rice Crackers

Serves 2–3

1 hardboiled egg, chopped
1 small onion, chopped
1 tablespoon light mayonnaise
2 tablespoons black caviar
Japanese rice crackers

• Mix first 4 ingredients together in a bowl, with a fork . . . gently. Serve on the rice crackers.

> "Everyone from Charlie Chaplin to Whoopie Goldberg has tasted it!"
>
> —Louise Kerz Hirschfeld

His longtime agent, Margo Feiden, called him a "characterist"—the legendary Al Hirschfeld created inimitable drawings that transcended caricature to become iconic portraits of the Broadway scene. Hirschfeld began drawing caricatures of performers for the *The New York Times* drama section in the 1920s. Since the 1940s, his daughter's name, Nina, was embedded into his drawings—Hirschfeld would hide the letters within the sinuous lines of an actor's hair or costume, inspiring legions of "Nina hunters" to find her name. The artist's wife, Louise Kerz Hirschfeld, told me that he loved to entertain, and was famous for his caviar rice cake hors d'oeuvres.

(Top left) Al Hirschfeld in his studio, courtesy Louise Kerz Hirschfeld.

(Above) Al Hirschfeld, *Self-Portrait,* courtesy Louise Kerz Hirschfeld and Margo Feiden Gallery.

Paul Cézanne Pommes de terres à l'huile Re-created by **Chef Mark Hix**

Considered the "Father" of modern art, the French Post-Impressionist painter Paul Cézanne was concerned with capturing the physicality of subjects on a one-dimensional surface, and exploring the space and relationships between the objects on this plane. His theory to "treat nature according to the sphere, the cone, and the cylinder" inspired artists from Matisse to Picasso.

During the 1860s, when Cézanne was in his twenties, he was persuaded to fill out a questionnaire entitled "Mes Confidences," consisting of questions designed to elicit information about an individual's personality. The questions are simple, but they give a wonderful insight into some of the painter's thoughts and opinions at the start of his career. He stated that his favorite color is "general harmony," his favorite smell is "the smell of fields," and the most estimable virtue is "friendship." In reply to question 28, "What is your favorite dish?" he wrote "Pommes de terres a l'huile," a simple Provençal recipe of potatoes in oil, which has been adapted here from the original by esteemed London chef Mark Hix. Philip Cézanne, great-grandson of the artist, wrote to me from Paris about the great master's tastes:

"I do not think that Cézanne was very concerned with his meals. He used to live very simply and eat the meals that his mother, for a period, and his kitchen maid after, cooked. He was very Provençal and of course liked those flavors."

Pommes de terres à l'huile (Potatoes in Oil)

Serves 8

Extra virgin olive oil
8 medium-size waxy potatoes, peeled and thinly sliced
4 strips (26 g) bacon, finely diced
6 medium shallots, peeled and finely chopped
Few sprigs of thyme with leaves removed

• Preheat oven to 400°F (200°C). Lightly brush an oven-proof dish or non-stick frying pan with a little olive oil. Place layers of the sliced potatoes into the dish, scattering the bacon, shallots, and thyme between each layer. Season every couple of layers with salt and pepper, and drizzle with a little more oil. Bake in the oven for 45–50 minutes, brushing the top with a little oil every so often.

Note: You can top with grated Gruyère and make individual servings for a simple starter or light lunch with salad. The bacon can be replaced with porcini and Parmesan or rosemary and garlic.

(Right) Paul Cézanne, *Still Life with Onions,* c. 1895.

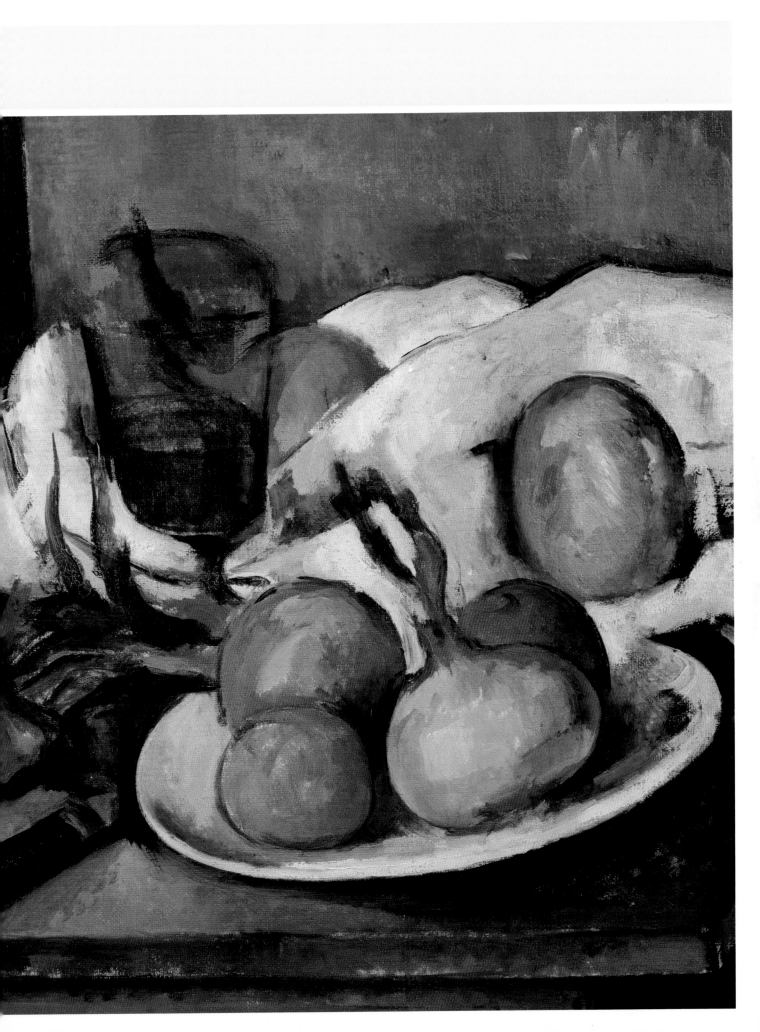

Vincent van Gogh Bread, Cheese & Absinthe

Although his work was not widely known during his lifetime, the Dutch painter Vincent van Gogh is now celebrated, romanticized, and revered—paintings such as *Starry Night* and *Sunflowers* have become instantly recognizable icons, his story is the subject of many films, and his paintings are auctioned for astounding sums of money.

Van Gogh was totally consumed by his art and sustained himself through the act of painting. He had little interest in eating; the van Gogh Museum in Amsterdam confirmed that the artist ate very frugally on a daily basis, except for crusty bread, Gouda cheese, and absinthe, a hallucinatory liqueur made with anise and wormwood oil. In fits of mania, van Gogh was known to have eaten oil paint and drunk turpentine as a substitute for absinthe, greatly exacerbating his fragile mental state and sending him to the asylum in St.-Rémy in 1889. This compulsive, artistic passion is made visible in his powerful artwork.

"Returning after spending the whole day in the blazing sun, the torrid heat, and having no real home in town, he would take his seat on the terrace of a café. And the absinthes and brandies would follow each in quick succession."

—Artist Paul Signac

Van Gogh was first introduced to the wild atmosphere of Paris nightlife and the opal-green, mind-altering drink by his friends and fellow artists Paul Gauguin and the fun-loving rascal Henri de Toulouse-Lautrec. It was 19th-century Paris and many of the brilliant minds of the day were seduced by absinthe, or the "Green Fairy," as she was called, including Pablo Picasso, Ernest Hemingway, Edouard Manet, Edgar Degas, Charles Baudelaire, and Oscar Wilde. Lautrec particularly adored the Green Fairy, and carried the liquid in his hollow walking stick on nightly

Bread, Cheese, and Absinthe

Serves 1–2

1 loaf of brick-oven crusted bread
1 small wheel of Gouda cheese
1 bottle absinthe or one of its substitutes
 (see Note)
Sugar cubes
Pitcher of water

• Cut the Gouda cheese into bite-size pieces. Rip off a piece of the oven-crusted bread and pour yourself a glass of absinthe.

Absinthe

• Pour 1 1/2 ounces (40 ml) of absinthe or substitute liqueur into a glass. Place the spoon across the top of your glass. Position a sugar cube on it.

• Dissolve the sugar cube into the liqueur by pouring 3 ounces (90 ml) of cold water over it.

• Stir with the spoon and enjoy. ▷

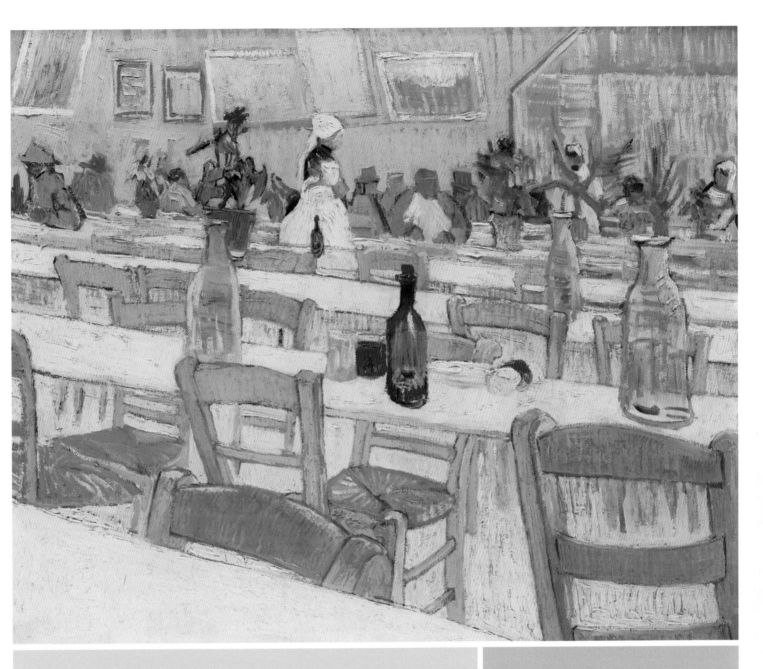

visits with van Gogh to the Moulin Rouge, the Café Weber, the Irish American Bar, and van Gogh's favorite, the Café du Tambourine. There they enjoyed absinthe cocktails made with white wine instead of water *(Absinthe Minuit)* and other absinthe-layered cocktails called Night Cups, Rainbow Cups, and their favorite—Lautrec's own recipe for *Tremblement de Terre* or "Earthquake." This potent concoction consists of absinthe and cognac.

(Above) Vincent van Gogh, *Interior of a Restaurant,* 1887–88.

(Top left) Portrait of Vincent van Gogh at age eighteen, 1873, collection Amsterdam, Van Gogh Museum (Vincent van Gogh Foundation).

(Far left) Bottle of Absente with absinthe spoon and sugar, courtesy Crillon Importers Ltd.

Note: Due to its hallucinatory and addictive properties, absinthe has been illegal in the United States and France since 1915, although it is available in many other European countries. Anisette, pastis, sambuca, and ouzo are descendants of absinthe; these are globally available in liquor stores and can be substituted. But if you would like to safely participate in the actual drinking ritual of absinthe, you can substitute Crillon Importers Absente Liquor, which is widely available as well and in many places can be purchased with replicas of authentic absinthe spoons and glasses.

Francisco Zúñiga Pickled Fish

The gentle power and graceful strength of Francisco Zúñiga's sculptures of goddesslike Mexican women at work and leisure are celebrations of his Pre-Columbian heritage and the people of Mexico. The artist's son, Ariel Zúñiga, writes of a beautiful memory of his father's love for art and the food of life:

"The image of the man is slowly fading out, almost disappearing; it refuses to be rebuilt from the outside. Nevertheless, some memories are still there . . . I am driving. We are traveling together, father and son; he talks most of the time. It is fascinating to listen to him. A particular gesture at the corner of his mouth changes his face . . . My hands at the car wheel, my eyes looking to the road, I do not see him but I feel his face change. I have seen it many times. Once a year we travel in Europe, we start in Paris for no real reason and we go to Carrara, in Italy, we go there for him to work on a marble sculpture, I drive, I translate, and I organize. . . . When it is time to stop and eat, it is always special, almost always a little late. It must be past noon I thought, as soon as I felt the change in his face. This man must have a watch in the same place I have a stomach. The one occasion I have in mind, the work in Carrara was not ready. . . . We decided to go to Pompeii. It is probably slightly after noon. I feel some tension, but as we come out of the curve, the sea is in front of us, my body relaxes. The presence of the sea relaxes my father, so it gives me more time to drive, and reach a place to eat. Just there at the roadside, there is a country road restaurant and we stop . . . If it is closed I will have to drive fast again. We cross the space through the tables and by the other side, at the shore we see a second building just there, some 200 feet down. Some people, around six or seven tables, it looks like a party. It is a wedding and somebody notices our presence, they shout: *'Vieni, vieni, qui con noi.'* We feel this strange feeling we are getting into others' intimacy. We stand still for a second and start moving backwards, but then a young boy runs to us and invites us to go down with the rest of them. We are invited to sit. Father and son toasting to people we have never seen before. We drink some wine, and my father shows his back to the sea. His lips are loose, his eyes shine. The image is faded out I said, but somewhere at the back of my memory I can still see it. 'You drive and never get to see the landscape; this is an occasion for it,' he tells me. I see him against the sea. They give us some bread, a platter with *frutti di mare,* and a bottle of wine without name. No name was needed. We eat. We are happy, we know it and they know it. I have never forgotten the taste of that bread. 'If only we could get some pickle,' he said. Then I knew pickled fish was his favorite. Later, while driving into the south he took a long time before he said a word: 'bread, wine, it is perfect, no sculpture could be done without bread and wine.'"

Pickled Fish

Serves 10–12 as an appetizer | Adapted

2 lbs (900 g) shark steaks (or other firm fish such as swordfish or tuna)
1 cup (240 ml) olive oil
4 cloves garlic
1 large onion, halved and sliced
2 large carrots, peeled and sliced (about 2 cups)
4 cups (950 ml) white wine vinegar
1 heaping tablespoon pickling spices
1 teaspoon salt
2 small zucchinis, sliced

• Slice the fish into bite-size pieces. In a large, heavy-bottomed pot, heat the olive oil over medium-high heat. When the oil is very hot, add the fish and garlic cloves and cook until browned, stirring occasionally, about 12 minutes. With a slotted spoon, remove the fish and garlic from the oil and reserve.

• Add the onion and carrots to the pot and cook until soft, about 8 minutes. Stir in the vinegar, pickling spice, salt, and zucchini. When the mixture begins to boil, stir in the fish and garlic and simmer the mixture for 15 minutes.

Serve warm or cold.

(Above) Francisco Zúñiga at work in his studio in Mexico City, undated.

(Left) Francisco Zúñiga with his sculptures, Hamburg, undated; both courtesy Fundaciòn Zúñiga Laborde A.C.

Joan Miró La calçotada

Joan Miró derived his own visual vocabulary from nature. The inventive Spanish painter and sculptor had a great influence on Picasso and succeeding generations of artists. Miró was born in Barcelona, but moved back and forth from Spain to Paris, where he was welcomed into the circle of Surrealist writers and poets. In Paris he began to develop his distinctive style, often referred to as "biomorphic abstraction"—but his lyrical imagery of free-flowing, sensuous amoebic shapes, curved lines, and stars suggests the dance of life itself.

Fiercely proud of his Catalan roots, Miró's favorite food was a Spanish dish of grilled calçots—a large Spanish variety of spring onion—called *la calçotada*. The dish is a specialty of Valls, in the province of Tarragona. The Fiesta Calçotada is held there every year at the time when the almond trees first break into bloom. The preparation for this fiesta, which Miró loved, takes place in December and January, when the shoots that sprout from the onions that have been stored for winter are removed, along with the bulb it has formed in the center of the vegetable. The shoots are then planted, watered only once, and allowed to grow into a calçot, which looks like an oversize green onion. The calçot must be fat enough so that after it has been charred and peeled there is something left to eat. They are grilled over a fire of vine cuttings, and are served outdoors both at upscale feasts or casual parties, where they are wrapped in newspaper. Either way, they are very messy to eat. The calçot is held in the left hand by its blackened base, and in the right hand by its inner green leaves at its top. Then the black part is slipped off and discarded. The remaining glistening white end of the calçot is then dipped in a spicy sauce and lowered into one's mouth, with one's head thrown back. The calçot is bitten off where the green part begins. To prevent a serious mess, everyone wears a bib and usually retires to a basin or sink to wash off the blackened soot. But the perfumed aroma and smoky flavor of the calçots make this unique dish a fascinating Spanish treat.

La calçotada (Grilled Calcots)

Serves 2–3 per person

2–3 calçots per person (see Note)
Salt

Note: If calçots are not available, you can purchase the biggest scallions or baby leeks you can find. One of the best sauces for dipping la calçotada *is salsa coloradita, recipe below. La calçotada is usually followed by lamb chops grilled over the same fire.*

• Heat coals on a grill, or a combination of coals and vine cuttings. Place the calçots on the coals and sprinkle them with salt as they are cooking. When they are thoroughly charred all around, remove them from the grill and wrap them in newspaper. They will steam in the paper, which will complete the cooking process. Serve them wrapped!

Salsa Coloradita

Makes 1 1/2 cups (360 ml)

1 head garlic, unpeeled and roasted
3 small tomatoes
1/2 cup (25 g) chipotle pepper
(or cayenne pepper to taste)
2 hard-boiled egg yolks
12 almonds, peeled and toasted
1/4 cup (60 ml) wine vinegar
3/4 cup (180 ml) olive oil
Salt to taste

• Place the the unpeeled garlic and tomatoes a small backing dish, and bake in a 425°F (220°C) oven until the tomatoes are very soft, about 10–15 minutes. Remove the peel from the garlic and tomatoes and mash them together in a mortar or blender, with the hot pepper. Add vinegar and reduce to a purée. Beat in oil. When blended well, add the hard-boiled egg yolks and the almonds. Stir together, serve in a bowl.

(Right) Joan Miró enjoys *la calçotada* at a festival in Valls, Spain, 1954.

Paul Delvaux Baked Oysters with Leeks

Baked Oysters with Leeks

Serves 2–3 | Adapted

10 tablespoons butter
3 leeks (cleaned, trimmed, cut finely)
Salt and pepper to taste
1/2 cup (80 g) finely chopped shallots
1/4 cup (60 ml) white wine vinegar
3/4 cup (180 ml/175 g) heavy cream
24 oysters in shells
Parsley sprigs for garnish

• Preheat oven to 500°F (260°C). Melt 2 tablespoons of the butter in a saucepan over medium heat. Add leeks, salt, and pepper and simmer while stirring, about 5 minutes. Set aside. In another saucepan, combine the shallots, vinegar, and 2 tablespoons butter. Cook over high heat until most of the liquid has evaporated. Add the cream and bring to a boil. Stir with a wire whisk. Add the remaining butter 1 tablespoon at a time and stir with a whisk until well combined. Season with salt and pepper and remove from heat.

• Place oysters in a baking dish and bake for 5–7 minutes (this is done to heat them gently and to make opening them easier). Remove the oysters from the oven and use an oyster knife to loosen the top shell. Open each oyster and discard the top shell. Cut away the oyster meat, reserving the liquid in the shells, and put the meat in the bowl.

• Spoon equal amounts of the leek mixture into each shell. Top each serving with an oyster. Spoon some butter sauce over the oysters. Garnish with parsley and serve immediately with a glass of Sancerre.

Painter and printmaker Paul Delvaux was, with René Magritte, one of the major exponents of Surrealism in Belgium. He applied a realistic, detailed technique to his paintings of immobile nude or seminude women, somnambulant figures that eventually became his trademark. Delvaux's atmospheric paintings derive their power from his unusual settings as well as unsettling incongruities that often include mythological and classical references.

The Delvaux Foundation in Belgium searched their archives and found Delvaux's favorite recipe. They discovered that the artist loved "poultry like pheasant with Bordeaux (never Bourgogne), but his culinary choice was Baked Oysters with Leeks and Sancerre."

(Top left) Paul Delvaux working on a painting, c. 1967; courtesy Delvaux Foundation, St. Idesbald, Belgium

Edward & Nancy Kienholz Hot-Cold Chinese Noodles

California artists Edward and Nancy Kienholz's assemblages, or "tableaux," are amazingly detailed statements on contemporary life; their sculptural environments created with actual distressed objects and reconstructed mannequins present life in all of its cold reality. Nancy Kienholz has given us their favorite recipe for spicy Chinese Noodles.

Hot-Cold Chinese Noodles

Serves 6–8 | Adapted

1/2 lb (225 g) Chinese noodles
1 large tomato, chopped, plus more for garnish
1 green hot pepper (such as serrano or
 jalepeño) minced
2 cloves garlic, minced
1 tablespoon *kimchi* (pickled Korean vegetables)
1 tablespoon peanut butter
1 bunch scallions (white part only), sliced,
 plus more for garnish
1 teaspoon dark sesame oil
2 tablespoons soy sauce
Pinch red pepper flakes
3/4 cup (180 ml) peanut oil
1/2 cup (75 g) roasted peanuts

• In a large pot of salted water, boil the noodles until cooked through but still firm. Drain and refrigerate for at least 2 hours.

• In a large heatproof bowl, mix the tomato, pepper, garlic, *kimchi,* peanut butter, scallions, sesame oil, soy sauce, and pepper flakes until well combined.

• In a small saucepan, heat the peanut oil until hot but not smoking. Carefully pour the hot oil over the vegetable mixture and mix well. Pour the hot dressing over the cold noodles. Using a large fork or tongs, toss the noodles to coat evenly.

• Garnish with peanuts, tomatoes, and green onions and serve immediately.

(Top left) Edward and Nancy Kienholz,
First Car, First Date, 1992, Private Collection

(Left) Edward and Nancy Kienholz, c. 1984;
both courtesy Nancy Reddin Kienholz.

Victor Vasarely Szilva Gombac

Acknowledged as the most inventive practitioner of Op Art, Hungarian-born Victor Vasarely loved the foods of his birthplace. His son Yvaral, a visual artist who has continued his father's explorations into Op Art, describes his father's joyful behavior in the kitchen, and shares their favorite recipe for *Szilva Gombac*.

"Memories with my father aren't lacking, but the funniest and warmest are those when we cooked Hungarian dishes together. My father, normally so precise and organized transformed the kitchen into a real mess. Our specialties were the *goulas* [goulash], the *töltött paprika* [paprika cabbage], the *korozott* [feta-cheese spread], and of course the *szilva gombac* [sugared plum dumplings]. The days in the kitchen were very private, just the two of us; the dishes were barely ready, and like diving back into childhood, we ate together in the studio, without sharing, where more than once, the dishes were knocked over onto the paintings, as each bite was washed down with wine from Tokai. These were rare moments, when I saw my father in total confusion, losing control of himself, singing folk songs from his childhood. For my father, Hungarian dishes will always be one of the greatest pleasures, and I inherited this appreciation."

Szilva Gombac
(Sugared Plum Dumplings)

Serves 6–8 | Adapted

2 lbs, 3 oz (975 g) potatoes, peeled, cubed, and boiled
2 tablespoons vegetable oil
2 3/4 cups (350 g) wheat flour
2 tablespoons semolina flour
1 teaspoon salt
1 egg
2 tablespoons sugar
1/2 teaspoon ground cinnamon
25–30 pitted prunes
2 cups (125 g) fresh bread crumb
1/4 cup (50 g) butter

• Mash the potatoes until smooth; allow to cool. Mix the cooked potatoes with the oil and both flours. Add the salt and egg and knead the dough until well combined and smooth.

• In a bowl, mix together the sugar and cinnamon.

• Melt the butter in a skillet over medium heat and add the bread crumbs. Toast the crumbs, stirring constantly, until golden, about 5 minutes. Transfer the crumbs to a large, shallow plate.

• On a floured surface, roll the dough to a thickness of about 1/4 inch (.5 cm). Using your fingers, make a small opening in each prune and fill each with about 1/4 teaspoon of the cinnamon sugar. Put a prune in the center of each dough square and lightly flour your fingers. Gather each corner and pinch them together over the prune. Pinch the edges together and make a packet.

• Bring a large pot of salted water to a boil. Drop the dumplings, a few at a time, into the water, and cook until they float, about 5 minutes. Rinse the cooked dumplings quickly in warm water, then roll them in the toasted bread crumbs. Repeat with the remaining dumplings. Serve warm.

(Left) Victor Vasarely, *Keple-Gestalt,* 1968

(Right) Victor Vasarely in front of one of his paintings, 1970; both courtesy Yvaral Vasarely.

Gutzon Borglum Mushroom Gravy

Between 1927 and 1941, sculptor Gutzon Borglum and 400 workers carved the 60-foot (18-m) busts of American presidents George Washington, Thomas Jefferson, Theodore Roosevelt, and Abraham Lincoln, at Mt. Rushmore, South Dakota. The artist's great-grandchildren, Jim Borglum and Robin Borglum Carter, offer a family favorite:

"Gutzon Borglum was a very driven individual, always with a project on his mind. Meals were an opportunity to relax with his family and friends and expound on his newest plans, or his thoughts on art and politics. Gutzon loved canned mushroom soup, but never seemed to realize its humble origins, and would be surprised to have the same recipes at someone else's home. Since he lived in the country and often had unexpected company, it was nice to have a dish that could be put together in any quantity of time without fresh ingredients."

Mushroom Gravy

Serves 2–4 | Adapted

2 tablespoons butter
1/2 sliced onion
3 tablespoons flour
1 cup (240 ml) beef stock
One 13-oz (375-ml) can of mushrooms with liquid
1/4 teaspoon salt
1/8 teaspoon pepper

• In a cast-iron skillet, cook the onion slices in butter until slightly browned. Remove the onions, reserving the fat in pan. Add flour, salt, and pepper, stir until brown. Add stock gradually, bring to a boil. Add mushrooms, some liquid from the can, and add the onions.

• Simmer 10 minutes.

"Best served with fresh biscuits!"

—Jim Borglum

(Far left) Gutzon Borglum planting the American flag at the summit of Mt. Rushmore, 1925.

(Left) Borglum suspended in a bosun's chair at Mt. Rushmore, 1930.

(Above) Gutzon Borglum, Mt. Rushmore National Memorial, South Dakata.

All courtesy Borglum Archives

Jackson Pollock & Lee Krasner Bread & Cheese Hominy Puffs

In the late 1940s, the American painter Jackson Pollock emerged as the undisputed leader of the New York School, a group of artists that went on to found Abstract Expressionism. His rhythmic drip paintings were forces of nature that forever changed the history of painting, and continue to inspire and challenge all who view them. Helen A. Harrison, the director of the Pollock-Krasner House and Study Center, related this story about Pollock and his wife, the noted Abstract Expressionist painter Lee Krasner, in the kitchen:

"Before they moved from New York City to a rural homestead in East Hampton, Long Island, neither Jackson Pollock nor Lee Krasner showed any interest in cooking. In fact, Lee was famously undomesticated. During Jackson's first visit to her East Ninth Street Studio, in early 1942, she offered him a cup of coffee. When he said yes, she took him to a coffee shop around the corner, remarking: 'You don't think I make it myself, do you?' Jackson, who lived with his brother Sande and sister-in-law Arloie on East Eighth Street, only entered the kitchen to eat the meals Arloie prepared. However when Jackson and Sande's mother, Stella, paid a visit, there would be a home-cooked banquet with fresh-baked bread and other country specialties. Even during the Depression, Stella always managed to produce a spread for her family.

"After Lee and Jackson married and settled into a place of their own out in the Hamptons, cooking for themselves became a necessity. Not only were they too poor to eat out, but the nearest coffee shop was four miles away and for the first couple of years they had no car. But all of the staples were in walking distance at the Springs General Store, where the kindly proprietor, Dan Miller, gave the Pollocks credit and eventually accepted one of Jackson's paintings to settle an overdue bill. Evidently determined to learn homemaking skills, Lee collected Arloie's and Stella's recipes. Sweet cornmeal pancakes and savory ones of potato, ham casserole, and a milk-based onion soup were Stella's contributions. Arloie's included baking-powder biscuits, prune whip, and fish with catsup and mustard sauce. Together with potatoes, fish is a staple of the Eastern Long Island diet. It was on the menu when Martha Holmes photographed Jackson and Lee for *Life* magazine in April 1949. When the day-long shoot was over, Lee invited Martha and her companion to stay for supper, and the two couples shared a fish feast. Clams were plentiful, and more than one visitor waded with Jackson into the shallows of the nearby inlet to dig a bucket of them for a meal—which might include one of Jackson's famous eggplants ▷

Jackson Pollock's Bread

Makes 1 loaf | Adapted

1 .6-oz (50 g) cake fresh yeast
1 3/4 cup (410 ml) lukewarm water
1 teaspoon sugar
1 1/2 teaspoons salt
1 tablespoon melted shortening
5–5 1/2 cups (625–700 g) flour

• Soften the yeast in water. Add the sugar, salt, and shortening, and then add the flour gradually, mixing thoroughly after each addition. When the dough begins to get stiff enough to knead, transfer to a lightly floured board. Knead until the dough is smooth and elastic, about 5 minutes. Cover with a warm, damp cloth and set aside. Allow it to double in bulk, then work it down with your hands. Cover and allow it to double again. Work down lightly. Form into a round loaf and place in a well-oiled pan; again cover with warm, damp cloth and allow it to rise again. ▷

(Above) Jackson Pollock's handwritten bread recipe, c. 1950, collection Pollock-Krasner House and Study Center, East Hampton

(Right) Jackson Pollock, in a staged photo shoot for *Art News* photographed by Rudy Burkhardt, at Pollock's studio in East Hampton, June 1950.

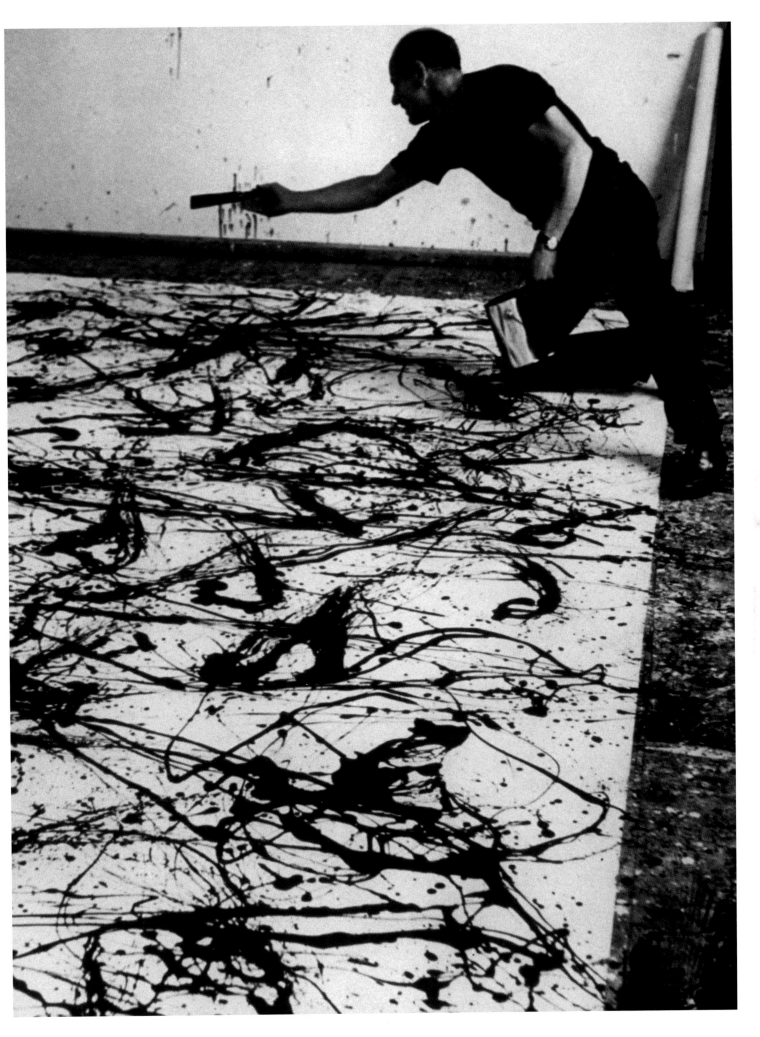

and fresh greens from the kitchen garden behind the house. In time, both Jackson and Lee developed culinary specialties that impressed their friends and neighbors. Jackson's was baking, perhaps because of his fondness for his mother's breads and pies. His apple pies were especially sought after, and always sold out at the Annual Fisherman's Fair. But according to Lee, baking was the only cooking that he liked to do, and he did it infrequently. She, on the other hand, displayed a real gift for food preparation, especially when the ingredients were fresh from the garden or the local waters. On one memorable occasion, a large tarpon landed off Amagansett beach was laid out on the kitchen counter, rubbed with ink, and printed on mulberry paper (a Japanese method known as *gyotaku*) before being cooked and eaten. The print still hangs in the kitchen as a testament to Lee's fascination with natural forms, like the patterns of fish scales. From 1951–53, Jackson's eating habits underwent a radical revision when he adopted a special regimen to arrest his alcoholism. After trying several other treatments—including psychotherapy—without lasting success, he began using a substance called 'Proteen' . . . [A soy emulsion] developed by a self-styled nutritionist named Grant Mark, who also prescribed salt baths and mineral injections to correct what he diagnosed as Pollock's 'chemical imbalance.' A quart of Proteen a day was the recommended dose, and Jackson had to travel to Manhattan once a week to pick up a fresh supply. The rest of the diet was a strict and somewhat quirky vegetarian regime, stressing fresh produce, although potatoes and spinach were banned. So were sugar, cereals (including all wheat products, which must have put a crimp in Jackson's baking), meat, fish, poultry, dairy products, dried beans and fruit, tea and coffee, canned and bottled beverages—and of course, alcohol. Unfortunately, Jackson considered Proteen an antidote to booze rather than a substitute for it, and the diet ultimately proved worthless as a cure for his drinking problems.

"Lee kept the Proteen diet with her recipes and cookbooks in the pantry of their former home and studio, now the Pollock-Krasner House and Study Center. The property, open to the public by appointment, is very much as they left it. They opened up the ground floor rooms of the 1879 house so that their work could be effectively displayed, and also for entertainment. Decades before exposed kitchens became ubiquitous in the Hamptons, they removed the wall between the kitchen and living room so everyone could socialize. . . . Visitors may be tempted to imagine the preparations for one of their dinner parties, with apple pie cooling on the windowsill, Jackson's bread and Lee's favorite hominy puff (a Southern specialty of her friend Josephine Little) baking in the 1940s gas oven, and a freshly caught bass poaching on the stove top."

- Bake in a preheated 450° (225°C) oven for 15 minutes, reduce heat to 400°F (200°C) and cook another 30 minutes. Allow to cool and then turn out of pan.

Lee Krasner's Cheese Hominy Puffs

Serves 4–6 | Adapted

6 cups (1 kg) cooked hominy (see below)
3 tablespoons flour
3 tablespoons butter
3 eggs, separated
1/2 cup (125 ml) milk, heated
1 1/2 cup (175 g) sharp cheddar, grated
 (Vermont white preferred, if available)
1 cup (100 g) chopped scallions or chives
1 teaspoon thyme
Several springs rosemary
Salt and pepper to taste

Hominy
1 cup (175 g) hominy grits
4 1/2 cups (1 l) water
1 teaspoon salt

- Add the grits to boiling water, slowly, to avoid massing. Return to a boil, then reduce heat and simmer about 25 minutes. Cool slightly.

- Melt the butter in a nonstick pan. Add the heated milk and cheddar cheese and stir over low heat until the mixture is thickened and the cheese completely melted. Stir in the scallions or chives, pepper, salt, and herbs. Whisk in the egg yolks and blend until smooth. Fold this cheese and egg sauce into the cooled hominy, blending thoroughly.

- Beat 3 whites until stiff but not overly dry. Stir in the hominy mixture, in small amounts, blending lightly. Pour into a 2-quart (1.9-l) buttered soufflé dish and bake in a 375°F (190°C) oven for about 35–40 minutes or until golden and puffy.

(Left) Lee Krasner, *Collage 1954,* 1954

Wifredo Lam Frijoles Negros

Born in Cuba to a Chinese father and Afro-Cuban mother, the painter Wifredo Lam was influenced by Cubism, Surrealism, and his close friendships with the artists Pablo Picasso and André Breton and their idealization of "primitive" cultures. Yet Lam used the structure of European Modernism as a basis from which to explore the roots of his Afro-Cuban heritage, creating a new form of modernism for the New World. Lam's cooking was another multicultural expression, as noted by his wife, Lou Laurin-Lam (translated from the French by Unity Woodman):

"Wifredo was Cuban and loved to cook very hot food. There is a theory that in hot countries you should eat hot and spicy food, whereas in cold countries you should eat cold food. The temperature of the food should match the temperature outside. I am Swedish and in Sweden we eat lots of sandwiches, *filmjolke* (fermented milk), salmon, and herring, all of them cold. When Wifredo saw, in the beginning of our relationship, that my cooking amounted to sandwiches, *filmjolke,* and on occasion, Swedish meatballs with boiled potatoes, he promptly barred me from the kitchen. At this time, we were living upon a hill overlooking a small Italian village with a beautiful view over the sea, but not easy to get to without a car. I succeeded in getting my driver's license and thus became the family chauffeur in a little Fiat Cinquecento. Wifredo never managed to pass his driving test. It was

Frijoles Negros

Serves 10–12 | Adapted

1 lb (450 g) black beans
1/4 cup (60 ml) red wine vinegar
1/2 cup (120 ml) olive oil
2 large onions, minced
2 cloves garlic, crushed
2 large red bell peppers, seeded and chopped
Two 28-oz (800-g) cans peeled whole
 tomatoes, drained and crushed
1 tablespoon salt
1 teaspoon dried oregano
Fresh black pepper to taste
1–2 red chili peppers (optional)
1/2 cup (25 g) finely chopped cilantro leaves

• Cover the beans in twice their volume of water and leave to soak overnight. Drain and rinse. Transfer the beans to a large pot and cover completely with water and add the vinegar. Bring to a boil and cook until soft, about 3 1/2–4 hours, adding water when necessary. Reserve 1 cup (225 ml) of the cooking liquid and drain the beans.

• Heat the olive oil in a large pot over medium-high heat. Sauté the chopped onions, garlic, peppers, and tomatoes until softened, about 6–8 minutes. Add the reserved cooking liquid and beans and simmer until tomatoes are completely broken down, about 20 minutes.

• Take out 2 cups (350 g) of the beans and mash them with a fork or potato masher. Stir them back into the pot. Add the salt, oregano, pepper, and chili peppers and simmer until thickened, about 5 minutes more. ▷

perfect, we simply reversed roles; Mom chauffeur and Dad the indisputable master, the supreme chef in the kitchen. Wifredo was a genius of a cook. He had the gift of Christ for providing food for many with almost nothing but a fish and five loaves.

"At the end of each winter, we would get ready for summer in Italy by buying several kilos of *frijoles negros* (black beans) in Belleville's African Market in Paris, as they simply didn't exist in Italy. Dry, the *frijoles* are very small and take up hardly any space; you wouldn't think they could feed so many people. The long ceremony of their preparation (several hours) began the day before; the *frijoles* needed to soak overnight. As they increase greatly in size once in water, the operation called for a very large pot. The content of the pot would last several meals and many people could feast on them. We often had guests or surprise visits. In Cuba, *frijoles negros* with rice is called *Moros y Cristianos,* Moors and Christians, and is the national dish. It is often served with a *lechon asado,* roasted black suckling pig. In Italy, however, it was easier to find shoulder of lamb or roasted chicken. The day of the cooking itself, which could take up to six hours, involved adding this or that ingredient, raising or lowering the heat et cetera, not an easy task when you have other things to do. Wifredo had the whole program down and he never seemed preoccupied by the cooking. When we had a lot of people over, he would disappear very discreetly for a few minutes to add something to the pot. He was, of course known primarily as a painter in Latin American circles; however, some people thought of him above all as the great *frijilero.*

"Every now and then, Wifredo would give instructions over the phone to the cook at the Cuban Embassy in Paris, on Avenue Foch, when they had receptions for several hundred people. He would assist each stage of the cooking, giving the cook moral support along the way. Then he would show up just a few minutes before the guests arrived to add the finishing touches, a drop of vinegar, or a few bunches of well-chopped cilantro. Michel Leiris, Aime Cesar, Pierre Matisse, Lucio Fontana, and John Cage were among some of our famous friends—all unconditional lovers of Wifredo's *frijoles.* Making *frijoles negros* was his *violon d'Ingres,* his favorite hobby, but he could also cook a host of other things: paella, lobster à l'Américaine, *tamales,* a superb risotto, spaghetti with clams, and a magnificent lobster with bitter chocolate sauce. Wifredo had a true passion for cooking. In 1973, he participated in a contest for painter-cooks at the Garden Riviera Hotel in the Italian-Swiss Lake District. He won first prize for his *minestrone alla Ligure* served in plates he had designed himself. Lucio Fontana won second prize for his blue (!) spaghetti that I never got to taste."

• Just before serving, stir in the cilantro. Serve very hot with white rice and a suckling pig, shoulder of lamb, or roasted chicken. We always served our guests frozen daiquiris made with Cuban white rum as an apéritif, and a good Cuban beer for the meal itself.

"He was, of course known primarily as a painter in Latin American circles; however, some people thought of him above all as the great *frijilero.*"

—Lou Laurin-Lam

(Above) Wifredo Lam poses in front of a painting in his studio, Albisola Mare, Italy, 1959.

(Bottom left) Wifredo Lam cooking in the kitchen Albisola Mare, Italy, c. 1964.

(Top left) Wifredo and Lou Laurin-Lam having dinner, Albisola Mare, Italy, 1963.

Red Grooms Confetti Egg Salad

Confetti Egg Salad

Serves 4

12 hardboiled eggs (grated)
1 small can pitted black olives (chopped)
1 small can pimentos (chopped)
1/4 lb (125 g) salami (diced)
1 cup (250 g) mayonnaise
Salt and pepper to taste
Juice of half a lemon

• Mix the eggs, olives, pimentos and salami.

• Dress with mayonnaise thinned with the lemon juice. Add salt and pepper to taste and serve.

Note: This is a nice dish for a picnic or a children's party.

Known for his exuberant Pop Art renditions of urban life, Red Grooms's playful constructions and paintings of hectic taxi cabs, crowded subways, and delightfully caricatured people offer truthful (if hilarious) insights into familiar experiences. Grooms often uses foods such as coffee or soup in his work because they are "cozy" images, although he says he would love to paint glorious food displays in French markets. He was also once interested in drawing live crabs, which are readily available in Chinatown, his neighborhood:

"First they attacked me, and then they moved around so much, I figured I'd better bump them off. But when I did, their legs fell off, and they lost their beautiful color. I boiled them, but they looked too innocent to eat—I just had to throw them out."

. . . so instead of creating a new crab recipe, Red has volunteered Confetti Egg Salad, his favorite recipe.

(Top left) Red Grooms sits inside of his subway car installation, 1987.

Chaim Gross Mamelige

Chaim Gross worked in a variety of media, including stone and bronze sculptures, pen-and-ink drawings, and watercolors, but he was noted above all for sculptures in wood. Growing up in Galicia as a Hassidic Jew, at the outbreak of World War I, Gross witnessed a brutal attack on his parents by cossacks. He was later pressed into service by the Austrian military, but eventually managed to escape to the West. Despite the horrors of his childhood and adolescence, many of Gross's themes are festive evocations of Jewish traditions and holidays, the circus, and popular art forms. Renee Gross, the artist's widow, contributes the following commentary and recipe for *Mamelige:*

"This is a favorite of Chaim's that he frequently made himself. It is a corn meal. In the country he comes from, East Austria, a small town in Galicia, . . . *[mamelige]* was the staff of life, served daily with sour cream and butter. For meat dishes, it was served with meat sauce, like in Italy. It was made sliced with a string and served with roast rabbit.

Mamelige

Serves 1

1 cup (250 ml) water
1/2 cup (50 g) cornmeal
1 tablespoon butter
3 tablespoons sour cream
1 oz (25 g) goat cheese, crumbled

• In a medium saucepan, bring the water to a roiling boil. Add the cornmeal very slowly. Using a wooden spoon, stir the mixture continuously until it is smooth. Remove the mixture to a plate and spread it like a pancake. Add butter and sour cream or a handful of crumbled goat cheese. If goat cheese is not available, Mr. Gross suggests farmer's cheese as the next best thing.

Note: To prepare a side dish for rabbit, roast leg of lamb, or roast beef, simply double the amount of water and add 2 cups (250 g) of cornmeal. When done, flatten the mixture on a platter and cut it into squares. Cover the squares with the juice from the meat.

"It is delicious!"

—Renee Gross

(*Left*) Chaim Gross standing behind his sculpture, *Ring Performers,* 1959; courtesy The Chaim Gross Studio Museum, New York.

Piet Mondrian & Harry Holtzman Ambrosia & Pommes Frites

The radical Dutch painter Piet Mondrian pushed Cubism toward total abstraction with his completely nonrepresentational paintings; he called this new style Neo-Plasticism, although it is also known as *De Stijle* (The Style), based on the *De Stijle* magazine and movement that Mondrian cofounded with other like-minded artists in 1917. Mondrian came to New York in 1940 at the prompting of an American artist named Harry Holtzman, 40 years his junior. Holtzman had fallen in love with Mondrian's work after seeing several of his paintings in a 1934 exhibition at the Museum of Living Art (now the Grey Art Gallery) at New York University. Holtzman "became obsessed with not only the paintings of Mondrian, but with the idea that the man had to think certain things about the historical transformation, the value and function of art. I really had to go to Europe to speak with him." Holtzman went to Paris to visit Mondrian and stayed for four months. Notwithstanding the age and language differences, the two artists came to admire and respect each other.

In 1940 Holtzman urged Mondrian to leave war-torn Europe and move to New York, and during the following years he became one of Mondrian's closest companions. Jason Holtzman, Harry Holtzman's son and a trustee of the Mondrian/Holtzman Trust describes their friendship and the inspiration for Mondrian's most famous painting, *Broadway Boogie Woogie*, 1942–43:

"Knowing Mondrian's passion for jazz music, Harry Holtzman took Mondrian to hear boogie-woogie music for the first time on the night of his arrival in New York City. The two would meet almost every day during the last few years of Mondrian's life to discuss their ideas and go to what Mondrian called 'dancing parties' to relax, socialize, and dance. Mondrian's response to this new music was, as Holtzman recalled, 'enormous, enormous.' Holtzman would buy Mondrian a record player for his studio and the two men even discussed plans for opening an ideal nightclub.

Ambrosia, Nectar of the Gods

Makes 3–4

2/3 pitcher of iced tea (Holtzman preferred Tetley)
1/3 pitcher orange juice
1 lemon, sliced
1 extra large orange, sliced
Mint as garnish

• Mix iced tea and orange juice. Squeeze in and add slices of fresh lemons and fresh oranges (skin and all), then add fresh mint.

(Above) Harry Holtzman and Piet Mondrian, 1940, in Holtzman's studio, New York, courtesy Mondrian/Holtzman Trust

(Left) Harry Holtzman, *Untitled,* 1938, courtesy Mondrian/Holtzman Trust and Washburn Gallery, New York

Pomme Frites

Serves 4–6

Vegetable oil for frying
2 lbs (900 g) potatoes, preferably Idaho or Russet
Kosher or sea salt to taste

• In deep-fat fryer, heat oil to 350°F (175°C).

• Wash, peel, and thoroughly dry potatoes. Cut them into matchsticks or thicker slices, depending on preference.

• Divide the potatoes into 2 batches. Fry each batch in hot oil, for 5–6 minutes or until golden brown. With a slotted spoon, remove cooked potatoes and place on paper towels to drain; keep warm. Sprinkle lightly with salt to taste; serve immediately.

"Holtzmann and Mondrian shared many meals together, both in Paris in the mid-1930s and in New York between 1940 and 1944. At the time both artists did not cook often but liked to share a bottle of red wine while listening to boogie-woogie. They also loved Holtzman's made-up drink he called 'Ambrosia, Nectar of the Gods,' which was a cool refreshing great drink in the hot summer months. Holtzman often served this drink at his Connecticut studio when entertaining Mondrian and other artists such as Josef Albers, Robert Motherwell, and Ad Rheinhardt. Mondrian entertained a critic named Paul Sanders from the *Dutch Daily Press* in his Paris studio in 1924. Sanders said of Mondrian: 'He would have liked to invite me to eat with him but didn't have a pan [in] which to make pommes frites (french fries), which he was so good at.'"

Did Mondrian consider *frites* to be vegetable or starch? The question was relevant according to Alfred Barr, founding Director of New York's Museum of Modern Art. Barr visited the artist in his Paris studio in 1935 and noted that Mondrian "earnestly follows the Hay Diet, a system that compartmentalizes food so that one eats meat with vegetables, or starch with vegetables, but never the three at once. This meal appeals to his subdividing mind. He probably heard of it from Man Ray who, once chubby, has become slim and youthful as a result." One can imagine Mondrian cooking up a batch of *frites* and Holtzman mixing a pitcher of Ambrosia on a warm August night in Connecticut, and a group of artists enjoying this small feast with the sounds of a boogie-woogie tune spinning on the turntable.

(Above and top left) Piet Mondrian's last studio, New York, 1943–44; both photos courtesy Mondrian/Holtzman Trust

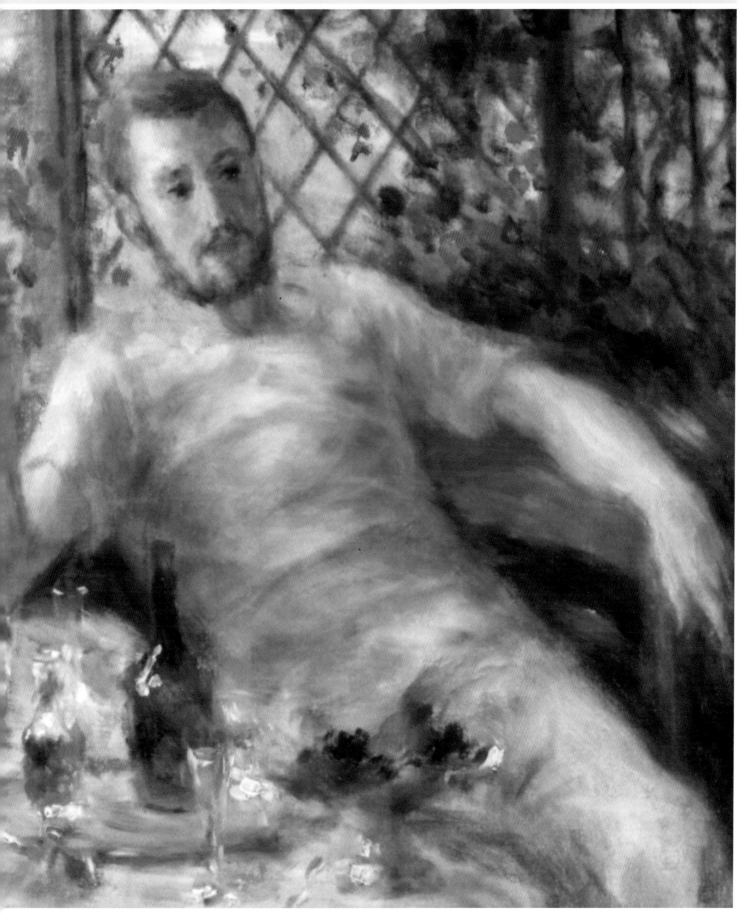

Horst Antes Spaghetti alla Roberto Barni

The principle representative of "Fantastic Realism," a visionary branch of Surrealism, Horst Antes is one of the most significant German artists of the late 20th century, whose many paintings and graphic works are complemented by his sculptural pieces. The *Kopffüssler,* or "Head-Footer," the prototypical figure and central theme of Ante's work, first appeared in the early 1960s.

Here, the artist's wife, Dorothee Antes, has contributed his favorite dish, Spaghetti alla Roberto Barni, which was created by Robert Barni, an artist from Florence, and a good friend of her husband's. She added that Antes's other favorites are *Lampredotto* (tripe) and *Lamponi con Zabaglione* (raspberries in zabaglione sauce), which comes from the Badia di Coltibuoni (an abbey in Tuscany). But first, New York fine art dealer John Szoke tells us about a memorable culinary excursion with Professor Antes:

"The first time I met Professor Antes was at the Basel Art Fair, sometime in the mid-70s. We were to discuss a project for the United States. We talked, we walked around, looked at some of the art, all the while keeping the project in mind. As time passed and the afternoon approached, we sat down in the food courtyard, and ordered (what else, in a German-speaking country) a huge wurst. When the waiter delivered the wurst, I felt faint—it smelled so good. It looked so beautiful, I couldn't wait to get to it. But in deference to the famous artist, and to comply with the formal European etiquette, I waited patiently until he started to eat. It wasn't easy! Professor Antes was in the middle of telling this long story about how he developed his images, how he was planning to go to the next step, how he related the images not only to his experiences, his interests, his collection of Kachina dolls, but to his own likeness.

"When the talk came to an end, he raised his big wurst, and with gusto, took a big bite. His eyes rolled back in his head, and he spit it out immediately. I never did find out if it was cold, or didn't taste good, or what was wrong with it. So we sat there. To bring this lunch to a conclusion, the artist picked up the mustard dispenser, and holding it like a thick pencil, wrote on the wurst *Nicht Geggessen* ["not eaten"]. Suddenly I didn't feel hungry. I just wanted to take this piece of 'art' with me, but I didn't have the nerve."

Spaghetti alla Roberto Barni

Serves 4

2 tablespoons olive oil
1/2 dried husk chili pepper, chopped
1 branch rosemary, chopped
2 teaspoons ground pine nuts or walnuts
3 teaspoons breadcrumbs
1 lb (500 g) spaghetti

• Add the chili pepper to hot oil and cook on all sides, for about 1 minute. The pepper should fry, not burn, which can happen quickly if not watched.

• Add chopped rosemary and pine nuts. Fry for approximately 2 minutes. Add breadcrumbs and stir mixture. Fry for approximately 1 minute.

• Pour mixture over a pot of al dente spaghetti and serve immediately.

(Previous pages) Pierre-Auguste Renoir, *The Rower's Lunch,* c. 1880

(Far left) Horst Antes at his desk, undated, courtesy Dorothee and Horst Antes

(Below) Horst Antes, *Olympische Spiele, Munchen,* 1972, courtesy Volker Huber Edition und Galerie, Offenbach, Germany

Salvador Dali Mesclagne Landais, Mère Irma

Surrealist par excellence, the Spanish artist Salvador Dali was not much of a cook, it seems. But he certainly indulged his extravagant tastes at the many restaurants he frequented. The complexity of the dishes he loved best corresponds well with what we know of him from his fantastic Surrealist visions. Dali created several memorable food-inspired artworks during his career. In 1973 he even illustrated a cookbook called *Les Dîners de Gala* (Gala's Dinners; Gala was his wife), a compilation of recipes from famous restaurants and chefs. He was especially fond of sea urchins, pink grapefruit, and cinnamon toast. One of Dali's all-time favorite meals was liver-stuffed chicken, which he often ate at the famous Lasserre Restaurant in Paris, adapted here. Curator of collections at the Salvador Dali Museum in St. Petersburg, Florida, Joan R. Kropf, writes about the artist's use of food in his creations:

"Salvador Dali was not limited to a particular style or medium. His oeuvre, from early impressionist paintings through his transitional and Surrealist works, and into his 'classic' period, shows a constantly growing and evolving artist. Dali worked in all mediums, leaving behind a wealth of oil, watercolors, drawings, graphics, sculptures, jewels, and objects of all descriptions. Whether working from pure inspiration or a commissioned illustration, Dali's matchless insight and symbolic complexity are unparalleled. The Dali Museum collection has several paintings representative of his relationship to food items in his works. His early still lifes reflect the various species of fish that is found in the surrounding Mediterranean Sea located on the northeastern coast of Spain where he lived. *The Basket of Bread,* painted in 1926, brought Dali early recognition when it was his first painting shown in the United States two years later. The bread, a staple of life, is rendered with such precise detail; very reminiscent of the early Flemish artists Dali so admired. In 1932, bread appears in the *Invisible Man* and *Catalan Bread,* both painted during the Surrealist Period. Here, bread takes on a symbolic representation with phallic characteristics. During Dali's later period his vision turns more classic—combining the two elements of fish and bread into traditional Christian icons in the painting *Eucharistic Still-Life,* 1952.

"*Nature Morte Vivante* (Still Life–Fast Moving), painted in 1956, explores Dali's fascination with subatomic particles by reanimating a painting from 1617, *Table with Food,* by the Dutch artist Floris Van Schooten. The twisting fruit dish and the swirling florets of the cauliflower on the right are both spirals. Dali felt that the

Mesclagne Landais, Mère Irma

Serves 2–3 | Adapted

1 goose liver
Salt and pepper to taste
Flour for dredging
5 large skinless, boneless chicken breasts
Unflavored bread crumbs
2–3 tablespoons butter

• Slice the goose liver in half and season with salt and pepper. Dip liver slices into flour and panfry in butter. When they are two-thirds cooked, remove them from the pan, reserving the fat. Refrigerate the livers for 20 minutes.

• Remove the liver halves from the refrigerator, and place each one in the center of one of the chicken breasts. ▷

(Above) Salvador Dali posing with a chicken, 1955

(Opposite) Salvador Dali, *Nature Morte Vivante* (Still Life–Fast Moving), 1956, courtesy Salvador Dali Museum, St. Petersburg, Florida

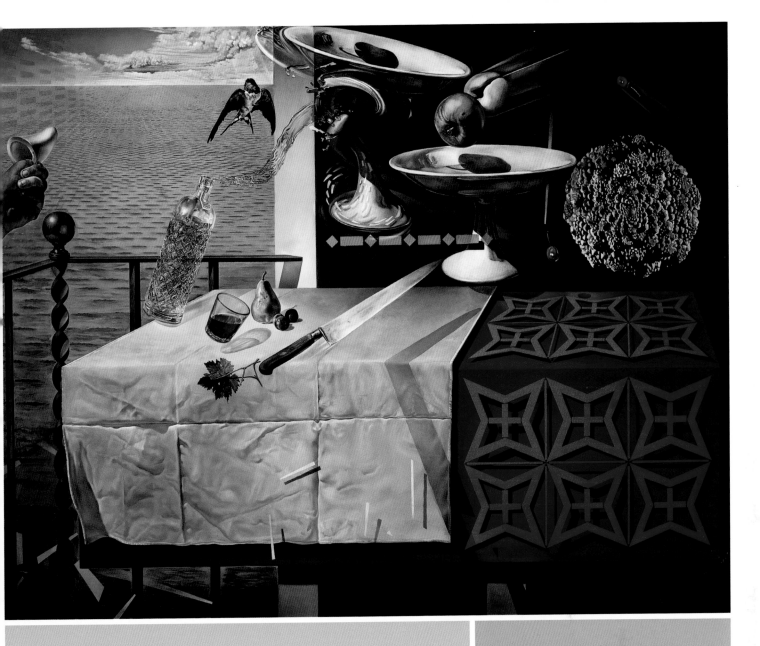

spiral was the basic form of life, an idea that was confirmed when Crick and Watson discovered the double-helix structure of the DNA molecule in 1953. While the painting may appear chaotic initially, Dali has ordered it according to a mathematical grid based on the Golden Section. This ancient Greek form of artistic composition provides an aesthetic harmony and balance to the complex composition.

"Dali's Surrealist objects from the 1930s would often combine utilitarian objects with food items. One item in particular in the museum's collection is the 1936 *Lobster Telephone*. Salvador Dali writes about this work in *The Secret Life of Salvador Dali* (1942): 'I do not understand why, when I asked for a grilled lobster in a restaurant, I am never served a cooked telephone; I do not understand why champagne is always chilled and why on the other hand telephones, which are habitually so frightfully warm and disagreeably sticky to the touch, are not also put in silver buckets with crushed ice around them.'"

• Fold the cutlets in half over the goose livers so that they are completely enclosed.

• Spread goose fat over the entire outer surface of the folded chicken breasts, then roll each in bread crumbs.

• Melt butter in a large skillet until bubbling, then add stuffed chicken breasts, sautéing 5–6 minutes per side. Serve immediately while the cutlets are hot and tender.

Note: Lasserre Restaurant suggests serving the cutlets on a bed of creamed mushrooms.

Friedensreich Hundertwasser Sashimi 101 re-created by Chef Ming Tsai

Austrian artist Friedensreich Hundertwasser was a modern-day Renaissance man. In addition to painting, drawing, and graphic work, he was known as an "architect-healer." Much of Hundertwasser's work was informed by his life experience as an adolescent during World War II and the loss of many relatives during the Holocaust. His art and architecture focused on the harmony between the creativity of man and the necessity of bringing humans into contact with their natural environments in order to further the survival of these areas. Hundertwasser incorporated natural elements into his buildings, paintings, and prints through the use of natural materials, organic forms, and vibrant colors. He was an expert printmaker; his prints emphasized natural-tone dyes and the absence of straight lines, which to Hundertwasser had a corrupting influence on humanity. Hundertwasser used art to promote world peace by sending each work to ateliers and artisans across the globe to incorporate their printing techniques and printers' marks. The final product merged these diverse printing styles into a single statement about the universality of art. He also designed many stamps with relevant social themes such as human rights, ecological preservation, and cultural diversity.

Andrea Christa Fürst, of the Hundertwasser Archives in Vienna, and the artist's manager, Joram Harel, told me of his liking for Japanese food—in particular, sashimi. Presented here is a culinary homage by Chef Ming Tsai. Chef Tsai is another artist fluent in multiculturalism, introducing global influences into the dishes he creates at his Boston restaurant, Blue Ginger, and on his Food Network program, *East Meets West*. First, though, art publisher John Szoke, of the John Szoke Gallery, New York, shares some interesting reflections on this unique individual.

"My meeting with Hundertwasser was one of the most memorable ones I have ever had. I was over at Hundertwasser's publisher Joram Harel's and he asked me if I would like to say hello to Hundertwasser. As I was with the artist James Rizzi, who had never met Hundertwasser, and Hermann Krause, my European colleague from Köln, we said yes. Joram called Hundertwasser and told him we were coming. We took a taxi and shortly arrived at the KunstHausWien. The KunstHausWien coffee shop was on the left, with the museum in the center and the entrance to Hundertwasser's apartment on the right. He lived on the top floor.

New Hamachi Sashimi with Curry Oil

I call this Sashimi 101 because the hamachi is served part-raw, part-cooked, making it perfect entry-level fish eating. The half-cooking is accomplished by the curry oil, which is heated and spooned onto the raw fish just before it's served, partially searing it. This method, based on the Chinese cooking technique called flashing, imparts richness and great flavor. A final touch of soy syrup enlivens the dish. The fish must be absolutely fresh. If the hamachi in your market is not up to par, buy tuna, salmon, or whatever sashimi-grade fish meets the freshness standard.—Ming Tsai

Serves 4

Four 2-oz (25-g) hamachi fillets (yellowtail)
Fleur de sel or regular sea salt
Coarsely ground black pepper
2 tablespoons chopped chives
2 teaspoons soy syrup
1/4 cup (60 ml) Curry Oil (see recipe on page 88)
1/2 tablespoon of finely julienned fresh ginger
Soy Syrup (see recipe on page 88)

• Wrap each piece of hamachi loosely in plastic film. Place on a work surface and, using a meat pounder or mallet, pound the fish gently to about 1/8-inch (3-mm) thickness.

• Unwrap the hamachi, transferring each flattened fillet to a serving plate. Season the fish lightly with salt and pepper and sprinkle with the chives. Drizzle each serving with about 1/2 teaspoon of the soy syrup in a zigzag pattern.

• In a small skillet over high heat, heat the curry oil until very hot, about 5 minutes. Stir in the ginger, remove from the stove, and immediately spoon a bit of the oil over one portion of the fish. The fish should sizzle when the oil hits it; if not, return the skillet to the stove and reheat the oil. Spoon 1 tablespoon of the hot oil over each portion and serve at once.

(Left) Friedensreich Hundertwasser, ⑦⑤⑦ *Rain Castle*, 1975, courtesy Joram Harel, Vienna, Austria

As we rang the bell, he buzzed back and mumbled something, which we understood him to say that he would come down and join us at the coffee shop. We waited and waited outside. Since it was somewhat chilly, after a while we went inside the coffee shop and sat by the window.

"Some time had passed, half an hour or so, and there comes Hundertwasser wearing his usual mismatched socks and obviously not very pleased. It appeared there was some misunderstanding, as he expected us to come up to his apartment. So, there we were sitting in the coffee shop, having an espresso, attempting to overcome the awkwardness of the moment. We all tried to make conversation, but Hundertwasser wasn't in the mood to talk, after all the waiting upstairs. Whatever we said, he just looked up at us and didn't respond. After a while, Hermann Krause and I gave up, but James Rizzi, a great fan of Hundertwasser, awed by this impromptu meeting, wanted to keep the conversation going. But Hundertwasser still wouldn't answer. Eventually, all attempts failed , and we listened to Rizzi repeating every two minutes or so how much he was inspired by Hundertwasser's work, and how much he treasured this meeting. Rizzi even had a print called *Hundertwasser's Neighborhood,* which he pointed out in the book we carried with us. It could not have been more uncomfortable. In spite of the cold weather, we were all sweating. Then suddenly, Hundertwasser jumped up and ran to the men's bathroom, yelling at us to follow him. We all assembled in the bathroom and stood there expectantly. He just turned around and walked out, leaving us there. We looked at each other, not knowing exactly what to do. After lingering for a couple of minutes, we did go outside. Hundertwasser was standing there. He looked at us triumphantly, anticipating that we understood the famous significance of this momentous event. The tile installation, forming his typical undulating color band of his famous *Jugendstil* (German Art Nouveau), was his pride.

"I guess we stood the test, we were invited up to his apartment. It was on the top floor of the building, three or four rooms totally devoid of furniture. He was famous for that. I also learned from him before that he usually slept on the floor. As he had slept on a ship for quite a while, I guess he got in the habit of not having furniture. Off on one of the rooms there was a door leading to the roof. The roof had dirt quite high, maybe two feet or so, and there we saw the most beautiful vegetable garden. Once before he told me that this is where he spent most of the day. That was the last time I saw him."

Curry Oil

I use this pungent oil to flash-cook hamachi sashimi. Use it also for sautéing scallops or in a vinaigrette, or make a large quantity and fry potato sticks with it.

Store the oil for up to one month, refrigerated, in an airtight container.

Makes 1/2 cup (120 ml)

1/2 cup (50 g) curry powder
Pinch of salt
2 cups (480 ml) canola oil

• In a small bowl, combine the curry powder and salt with 1/8–1/4 cup (30–60 ml) water to make a loose paste. Whisk in the oil slowly, stirring. Allow the oil to stand for 1 hour to settle. Use the clear oil only.

Soy Syrup

This thickish flavoring is a perfect seasoning or garnish for fish and all types of sushi. Store it, tightly covered, in the fridge, where it will last for a month. (In a pinch, you can substitute kechap manis, the Indonesian sweet soy sauce, for soy syrup.)

Makes 2 cups (475 ml)

2 cups (475 ml) soy sauce
1/2 cup (125 g) brown sugar
Juice of 1 lime

• In a medium saucepan, combine the soy sauce, brown sugar, and lime juice. Bring to a boil slowly over medium heat, turn down the heat, and reduce the mixture by three-fourths or until syrupy, about 30 minutes. Strain, cool, and use or store.

Pierre Auguste Renoir Omelette au lard pour Monet et Pour Deux

or The Days of Youth—In tribute to the great ham omelet that Renoir and Monet enjoyed in a town near Barbizon, reluctantly taking a break from their search for inspiration

Serves 2 | Adapted

1 tablespoon goose fat, lard, or butter
4 oz (100 g) ham, chopped into little bits (Renoir used fresh, raw ham, not widely available today)
6 eggs
1 tablespoon milk
Salt and pepper to taste
1 handful fresh parsley (or any herb of your choice) or 1 pinch dried herbs, chopped

• Brush the bottom of a deep frying pan with a napkin soaked in the goose fat, lard, or butter.

• Set the pan on a burner at medium heat. When the pan is hot, place the ham in it. Stir the ham, browning all sides evenly, for about 6 minutes.

• While the ham cooks, whisk together the eggs, milk, salt, and pepper.

• When the ham has finished cooking, remove from pan and set on a dish covered with paper towels or napkins to absorb excess oil.

• Without wiping or cleaning the pan, set it back on the burner at medium heat. When the pan is hot again, quickly pour in the egg mixture.

• Sprinkle the ham into the eggs just as the eggs begin to cook. Shake the pan back and forth with one hand. With the other hand, use a spatula or a knife to separate the cooked egg from the edge of the pan. (This allows for the eggs to cook evenly and thoroughly.)

• When the consistency of the eggs has thickened (but before they are fully cooked), sprinkle in the herbs. Carefully flip the omelet with a spatula. If desired, fold the omelet in half once both sides have cooked. Place on a warm plate and serve with a well-seasoned green salad.

(Top left) Pierre August Renoir, *The Rower's Lunch, c. 1880*

The 19th-century French Impressionist Pierre Auguste Renoir began his career painting in a porcelain factory. He went on to become one of the most admired painters of his time, and is still beloved today. I asked Sophie Renoir, his great-granddaughter, about Renoir's culinary favorites; she was not aware of specific dishes but did say that he liked to eat and enjoyed drinking Rosé des Riceys. His son, Jean, once wrote that Renoir liked to drink the little wine of Essoyes—champagne—which at the time was called "quiet wine." Stephanie Barbas, at the Association Renoir, Paris, delves deeper:

"Here we don't know many things about Renoir's habits. We just know his wife Aline, Charigot, born in the village of Essoyes, was a very good cook and enjoyed to eat. I read the book *Renoir, a la table d'un impressioniste,* by Jacqueline Saulnier, to know what Renoir was eating for breakfast . . . bread toasted in the fireplace, butter, all drenched in white coffee. . . . The author gives in fact dishes that were eaten by Renoir all his life. Most of the recipes of the book were creations of the cookers who were at the service of the family Renoir or were some of the cookers of the restaurant. Aline was famous for [bouillabaisse]. . . . Moreover the author writes that the family were always eating dishes from the area where they were."

Henri de Toulouse-Lautrec Lobster à l'Américaine

Henri de Toulouse-Lautrec was born into one of the oldest aristocratic families in France. His growth was stunted as a teenager due to two consecutive accidents that broke his legs (they never healed properly because of a congenital calcium disorder), and during his convalescence, Toulouse-Lautrec studied art. He went on to become a prolific painter and graphic artist whose acutely observed, unsentimental depictions of Parisian nightlife in the late 1800s remain synonomous with Moulin Rouge and the café scene. Toulouse-Lautrec was also an unquenchable bon vivant who counted Vincent van Gogh and Oscar Wilde among his circle of friends.

He was also an excellent cook. The following recipe, reprinted in its original prose form below, first appeared in *The Art of Cuisine,* a book of recipes and Toulouse-Lautrec's artwork compiled by his close friend Maurice Joyant, a Parisian art dealer. First published in France in 1930, the book contained recipes created by both men over the course of their lifelong friendship. Toulouse-Lautrec and Joyant probably shared this meal many times in Montparnasse over a bottle of Bordeaux.

"Choose two fine specimens of lobster straight from the pots. When they are still alive, cut them in two in the width; cut them again into two lengthwise pieces; break open the claws and feet, and with the tails make some nice rounds. Carefully keep all the liquids from these shellfish. In a big saucepan put 1/2 a pound of butter, two or three spoons of fine olive oil, two onions and a shallot chopped very fine; let it brown and get very hot, but without letting the olive oil boil.

"When butter and oil are very hot, quickly throw in the pieces of lobster and let them brown on a nice medium-high flame for about ten minutes, stirring frequently.

"This done, into a big saucepan pour the contents of the sauté pan and the reserved lobster liquid, as well as the pieces of the lobster shell; moisten to the height of the lobster with boiling water, add a glass of good cognac, half a glass of good white Bordeaux, half a whole lemon, a large glass of very thick tomato sauce, a large glass of meat glaze, black pepper, red cayenne pepper, and salt. Let this mixture simmer for 20 to 30 minutes; take out the pieces of lobster and arrange them on a warm dish.

Lobster à l'Américaine

Serves 4

Two 1 1/2 lb (675 g) lobsters
1/2 lb plus 1/4 lb (225 g plus 100 g) butter, at room temperature
3 tablespoons olive oil
2 medium onions, chopped fine
1 shallot, minced
1 cup (250 ml) good cognac
1/2 cup (125 ml) white wine (Bordeaux)
1/2 lemon
1 1/3 cups (325 ml) tomato sauce
1 1/3 cup (325 ml) beef broth
Black pepper to taste
Cayenne pepper to taste
Salt to taste
1 tablespoon parsley, finely chopped
2 teaspoons tarragon, finely chopped
2 teaspoons chives, finely chopped
2 teaspoons chervil, finely chopped

If doing this dish with an abundance of lobster, increase the number of tails and claws to have more nice pieces of meat, and continue to boil with the well-crushed shells. Pour the remaining strained liquid into a large frying pan and cook over a medium-high flame until the sauce is reduced by half. Using butter that is almost, but not quite, at room temperature, bind the sauce; remove the sauce from the heat source and stir in up to 1/4 pound of butter (to the consistency you desire) one piece at a time, whisking thoroughly until each piece dissolves. The sauce should be warm rather than hot when the procedure is done. It is the viscous quality of barely warm butter that does the trick. These sauces cannot be reheated effectively, as the butter melts entirely and the sauce becomes oily and separates. Quickly add to this red pepper, salt, and fine herbs—parsley, tarragon, chives, chervil, and any other leafy green herb you may wish to try, all chopped very fine. Pour the sauce over the lobster pieces and serve."

• Blanch the lobsters in rapidly boiling water for 3 minutes, they will be slightly cooked. Remove them from the water and let them cool enough so you can handle them without burning yourself. After the lobsters have cooled, remove the meat from the shells, tearing the meat into bite-size pieces. Reserve the cracked shells and any liquid.

• In a large sauté pan place 1/2 lb (225 g) butter, the olive oil, onions, and shallot. Sauté over medium-high heat until golden-brown. Add the lobster meat and sauté for about 5 minutes, stirring frequently. Remove the lobster meat from the sauté pan and arrange on a warm dish. Cover with foil to keep warm. Set aside.

• In a large saucepan, add the remaining contents of the sauté pan, the reserved lobster liquid, and pieces of lobster shell. Add boiling water to cover. Add the cognac, wine, lemon, tomato sauce, beef broth, pepper, cayenne pepper, and salt. Let simmer for 20 minutes.

• Strain the remaining liquid from the saucpan into a large frying pan and simmer over medium-high heat until the liquid has reduced by half. Remove the sauce from the heat and stir in 1/4 pound (100 g) of butter, 1–2 tablespoons at a time, whisking thoroughly until each piece dissolves. The sauce should be warm rather than hot when the procedure is done. If the butter gets too hot it will separate and the sauce will be oily rather than creamy. Taste and adjust the seasoning with black pepper, cayenne pepper, salt, and herbs. Pour the sauce over the lobster pieces and serve.

Accompany with one of the Château Malromé Bordeauxs, from the vineyards at Château de Malromé, an estate once owned by Toulouse-Lautrec's mother, and where he spent many summers painting.

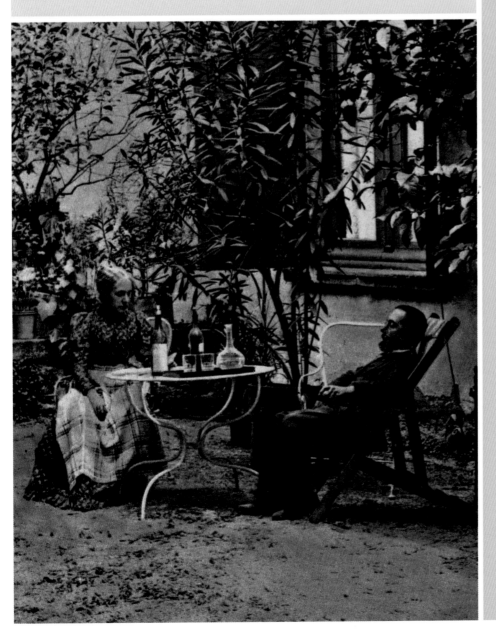

(*Far top left*) Henri de Toulouse-Lautrec, *Reine de Joie,* 1892

(*Left*) Henri de Toulouse-Lautrec and his mother, at her estate, Château de Malromé, near Bordeaux, enjoy a bottle of wine from their vineyards, 1897.

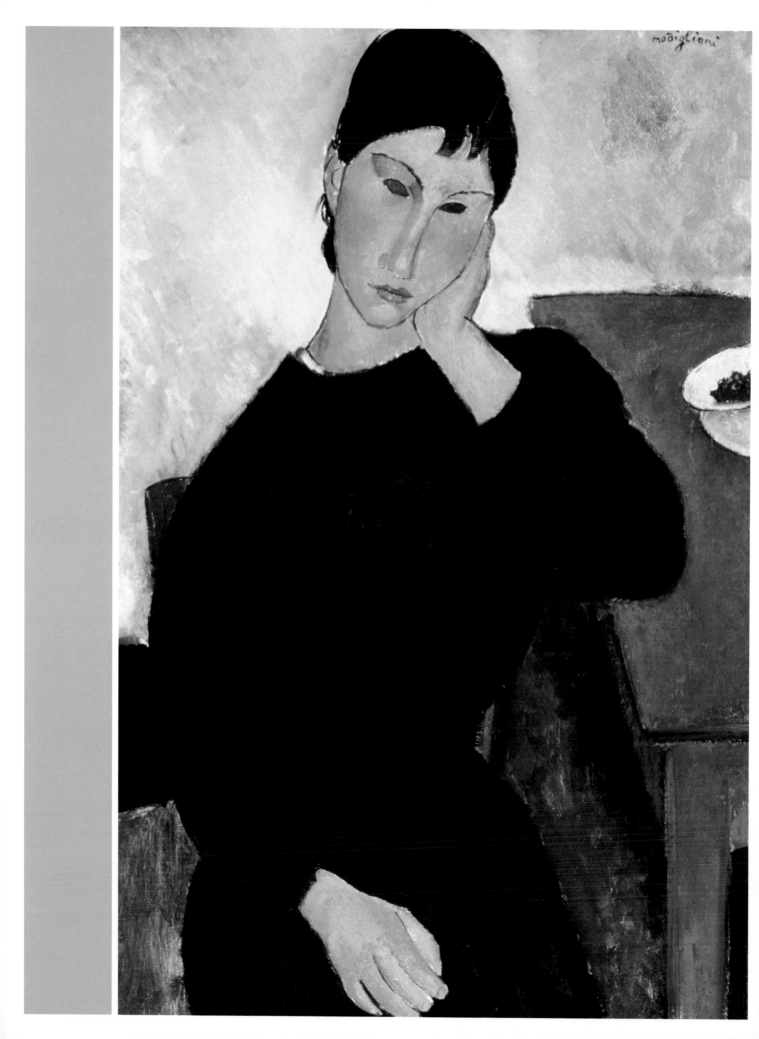

Amedeo Modigliani Triglie alla Livornese re-created by **Chef Mary Ann Esposito**

The portraits and nudes created during the brief career of Italian-born painter and sculptor Amedeo Modigliani are instantly recognizable for their simplicity, sensuality, and graceful, elongated forms, strongly influenced by African sculpture. After moving to Paris in 1906, Modigliani became a legendary figure in the bohemian café and cabaret scene, befriending artists such as the painters Chaim Soutine and Moise Kisling, and the sculptor Jacques Lipchitz. The director of the Modigliani-Kisling Institute, Christian Parisot, Paris, shares with us Modigliani's culinary interests:

" Amedeo Modigliani, the artist of Livornese origin (Livorno 1884–Paris 1920) . . . had an open and liberal conception about kosher food. He did not eat pork, but loved all kinds of fish! Red mullet alla Livornese (fish with tomatoes and garlic) [was a favorite] and [made from] the fish they used to catch around Arveriza rocks. The Livornese cuisine [features] *farinata* (starch-based) specialties [such as] *pizza de poichiche* (chickpea pizza), *azyme-Toscan* (unleavened bread), *spaghetti a la puttanesca* (with a spicy oil and garlic sauce), *spaghetti al pesce spada* (with swordfish), and spaghetti. He was very passionate about homemade pasta. He knew how to cook, he used to like inviting women [to his house] and mak[ing] spaghetti for them."

Chef Mary Ann Esposito, whose PBS program, *Ciao Italia,* celebrates the cuisine of Italy, has re-created a classic fish dish that Modigliani would have enjoyed at a seaside Tuscan trattoria. She notes that Livorno, a western port city in Tuscany known as Leghorn in English, is famous for its fish dishes, including *Triglie alla Livornese,* or red mullet stewed with tomatoes. It is traditionally served with small boiled potatoes or small whole onions called *cippoline.* Red mullet are small in size, about 4 ounces (125 g) each, and cook very quickly. In their place butterfish or small red snapper can be used.

Triglie alla Livornese (Stewed Red Mullet)

Serves 4

1/3 cup (80 ml) extra-virgin olive oil
2 whole peeled garlic cloves cut in thin slices
1 teaspoon hot red pepper flakes
1/4 cup (15 g) chopped fresh parsley
Fine sea salt to taste
3 1/2 cups (830 ml) chopped plum tomatoes
 with their juices
8 small, whole, and cleaned red mullet

• Heat the olive oil until it shimmers in a chef's pan large enough to accommodate the fish in a single layer. Stir in the garlic and cook it over medium heat until it begins to turn golden brown. Remove and discard the garlic and stir in the pepper flakes, parsley, and salt. Cook 1 minute, then stir in the tomatoes and cook the mixture, covered, for 15 minutes over medium heat. Layer the fish in the sauce and cook 5 minutes longer or just until the fish meat has turned white when poked with a fork.

• Serve the fish with some of the sauce, accompanied by boiled potatoes that have been tossed with parsley and extra-virgin olive oil.

(Left) Amedeo Modigliani, *Elvira Resting at a Table,* 1919.

(Top right) Amedeo Modigliani in his studio, Paris, early 1900s.

Pablo Picasso Matelote d'Anguille re-created by **Chef Antonio Cabanas**

Spanish artist Pablo Picasso is the greatest artist and most prolific creator of the 20th century. Producing over 20,000 artworks, and a master of all media—from paintings, collages, prints, drawings, to sculptures, ceramics, and porcelain—Picasso constantly reinvented his vision throughout his long career. He had an insatiable curiosity and a fertile imagination that allowed him to see art in found objects and the ephemera of daily life—one of his most famous sculptures, *Bull's Head* (1943), was assembled from a bicycle saddle and handle bars. As an adult, he was so creatively playful that even when dining, he would rearrange the knife, spoon, fork, salt and pepper shakers, and sugar bowl to make a face or human figure.

"Drink to me."

—Pablo Picasso

Matelote d'anguille (eel in brandy sauce) was the dish that Picasso adored. And the cabaret restaurant where Picasso enjoyed this dish most often, Els Quatre Gats, is still in operation at its original landmark building in Barcelona. The cabaret was a cultural center for artists and intellectuals during the early 1900s in Barcelona. The chef at Els Quatre Gats, Antonio Cabanas, has re-created the original recipe as it was served to Picasso and his circle of friends. And Rodolfo Celecia, the director of Els Quatre Gats, provides a little background history about the restaurant and Picasso:

" As you may know, Els Quatre Gats (The Four Cats) is a neo-Gothic building designed by the famous architect Puig i Cadafalch. The original idea was conceived by Pere Romeu, who thought of a beer-restaurant like Le Chat Noir in Paris. The painter Rusiñol considered it a bad idea and said 'four cats' would go there (a Catalan expression [meaning] no one would go). Picasso began to hang out in this establishment when he was 17. There he exhibited his works for the first time, in 1900."

Matelote d'Anguille (Eel in Brandy Sauce)

Serves 6 | Adapted

2 lbs (900 g) eel, skinned and cleaned, cut
 into 1-inch (2.5-cm) pieces
All-purpose flour for dredging, plus 2 tablespoons
Salt and pepper to taste
1/4 cup (60 ml) olive oil, plus more as needed
1 medium onion, sliced
2 scallions, sliced
2 cloves garlic, chopped
4 sprigs thyme, 4 sprigs parsley, and 1 bay leaf
 tied together with kitchen twine (bouquet garni)
3 cups (710 ml) red wine
6 small blue crabs
1/2 cup (120 ml) cognac
4 tablespoons butter
50 cooked pearl onions
8 oz (225 g) button mushrooms, sliced
Toasted sliced bread, for serving

• Heat 2 tablespoons of the oil in a large skillet over medium-high heat. Season the eel with salt and pepper and dredge in flour, shaking off the excess. Fry the eel until golden, turning once, about 5 minutes per side. Transfer to a paper towel lined plate to drain. Reserve the skillet.

• In a very large Dutch oven or heavy-bottomed pot, heat the remaining oil over medium-high heat. Add the onions, scallions, and garlic and cook, stirring until golden, about 8–10 minutes. Add the bouquet garni and wine and bring to a boil. Reduce the heat to maintain a gentle simmer, add the eel, and cook for 20 minutes.

• Meanwhile, return the reserved skillet to medium-high heat and add more oil if necessary. Fry the crabs until bright pink and beginning to turn golden, turning once, about 6 minutes per side. Add the cognac, stirring up any bits in the pan, and cook until liquid is nearly evaporated, about 5 minutes. ▷

(*Right*) Pablo Picasso feeding his son Claude, Provence-Alpes-Côte d'Azur, France, 1951.

Pablo Picasso Matelote d'Anguille

• Transfer the crabs to a plate and set aside. Pour any remaining liquid into the pot with the eel.

• Return the skillet to medium heat and melt the butter. Add the pearl onions and mushrooms, season with salt and pepper, and cook until soft, about 8 minutes. Sprinkle the 2 tablespoons of flour over

the mushrooms and cook, stirring, for 3–4 minutes more.

• Add the mushroom mixture to the eel/wine mixture, and increase the heat to medium. Stir until it begins to boil. Add the crabs, cover, and cook until thickened and crabs are hot, about 5 minutes. Adjust seasoning and remove the bouquet garni.

• To serve, pour the eel stew into a large shallow platter and place the crabs around the edge. Eat with toasted bread.

(Above) The dining room of Els Quatre Gats, Barcelona, where Pablo Picasso and other artists and intellectuals gathered in the early 1900s.

Will Barnet Linguini with Garlic and Oil

Linguini with Garlic and Oil

Serves 4–6

1 lb (450 g) linguini
6–7 cloves garlic (crushed and chopped)
1/2 cup (120 ml) extra virgin olive oil
Bunch of fresh parsley, roughly chopped
1/4 cup (25 g) grated Parmesan cheese
Salt and pepper to taste

• Cook the pasta in boiling water (salted) and drain. Heat oil to hot, but not smoking, add the garlic, and lower the heat, stirring constantly for 2–3 minutes. Do not let the garlic burn. Add three-fourths of the parsley, and salt and pepper to taste. Remove from heat. Pour the sauce over the linguini and toss thoroughly. Add the grated cheese and garnish with the remaining parsley.

• Finish off with a cup of hot tea and a sliver of Scharffen Berger dark chocolate.

(Above) This Scharffen Berger dark chocolate label came with a note by Will Barnet, 1995

(Top left) Will Barnet, undated

The American painter and graphic artist Will Barnet is best known for his elegant, pared-down portraits of women at repose, executed in a style he calls Classic Modernism. He had absolutely no trouble in deciding his favorite recipe. It was easy to determine since he eats it almost every day: linguini with garlic and oil. Will told me that he always finished the meal with a glass of hot tea and a sliver of Scharffen Berger dark chocolate. He sent in the label from a bar of the chocolate annotated with this handwritten note: "Sliver with a glass of hot tea—lunch or dinner—great dessert!"

Alex Katz Salmon Coulibiac

Salmon Coulibiac (Salmon in Pastry)

Serves 10 | Adapted

14 oz (400 g) skinless boneless salmon filet
3/4 cup (180 ml) white wine
4 sprigs flat-leaf parsley
4 sprigs thyme
1 bay leaf
1/2 teaspoon paprika
3 shallots, chopped
3 cups (200 g) mushrooms, sliced
1 tablespoon butter
4 oz (125 g) instant polenta (semolina)
1 teaspoon salt, plus more as needed
Freshly ground black pepper
3 hard-boiled eggs, quartered
1 egg, beaten
1 cup (175 g) cooked rice
1 package puff pastry (2 sheets)

Alex Katz was born to Russian parents in New York. A major force in American Neo-Realism, his flatly painted canvases combine elements of abstraction and representation, with compositions reminiscent of movie screens and billboards. Katz's love for *coulibiac* (a French version of an old Russian dish called *kulebiaka*) traces back to the comforts of his childhood. However, when he was interviewed in 1998 by his son, Vincent, for *Flash Magazine,* Katz recalled that after visiting Russia he could relate to some Russian traditions, but others were "out to lunch." Vincent discusses Katz's eating habits, below, followed by an excerpt from the interview:

"My father's quite eccentric. One summer he didn't eat anything but doughnuts and milk. He's not particular. He'll eat anything, and if he really likes something, he takes it right off my plate. But he's a nice guy anyway. Basically, he's a meat and potatoes guy, though his favorite food is *coulibiac.*"

Vincent: "What were your impressions of Russia? Did you feel in any way like you were going home?"
Alex: "Yeah, I did. Russian people were easy for me to read. Russia seemed from another time period, as my parents were. All of it felt very romantic. I could relate to the upside of a depressing life, the partying and the vodka. But it was hard, it wasn't easy for me. I couldn't for the life of me clap hands to the mandoline music. You go to these cabarets, and the whole place is clapping hands and screaming to this minor key, sad music, which is really out to lunch."

- Poach the salmon in simmering salted water with the wine, herbs, bay leaf, and paprika for 12 minutes, then allow to cool in the poaching liquid. Remove the salmon, and flake it.

- Cook the shallots and mushrooms over medium heat until soft, about 10 minutes.

- Bring 2 1/4 cups (530 ml) water and 1 teaspoon salt to a boil in a medium saucepan. Gently stir in the polenta, reduce heat to medium low, and cook 5 minutes, stirring often.

- Preheat the oven to 450°F (230°C). On a lightly floured work surface, roll one pastry sheet into a rectangle 1/4-inch (.5-cm) thick and transfer to a baking sheet. Roll the second pastry sheet slightly larger than the first; set aside. Leaving a 1-inch (2.5-cm) border, spread the rice on the pastry, topped by the salmon. Put the mushrooms over the salmon, followed by the polenta, and top with the hard-boiled eggs.

- Season to taste with salt and pepper as you go. Wet the exposed pastry edge with water and carefully lay the other pastry sheet over the top, pinching to seal. Glaze with the beaten egg. Bake until golden brown, about 30 minutes. Allow to cool 15 minutes before slicing. Serve drizzled with melted butter.

Arman Alternating Slices of Marinated & Cooked Tuna

Born in Nice, France, as Armand Pierre Fernandez, Arman is famous for what he calls his "accumulations": sculptures that juxtapose and layer unexpected elements or take them apart, including watches, telephones, violins, and even cars. "As an artist," he says, "I have always used the method of slicing and cutting and putting the parts back together. Therefore, in my recipes, I apply this method as I do with my works of art." The tuna recipe, which Arman created especially for this book, deliciously employs his masterful technique.

Alternating Slices of Marinated and Cooked Tuna

Serves 4

Two 8-oz (225 g) tuna steaks, 1 1/2-inch (4 cm) thick
Juice of 2 lemons
1 teaspoon ground ginger
1/2 teaspoon salt
1/2 teaspoon white pepper
1 tablespoon lemon pepper seasoning
3 tablespoons cooking oil
Baby red leaf lettuce, shredded, and green or red peppers, sliced, to garnish

• Slice three-fourths of one steak into 3/16-inch (5-mm) slices horizontally. In a bowl, combine the lemon juice, ground ginger, salt, and white pepper, and marinate the thin slices of tuna approximately 15–30 minutes in the refrigerator. Slice the remaining steak and the rest of the first steak into 1/4-inch (1/2-cm) slices and season with lemon pepper seasoning. Cover and refrigerate. In a heavy skillet, heat the cooking oil over moderately high heat until hot but not smoking, and sear the 1/4-inch (1/2-cm) thick tuna slices until just cooked—approximately 30 seconds on each side (do not overcook or slices will break). Remove from the skillet and put aside. Remove the thin slices from the marinade and drain off the excess liquid. In a serving dish alternate 1 slice of cooked and 1 slice of marinated tuna. Garnish with shredded baby red leaf lettuce and pepper slices.

(*Far left*) Alex Katz, 1996; courtesy Marlborough Gallery and Vivien Bittencourt

(*Left*) Arman in his studio in Vence, France, 1995, courtesy Arman

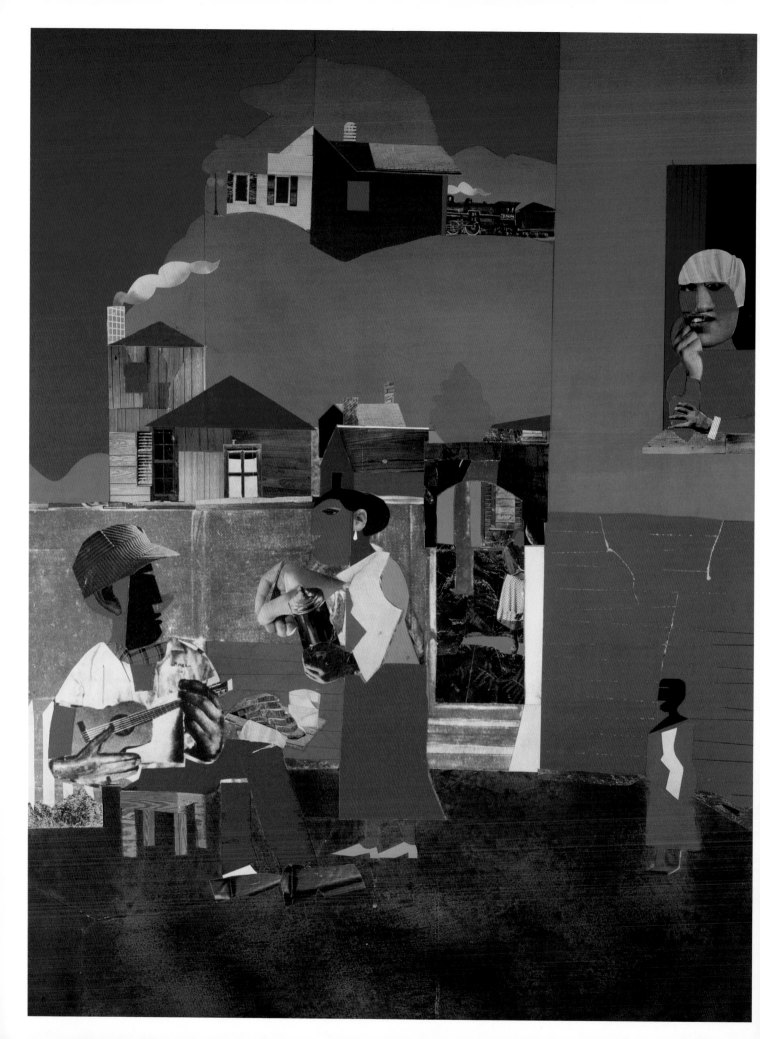

One of the best-loved artists of his time, Romare Bearden's carried the civil-rights torch that his mother Bessye B. Bearden, editor of *The Chicago Defender* and founder and president of the Negro Woman's Democratic Association, had handed him. Romare Bearden's narrative and expressive collages and watercolors are brilliant statements on socio-political and civil-rights issues. The artist once said that his goal was to "bring the Afro-American experience into art and give it a universal dimension." Bearden's sister-in-law, Sheila Rohan, remembers his creativity as a host and a cook:

"Romare Bearden was my brother-in-law, married to my sister Nanette Rohan. He really enjoyed cooking. I recall many tasty dinners at his apartment on Canal Street in Manhattan, and at his home in Saint Martin, where he cooked for many of his visiting friends. One of his favorites was Southern seafood gumbo, along with his buttermilk biscuits. Unfortunately, I don't have his recipes. My nieces were invited and took turns spending their summer holidays with Romie and Nanette, and he would cook spaghetti (my sister loved pasta) with his special sauce, and fried chicken. When called for, he could really do a job with a ham. He would marinate it overnight with his blend of spices and slather it with mustard. This was an Easter treat.

"When called for, he could really do a job with a ham."

—Sheila Rohan, Romare Bearden Foundation

"Romare called the following quick-and-easy-to-prepare dish his 'Artist Meal' and said, 'This recipe is also easy on the budget. It can be served over toast as a quick and delicious pick-me-up for a busy artist!'"

Artist's Meal

Serves 5

Two 7 1/2-oz (200 g) cans of salmon
Two 11-oz (325 ml) cans undiluted cream of
 mushroom soup
1/2 small jar chopped pimentos
1 medium onion, sliced
One 16-oz (450-g) can green peas
3 tablespoons Parmesan cheese

• Combine all of the ingredients except the cheese in a casserole dish. Sprinkle the cheese on top. Bake until heated and browned in a 350°F (175°C) oven, about 45 minutes. Serve over rice.

(Above) Romare Bearden, undated, courtesy Romare Bearden Foundation

(*Far left*) Romare Bearden, *Back Home from Up the Country*, undated

Stuart Davis Finn an' Haddie

Finn an' Haddie

Serves 6 | Adapted

2 tablespoons unsalted butter
3 tablespoon all-purpose flour
4 cups (950 ml) whole milk
Salt and pepper to taste
Pinch cayenne pepper
Freshly grated nutmeg to taste
2 lbs (900 g) smoked cod or whitefish filets, boned
1/2 large onion, sliced (3/4 cup/75 g)
3 sprigs parsley
1 bay leaf
3/4 cup (175 g) heavy cream

• In a large saucepan, melt the butter over medium heat. Whisk in the flour until it is well incorporated and begins to bubble. Slowly whisk in 3 cups (700 ml) of the milk, a little at a time, to prevent lumps from forming. Add the salt, pepper, cayenne, and nutmeg and bring to a boil. Simmer for 2–3 minutes, until thick.

• In a large skillet, add the fish, onion, parsley, bay leaf, and remaining 1 cup (225 ml) of milk. Add enough water to just cover the ingredients. Bring to a low boil over medium heat and simmer until the onions are softened, about 4–5 minutes. Reserve 1/2 cup (120 ml) of the cooking liquid, strain the fish mixture, and discard any remaining liquid. Discard the bay leaf.

• Over medium-low heat, whisk the reserved cooking liquid and heavy cream into the sauce until combined. Cook until sauce is hot.

• To serve, divide the fish/onion mixture among 6 warm shallow bowls and pour the hot sauce over the top.

In the 1950s, Stuart Davis gave modernism a distinctly American twist with his bold, colorful abstract paintings of urban landscapes. Inspired by the rhythms of jazz and the lines, planes, and geometric patterns of everyday objects, Davis's unconventional use of commercial signs, words, and numbers was an exciting innovation. The artist's son Earl reminisces about his father's favorite dish:

"One of the earliest and fondest memories related to my father and food is the smell and taste of finn an' haddie. I recall it as a rare treat when he would take me to a restaurant in Manhattan that served it. Besides being delicious, finn an' haddie was filled with sentiment for my father. It served as a staple in his diet over the course of twenty long summers during which he lived and painted in Gloucester, Massachusetts, amidst a community of other artist friends. It was apparently a favorite dockside preparation among fishermen. In my father's later years, finn an' haddie was as close as he would get to the Gloucester piers that had served as the stimulus for a whole family of paintings based upon the arbitrary arrangement of shapes and configurations that he found there."

(Top left) Stuart Davis stands on a dock in Gloucester, Massachusetts, in January 1940; on the photograph was a notation—"freezing weather." Courtesy Earl Davis.

Roy Lichtenstein Spaghetti with Broccoli Rabe

Spaghetti with Broccoli Rabe

Serves 4

1 1/2 lbs (675 g) broccoli rabe
1/2 teaspoon crushed red pepper
1/2 cup (120 ml) olive oil
2 cloves garlic, minced or crushed (optional)
Dash nutmeg (optional)
1 lb (450 g) spaghetti
Grated Parmesan cheese for the table

• Trim the bottom 1 inch (2.5 cm) or so from the stems of the broccoli rabe. Remove woody stems. Wash thoroughly, and shake off the excess moisture, or dry on paper towels. Cut the remaining parts into pieces 1 inch (2.5 cm) long.

• Cook the spaghetti as directed on the package.

• Heat the pepper in oil in the saucepan. If using garlic, put it in now. When the oil is sizzling hot, add the broccoli rabe and stir over high heat until its bulk reduces. If using nutmeg, add it to the broccoli rabe at this time and stir well.

• Cover and let simmer over low heat 5 minutes, or until the thicker stems are cooked. Cook spaghetti as directed on package. Toss with the broccoli rabe.

• Serve with Parmesan cheese at the table.

A former commercial artist and designer, Roy Lichtenstein was one of the originators of the New York School of Pop Art. In 1961, Lichtenstein introduced the use of the Ben Day dot system (a commercial printing technique used to denote halftones, invented in 1879 by Benjamin Day). He also employed lettering and dialogue balloons in large, witty, and ironic paintings of comic book-like images from popular culture. Dorothy Lichtenstein, Roy's wife, offers this recipe for Spaghetti with Broccoli Rabe, one of Roy's prized old Italian recipes that uses an authentic touch of freshly grated nutmeg.

(Top left) Roy Lichtenstein posing in front of his painting, *Spaghetta!*, c. 1985, courtesy Estate of Roy Lichtenstein

Beverly Pepper Spaghetti al Limone

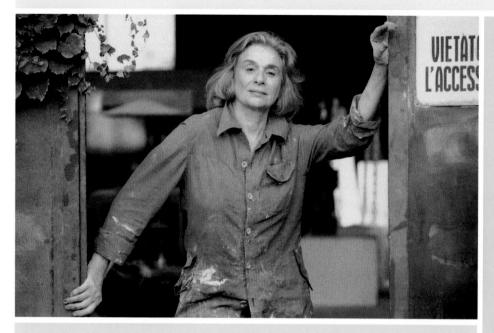

Spaghetti al Limone (Spaghetti with Lemon)

Serves 4 | Adapted

3 lemons
1 large onion, coarsely chopped
1 lb (450 g) spaghetti
2 tablespoons butter
2 tablespoons olive oil
One 2-oz (50-g) tin of anchovies in oil, drained
1 cup (225 g) heavy cream
1 cup (100 g) grated Parmesan or Romano cheese
2 tablespoons fresh parsley leaves, finely chopped

• First, prepare the lemons and onion; grate one lemon, reserve the zest, and juice the lemon. Peel large strips off the second lemon and cut them into hair-thin strips and reserve as garnish. Juice the second lemon and add to the first. Thickly slice the third lemon and add the slices to a large pot of water. Bring the water to a boil, lightly salt it, and add the spaghetti. Cook until al dente, about 7–8 minutes. Purée the onion in a food processor.

• While the pasta is cooking, heat the butter and oil in a large saucepan over medium-low heat. Add the anchovies and simmer, stirring constantly, until anchovies dissolve. Add the onion purée and continue cooking until softened but not browned, about 5 minutes. Add reserved grated lemon zest and juice and continue cooking until well combined and hot.

• When the pasta is ready, drain and add it to the anchovy sauce. Stir in the cream and cheese until well coated. Raise the heat to medium and stir the pasta until hot but not boiling.

• Serve the pasta in a heated serving bowl and sprinkle the lemon zest strips and parsley over the top.

Beverly Pepper, a central figure in such watershed modern movements as Constructivism, Assemblage, and Minimalism, is perhaps best known for her monumental works; Pepper's 18-foot high (5.5 m) construction in stainless steel, located in midtown Manhattan, is one of the very first outdoor abstract sculptures in America. Pepper's sensitivity to the potential of natural forms extends to the kitchen as well, as her assistant Janet Goleas explains:

"I'll never forget the first time I tasted Beverly's cooking. It was a cold and gloomy New York afternoon, well past lunchtime. There was nothing to speak of in the refrigerator—some unremarkable mushrooms, a crock of grainy French mustard, a few other things not quickly identifiable as food. While we talked, Beverly chopped and sautéed. I confess to a little healthy skepticism. But shortly, two porcelain bowls of steaming soup appeared, cloth napkins, big silver spoons. Giddy with enthusiasm, Beverly sat down next to me. Our first hot sip revealed a subtle fusion of flavor and stunning inventiveness. She looked at me with a big smile. 'It's good, isn't it?' And yes indeed, whether it was alchemy or sorcery or a simple triumph of creative will, it was really quite good. And it was most definitely memorable. Beverly's approach to cooking, much like her approach in the studio, is resourceful and expansive, perceptual and experimental. Having spent much of her adult life in Italy, she understands simplicity and fresh, honest flavors. This spirited recipe, Spaghetti al Limone, is piquant and creamy—a wonderfully surprising marriage of tastes."

(Top left) Beverly Pepper in Italy, undated

(Right) Beverly Pepper, *Manhattan Sentinels,* 1993–6, Federal Plaza, New York.

Both courtesy Beverly Pepper

The Abstract Expressionist artist Helen Frankenthaler was originally influenced by Jackson Pollock and Willem de Kooning, but she developed her own "action painting" gestural technique and originated the method of pouring thinned pigments directly on unprimed canvas, instead of the established technique of working on a prepared, primed surface. This unusual staining process brought about translucent, veiled effects and was a defining element in the development of the Color Field school of painting.

Unlike other Color Field painters of her generation who produced nonobjective work, Frankenthaler continued to base her work in nature, both observed and imagined. Her paintings are perhaps best loved for the sheer beauty of their colors, and for the powerful emotions they evoke. Considered one of the most influential artists of the second generation of Abstract Expressionists, she is also recognized throughout the art community as a fantastic cook.

> "Poached stuffed striped bass can serve as an elegant buffet or party dish and works equally well hot or cold."
>
> —Helen Frankenthaler

(Left) Helen Frankenthaler works on an Abstract Expressionist painting in her studio, New York, 1957.

Poached Stuffed Striped Bass

Serves 10–12 as a main course or
12–16 as an appetizer

5–7 lb (2.25–3 kg) striped bass, slit and boned, with head and tail left on

For the Court Bouillon:
1 bay leaf
1/2 teaspoon rosemary
3 celery leaves
2 slices of lemon
8 peppercorns
3 oz (90 ml) dry vermouth
1 1/2 cups (350 ml) water
1 bouillon cube

For the Stuffing:
1 raw carrot, chopped
3 stalks celery, chopped
3 scallions (include 1/2 of green ends)
1/4 lb (125 g) shrimp, cleaned and cut into quarters
1 peeled tomato, chopped
1 large mushroom, sliced

• Combine all stuffing ingredients and stuff the fish. Wrap fish in cheesecloth. Take care that the stuffed side of the fish is tightly covered so that the stuffing remains in place.

• Put the fish into a poacher and add bouillon ingredients. Cover. Cook over low flame on two burners for 45 minutes.

• Remove cheesecloth and serve.

Sam Francis Smoked Salmon & Jicama Maki Sushi re-created by Chef Ming Tsai

Smoked Salmon and Jicama Maki Sushi

Serves 4

1 teaspoon vinegar
4 toasted *nori* sheets (dried seaweed)
4 cups (750 g) sushi rice, cooked according to
 package instructions
4 thin slices smoked salmon, cut into 1/4-inch
 (.5-cm) strips
1 cup (125 g) jicama, peeled and cut into strips
 1/4 inch (.5 cm) thick
1/4 cup (60 ml) *wasabi* oil (see below)
1/4 cup (60 ml) soy syrup (see below)

Note: A bamboo rolling mat, called a maki-su,
is recommended for preparation of this dish.

For the Wasabi Oil:

Makes about 1 cup (225 ml)

1/2 cup (50 g) *wasabi* powder
2 tablespoons *mirin* (Japanese sweet sake)
2 tablespoons sugar
1/2 cup (120 ml) canola oil

• In a small stainless-steel bowl, combine the
wasabi powder, mirin, and sugar, and whisk to
blend. Add a little less than 1/2 cup (120 ml)
water gradually, whisking, until a pancakelike-
batter purée is formed. Whisk in the oil. Let
stand for 10 minutes before using.

For the Soy Syrup:

Makes 2 cups (475 ml)

2 cups (475 ml) soy sauce
1/2 cup (75 g) brown sugar
Juice of 1 lime

• In a medium saucepan, combine the soy sauce,
brown sugar, and lime juice. Bring to a boil slowly
over medium heat, turn down the heat, and reduce
the mixture by three-fourths or until syrupy, about
30 minutes. Strain, cool, and use or store.

Preparing the Sushi
• Fill a small bowl with water; add the vinegar.
Place 1 sheet of *nori* shiny side down on the

Acclaimed American painter Sam Francis began painting in 1944 at age 21,
while recovering from a crash during military flight training. While influenced
by Abstract Expressionism, Francis's translucent, luminous paintings are
uniquely his own. Greatly inspired by the purity and serenity of Japanese art,
he was also a connoisseur of Japanese cuisine. Chef Ming Tsai, a master of
East-West cuisine fusion, has created a maki that would surely have been
relished by Sam Francis. Below, Margaret Francis shares some loving thoughts
and memories about her husband's love of sushi, art, family, and life:

"Sam loved food almost as much as life itself, and one of his greatest pleasures
was sitting around a dining table sharing food and good conversation with
family, friends, and other artists. We always had open house at our home in Santa
Monica and Sam loved the interaction of ideas that flowed over a table laden with
good food and wine. . . . I met Sam in Tokyo, where we first ate sushi together. He was
really keen on eating at the best sushiya in Tokyo. Usually small family businesses
where a lot of pride and effort goes into creating exceptional sushi . . . starting with
buying the best fish, at the break of dawn in downtown Tokyo, the scrubbed shining
white of the special wooden counter, gleaming glass cabinets, to plump juicy pieces
of tuna, arranged for the eye to excite the taste buds for the very tactile and sensual
experience of placing the sushi upon the tongue and completely filling the mouth
with large mouth-shaped bites. To hold the sushi more correctly than using
chopsticks, use three fingers, one on each side of the piece and one curled bent
behind, while the little finger is bent upwards in expectation of a true delicacy!

A quick dash in the soya sauce of the small dish . . . not too much though because raw fish is a delicate flavor and must not be drowned out. After a piece is released in the mouth—a clean mouth in which ginger has been previously chewed to prepare the palate for an unhampered taste experience—a moment should be taken to be in the moment of mindful tasting bliss . . .

"When we first married, Sam took me to an organic supermarket . . . He liked real butter, organic and without salt, fresh produce, fresh fish, organic meat, so it took several trips to several different markets to get everything he loved. When he was diagnosed with cancer, we moved to the countryside, to better air, a place where you could look up and still see the stars. We had a house overlooking the San Andreas Fault, on the side of a cliff . . . we built terraced gardens using railway sleepers. Because it had never grown anything before, the vegetables and salad were fantastic, the artichokes, potatoes, everything was incredibly delicious. Believing in 'you are what you eat' and having strong environmental concerns about how the food is produced, organic truly for him was the only way to eat and grow food . . . But Sam was not against meat, poultry, or fish, he actually wasn't too keen on vegetarianism. Once he professed that macrobiotic cooking was the way to go. So once when I had to leave for England I hired him a macrobiotic cook. She was to cook only this type of food for the month that I was away. He complained bitterly after only a week or so and never asked for it ever again.

"We also built a bread oven on this cliffside looking out to sea . . . most of the time it acted as an open fire to sit around, sing and play guitar, or simply enjoy the food and the view and the fresh air. The oven was so simple to use and it baked the best bread, pizza to die for, baked potatoes, fresh local sausages, but also a full-size 30-pound turkey, our own chickens. . . . In front of the oven looking out to the ocean we enjoyed the best oysters shucked fresh from the ocean that day, eaten outside in starlight and downed with California red and white wines. Paradise now lost!

"Sam, the quintessential consumer, the environmentalist, the gentle consumer of delicious food and wine. Aware of the ground he trod upon, the air he breathed, the sky above him, the light reflecting upon the wall, rippling light that falls upon the food we eat. This awareness carried over into what and where he bought the food he ate and the way it was prepared. . . . Food, he believed, is the alchemical experience that every family unites around, the kitchen is hallowed ground, people are drawn to the fire that binds one and all in the necessary preparation of sustenance, in breaking bread together, holy bread, symbolic and truly necessary for a family to stay harmonious. We take with us into adulthood simple rituals that are worldwide, the family united sharing a meal."

sushi mat with one long edge toward you. Wet your hands and pat a 1/4-inch (.5-cm) layer of the rice over the bottom half of the *nori*.

• Cover the rice with one-fourth of the salmon strips and top with one-fourth of the jicama and pickled ginger. Drizzle a thin line of wasabi oil over the filling. To roll, lift the mat, compressing it against the filling as you roll the bottom edge in on itself. Continue rolling toward the top edge until only 1/4 inch (.5 cm) of the *nori* remains unrolled. Moisten a finger and wet the edge of the *nori*. Press the mat to seal the roll. Repeat with the remaining *nori* and filling. Allow the *maki* to rest, seam side down, for 2 minutes.

• With a sharp knife, slice each *maki* in half. Cut one half straight across into 3 pieces and cut the other half diagonally into 2 pieces. With a spoon, drizzle additional *wasabi* oil and the soy syrup onto plates in a zigzag pattern, arrange the *maki* pieces over, and serve.

(Above) Sam Francis carves a turkey leg while his son, Augustus, looks on, c. 1992

(Far left) Sam and Margaret Francis at a sushi restaurant, c. 1990; both courtesy Margaret Francis.

Josef & Anni Albers Himmel und Erde

Best known for his exploration of color theory, Joseph Albers influenced a generation of young artists as a teacher and theoretician. Anni Fleisher, who married Albers in 1925, is considered the foremost textile artist of the 20th century. She emigrated to the United States with Albers after the Bauhaus school was closed by the Nazis in 1933. Nicholas Fox Weber, executive director of the Josef and Anni Albers Foundation, shares memories of the Albers and one of their favorite dishes:

"Ironically, Josef Albers very often referred to the legends on the backs of his paintings, in which he gave the colors, often with the manufacturer's name, as his 'recipes.' Albers, however, did not have a clue how to cook. On a rare occasion, when his wife had to leave him alone in the house for several days, because she was going to be hospitalized, she even had to give him instructions on how to operate a can opener. He loved to eat and we often discussed food together, but its preparation was completely foreign to him. Anni Albers, however, did have several favorite recipes. Whether she invented them or not, I do not know, but I well remember her telling me about them. One was a dish she called *Himmel und Erde*. For this, she simply used equal proportions applesauce (right out of the jar) and mashed potatoes (not the real ones, but instead mashed, made with a mix). She was very proud of this. I think she considered it extremely efficient, as well as delicious."

Himmel und Erde

Serves 1–2

1 jar applesauce
2 cups (425 g) instant mashed potatoes
1–4 pieces Kentucky Fried Chicken
 (depending on appetite)

• Cook mashed potatoes as directed on the box. Place the mashed potatoes into a bowl, add the applesauce, and mix together. Serve with chicken.

Note: Himmel und Erde is actually a traditional German dish, which translates as "heaven and earth"—the apples of heaven mixed with the apples of the earth (potatoes).

"She liked to serve it with Kentucky Fried Chicken, which she considered to be one of the greatest things in modern America."

—Nicholas Fox Weber

(Left) Josef and Anni Albers in her studio, New Haven, Connecticut, 1955; courtesy The Josef and Anni Albers Foundation, Inc.

Robert Motherwell Late Supper

Late Supper

Serves 1–2

20-inch (50-cm) liverwurst in natural casing
(casing can be removed if desired)
2 cans beer
French, Italian, or thinly sliced German dark bread

• Place in pan with beer and bake at 325°F
(160°C) for 45–60 minutes. Slice and serve on
warm bread.

"The Surrealists were
real comrades, a real gang,
the only real gang of artists
I've ever known. And so if
you knew one pretty soon
you'd know them all.
Two or three times a week,
they'd all have lunch
together."

—Robert Motherwell,
from an "Oral Art History"
Interview with Paul Cummings
for the Archives of American Art,
Smithsonian Institution, 1971

One of the founding fathers of Abstract Expressionism along with
Jackson Pollock, Mark Rothko, Willem De Kooning, and Franz Kline,
the innovative artist Robert Motherwell laid the groundwork for this new
gestural movement in art. His total dedication to painting left little time for
the dinner table, and when it occurred, usually late at night,
it would be the simplest of meals, as he describes below:

"For a late evening party, get a piece of liverwurst, as long as your oven will
hold. Put it in a pan with a half-inch of beer, and bake it at 325 degrees
for 45 minutes to half an hour. Serve it on a carving board, with warm bread on
hot plates. The casing will be difficult to slice, unless you have a razor sharp knife,
but the wurst can be easily scooped out with a spoon."

(Left) Robert Motherwell drawing with a bamboo pen
in his studio, New York, undated.

Sandro Chia Vegetarian Lasagne

Vegetarian Lasagne

Serves 8–10 | Adapted

1/4 (60 ml) cup olive oil
1 medium onion, chopped
1 clove garlic, minced
Two 28-oz (800 g) cans Italian peeled
 tomatoes, drained and crushed
2 vegetable bouillon cubes
1 cup (50 g) fresh basil leaves
Salt and pepper to taste
1 large red pepper, sliced (about 1 cup/90 g)
1 leek, halved and sliced
2 cups (150 g) sliced mushrooms
1 small zucchini, sliced
1 large carrot, grated
1 9-oz (250-g) box no-boil lasagna sheets
1 lb (450 kg) grated mozzarella
3/4 cup (75 g) grated Parmesan cheese

• Preheat oven to 350°F (175°C). In a large saucepan over medium heat, sauté the onions and garlic in 2 tablespoons of olive oil until soft, about 5 minutes. Add the tomatoes and bouillon cubes. Simmer, stirring frequently, for 30 minutes. Remove from the heat, stir in the basil leaves, and season with salt and pepper.

• In a large skillet, heat the remaining olive oil over medium heat, add the red pepper and leek, and cook until soft, about 6 minutes. Add the mushrooms, zucchini, and carrot and cook until soft, about 5 minutes. Season with salt and pepper.

• Lightly oil a 9 x 13-inch [25 x 35-cm] baking pan. Spread about 1/2 cup (120 ml) of sauce on the bottom of the pan, and lay 4 lasagna sheets over it. Sprinkle one-third of the vegetable mixture, followed by about 1 cup (240 ml) of sauce. Top with 1/4 cup (25 g) of the mozzarella and 3 tablespoons of Parmesan. Repeat, ending the top layer with the remaining sauce and cheese. Lightly cover with foil and bake 40 minutes.

In the late 1970s, Italian artist Sandro Chia established himself as a major force in a movement in Italian figurative painting known as *Transavanguardia*. Chia, who exhibits his work internationally, divides his time between New York City and Montalcino, Italy. Here he offers his favorite recipe, Vegetarian Lasagne.

"When I was a boy, any recipe that my mother prepared that included meat, was a cause for celebration. But most of the time, our family ate vegetarian dishes that cost a lot less to prepare, with leftovers lasting much longer. The recipe here is not one of my mother's, but I think she would appreciate it nonetheless. I eat very little meat these days and find that lasagne does not need meat to be great tasting. I have always thought that lasagne is the perfect culinary opportunity to take advantage of whatever the season offers in the way of vegetables. The subtleties of these ingredients blend together to make a sublime dish that compliments everything else on the table."

(Far left) Sandro Chia, undated

(Top Left) Sandro Chia at the dinner table, c. 2000; both courtesy Sandro Chia

Diego Rivera Two Hot Mexican Chiles

The Mexican artist Diego Rivera was one of the 20th-century's great revolutionaries, both artistically and politically. A pioneer of mural painting and a devout Marxist, Rivera believed that art should be used to both teach and convey political messages. His iconic paintings bestowed dignity to everyday life and a sense of nobility to the Mexican people. Rivera's personality was as powerful as his art. His life, and the story of his third wife, Mexican artist Frida Kahlo, have been well-publicized, but Rivera's second wife, talented artist and designer Lupe Marin Rivera, is the woman who taught Frida to cook for Diego. Occasionally, though, Diego took to the stove. Lupe's daughter, Guadalupe Rivera Marin, kindly submitted Diego's favorite dish cooked by Lupe—*Chiles Rellanos de Picadillo, Frios o Callientes* (Peppers Stuffed with Meat, Served Hot or Cold), along with a variation that Diego liked to make himself: *Chiles Relana de Questa* (Peppers Stuffed with Cheese).

"Diego Rivera and Frida Kahlo married in August 1929 in Mexico City. Their first home was a small apartment in a small building located at 8 Calle de Tampico, near Chapultepec Forest, which Diego crossed every day to work. At this time, Rivera was completing murals for the National Ministry. The building was owned by my mother even though Diego felt it also belonged to him, since he considered the money invested in the building when it was constructed was also his and not only that of the beautiful Lupe Marin.

"The Riveras lived on the ground floor. On the second floor, there was a young couple named Cejudo, and on the third floor lived Lupe Marin, her second husband, the poet Jorge Cuesta, my sister Ruth Marin, and I. We were two and four years old respectively. While my father was at work, Lupe and Frida would tend to household chores. Also Frida would paint and Lupe would make simple clothing for the family, even the shirts of her ex-husband Diego. They also spent their time going to the market to buy the vegetables and fresh fruit that Diego liked so much: pineapple, watermelon, melon, and when in season mamey fruit and chicozapotes, which were the famous painter's favorite. Later Lupe spent time teaching Frida how to cook 'El Gordo's' (Fatty's) favorite dishes. This was their nickname for my father. Everything was small in the apartment, including the kitchen, which had an old three-burner-stove, a wooden table and chair, a simple cupboard for the necessary pots and pans ▷

(Right) Diego Rivera, *Woman Making Tortillas*, 1924

Two Hot Mexican Chiles

Chiles Rellenos de Picadillo, Frios o Callientes (Peppers Stuffed with Meat, Served Hot or Cold)

Serves 8 | Adapted

16 poblano peppers, grilled, peeled,
 de-ribbed, and seeded

1 cup (tk g) all-purpose flour

Salt and pepper

6 eggs, separated

1 1/2 lbs (675 g) ground pork

1 onion, quartered (root end intact), plus
 1 small onion, finely chopped

2 cloves garlic, smashed

Salt and pepper to taste

1/2 cup (100 g) shortening, lard, or vegetable oil

3 carrots, peeled and finely chopped

2 small zucchinis (about 6 inches/15 cm long),
 finely chopped

1 cup (145 g) blanched slivered almonds, chopped

1/3 cup (50 g) raisins

• In a large skillet, cook the pork, quartered
onion, garlic, and salt and pepper, to taste, ▷

Diego Rivera Two Hot Mexican Chiles

and an icebox for which we would replace the ice every three days. When Lupe and Frida cooked, nobody, not even a cockroach or mouse, would enter since there wasn't even room for *los chomacos* (the kids), that is for my sister and me. The most important utensils were the *metate* for grinding, and the *molcajete,* a mortar and pestle made of hard black stone. They were used to mash tomatoes and peppers and to roll the dough for the tortillas and sometimes for cocoa for homemade chocolate. Frida first learned to cook beans, stewing them in a Crock-Pot with a lot of water and a good chunk of onion. Then she fried them until they were pretty dry. Sprinkled with cheese, this was and is the traditional way of serving them throughout Mexico. Diego Rivera didn't have to eat during the day, but come night, he would get mad if he didn't find a table full of red or white rice, tomato salsa, his *chilitos verdes* (small and thin peppers), his basket of warm tortillas, and one or two dishes of his choice from a wide range of recipes in Mexican cuisine. One of El Gordo's favorite dishes was *chiles poblanos,* peppers stuffed with cheese and topped with a delicious tomato sauce. The recipe for this dish is as follows."

(*Above*) Diego Rivera, Lupe Marin, and Guadalupe Rivera Marin, 1924, Mexico City, courtesy Guadalupe Rivera Marin.

covered over medium-low heat for 20 minutes. Add water as necessary to keep from scorching. Remove from the skillet and drain.

• In the same pan, over medium heat, heat the shortening and sauté the chopped onion, carrots, and zucchini until the onion is translucent, about 6 minutes. Stir in the almonds and raisins. Add pork mixture, reduce heat to medium low, cover, and simmer for 20 minutes, stirring occasionally.

• Stuff each pepper with 1/3 cup (50 g) of pork mixture and form the pepper around it to enclose. Pour the flour onto a large plate and season to taste with salt and pepper. In a large bowl, whip the egg whites with a handheld mixer until they hold soft peaks. In a small bowl, season the yolks with salt and beat. Gently fold the yolks into the whites until combined.

• Fill a large heavy-bottomed pot with oil to a depth of 3 inches (8 cm) and heat over high heat. Roll each stuffed pepper in the flour and shake off the excess. Working one or two at a time, dip the stuffed, floured peppers into the eggs and fry, turning once, until golden, about 7 or 8 minutes per side. Transfer to a paper towel-lined plate to drain and continue frying remaining peppers. Serve with the caldillo.

For the Caldillo (Light Broth):

3 tablespoons olive oil
1 medium onion, thinly sliced
2 carrots, peeled and thinly sliced
10 tomatoes, grilled, peeled, seeded, and chopped
1/2 cup (120 ml) white or cider vinegar
3 tablespoons sugar
Salt and pepper to taste
2 tablespoons dried oregano or to taste

• In a large skillet, heat the olive oil over medium-high heat. Add the onions and carrots and cook until golden, about 8 minutes. Add the tomatoes, vinegar, and sugar. Season with salt and pepper, reduce the heat to medium-low, and simmer for 10 minutes. Add the oregano and simmer for 10 minutes more. Serve warm with the rellenos.

Note: For Rellenos de Questa *(Peppers Stuffed with Cheese), fill each pepper with 1/4 cup (25 g) of mozzarella, jack, or chihuahua cheese*

Tom Wesselmann Almost Fat-free Chili con Carne

Almost Fat-free Chili con Carne

Serves 3–4

Pam or nonstick cooking spray or
 1 tablespoon of olive oil
1 large onion minced
2 cloves garlic minced
1 cup (725 g) TVP (see Note)
2 cups (470 ml) undiluted canned beef broth
1 1/3 cups (325 g) canned tomatoes
1 can kidney beans
1 green pepper, minced
1/2 teaspoon celery seeds
1/4 teaspoon cayenne pepper
1 teaspoon cumin seed crushed
1 small bay leaf
1–2 tablespoons chili powder (to taste, more or less)
1/2 teaspoon dried basil
1 1/2 teaspoon salt

Tom Wesselmann was one of the original founders of Pop Art, best known for his *Great American Nude* series: evocative nudes painted with hard edges, flatly rendered in pink flesh with bold red lips and boldly patterned backgrounds. Wesselmann is a strict vegetarian. He has provided us with this, his favorite healthy and nutritious recipe.

"Some of the worst things about Pop Art have come from its admirers. They begin to sound like some nostalgia cult—they really worship Marilyn Monroe or Coca-Cola. The importance people attach to things an artist uses is irrelevant. . . . I use a billboard picture because it is a real, special representation of something, not because it is from a billboard. Advertising images excite me mainly because of what I can make from them."

—Tom Wesselmann, 1963

• Heat nonstick pan or flat bottom wok with cooking spray or olive oil. Add onion and garlic and sauté until brown. While the onion and garlic mix is browning, drain the reconstituted TVP thoroughly. Add the TVP to the skillet and stir to mingle with the onion mix, and cook briefly. Transfer this mixture to a large saucepan, and add the remaining ingredients. Bring to a boil, reduce the heat and simmer uncovered until the sauce thickens, about 2 hours. Drain the kidney beans and add to the chili just before serving. Serve the chili over plain spaghetti and on top of fat-free cheese (see Note).

Note: TVP stands for "texturized vegetable protein," a food product made from soybeans. As such it has a very small amount (1 gram) of total fat from that source, but no cholesterol and a negligible amount (.10 grams) of saturates within that total. TVP products, both in the granules used here, and in other forms, can be purchased from Harvest Direct (1-800-835-2867) and in most natural food stores.

There are many fat-free cheeses to choose from. Mr. Wesselmann suggests using soy cheese, like Soya Kaas or Zero Fat Rella.

(Above) Tom Wesselmann standing behind one of his sculptures, undated.

Yozo Hamaguchi Cherries Jubilee

Yozo Hamaguchi is considered the central figure in reviving, refining, and reintroducing the 17th-century tonal engraving technique of "mezzotint" as a popular medium of 20th-century art. As early as 1964, the *Encyclopedia Britannica* illustrated "mezzotint" with Mr. Hamaguchi's art and described the artist as "mezzotint's most distinguished and almost solitary advocate." Muldoon Elder, owner of Vorpal Galleries in New York City and San Francisco, has represented Hamaguchi's works for the past 20 years. Here he reminisces about the artist and shares Hamaguchi's favorite recipe, Cherries Jubilee:

"Hamaguchi was a very serious man with a good sense of humor. We were standing in the backyard of his San Francisco house on Alder Street. He and George Washington had something in common, each had a cherry tree in his backyard. The first cherry of the season had ripened. I asked Yozo if I could pick it, he nodded solemnly, so solemn that before eating it I placed it on his head and took a photo with the other 'Autoboy' camera he had given me some 10 years earlier. It was perhaps the most delicious cherry I ever ate. I kept the photo, and I am sending it to you along with his favorite recipe. The cherry was his favorite fruit . . . Cherries Jubilee."

Cherries Jubilee

Serves 6 | Adapted

4 cups (575 g) cherries, pitted (see Note)
1/2 cup (100 g) sugar
1/4 cup (60 ml) freshly squeezed lemon juice
1/3 cup (75 ml) Grand Marnier
2 tablespoons grated orange zest
2 teaspoons grated lemon zest
1/3 cup (75 ml) Courvoisier
Vanilla ice cream (see Note)

• Put the cherries, sugar, lemon juice, Grand Marnier, and half of the orange and lemon zests in a saucepan and bring to a simmer over medium heat. Cook for 25 minutes. Add the remaining zest and simmer for 5 minutes. Stir in the Courvoisier and cook briefly, 1 or 2 minutes.

• Scoop the ice cream into elegant dishes. Pour the cherry mixture over ice cream and ignite. Serve immediately.

Note: Hamaguchi's personal source for bottled cherries is Becky's Saucy Cherries, Frog Hollow Farm, Brentwood, CA, 888-779-4511 or www.froghollow.com. Hamaguchi suggests homemade ice cream, Ben & Jerry's, Häagen-dazs, or Uncle Ben's Best Vanilla in the World.

(Previous pages) Detail of Alphonse Mucha's poster for *Cacao Schaal,* c. 1900; courtesy Mucha Trust

(Above) Yozo Hamaguchi poses with a cherry on his head, San Francisco, undated.

(Right) Yozo Hamaguchi, *Robina's Cherry,* 1981; both courtesy Vorpal Gallery, San Francisco

Charles Burchfield Dumplings

One of the most significant American watercolorists of the 20th century, Charles Burchfield has been called a naturalist, a romantic, a transcendentalist, and an unparalleled chronicler of the American landscape.

Two experts from the Burchfield-Penney Art Center, Nancy Weekly, head of collections and programs, and Charles Cary Rumsey, curator, offer recollections from Burchfield's children as well as an entry from the artist's journal:

"Burchfield's daughter, Sally, and son, Art, remember their father as having humble tastes and enjoying his wife's good home cooking. He always insisted on fresh products and would often do the shopping. He would make the effort to visit specialty shops—the baker, butcher, dairy, fruit, and vegetable market or farmer's market—to get simple but delicious foods. One of Burchfield's journal entries, made March 13, 1941, illustrates his aesthetic observations of one of the markets in downtown Buffalo, New York: 'The market is a never-ending source of delight to me—the abstract beauty of food! At the cured meat and dairy stall—a huge sausage, dark mottled maroon tones, with white veins running over it—what a delightful 'prop' for a still life! I watched one of the men slicing bacon and placing it, as is the custom, in such a way that all the meaty edges show in succession—beautiful red and white stripes—then there are bins of beans—black, red, black-eyed, white, peas, lentils, etc.—I must get some to put under glass. They strike some forgotten impressions of my boyhood.'"

C. Arthur Burchfield, the artist's son, has provided the following recipe for apple dumplings from his mother, Bertha Burchfield; they were one of his father's favorite desserts.

(Top right) Charles Burchfield in his studio, c. 1950, collection of the Burchfield-Penney Art Center, Buffalo State College, Buffalo, New York.

Bertha's Apple Dumplings

Serves 12 | Adapted

6 firm Fuji or Gala apples, peeled, cored, and halved
1/2 cup (100 g) sugar mixed with
 1/2 teaspoon cinnamon
1 pie pastry, enough for a double-crust pie

For the Sauce:
2 cups (400 g) sugar
2 cups (470 ml) water
1/4 teaspoon cinnamon
1/4 teaspoon nutmeg
1/4 cup (50 g) butter

• Preheat the oven to 375°F (190°C). On a floured work surface, roll out 1/2 of the pastry dough to a thickness of 1/4–1/8-inches (.5 cm). Cut into 6 equal squares. Place half an apple, cut side down, on each square and sprinkle with cinnamon sugar mixture. Fold in corners and pinch edges, completely covering the apple. Repeat with the remaining dough and apple halves. Place 1 inch (2.5 cm) apart in a large, deep baking pan.

• Prepare sauce. Place first four sauce ingredients in a saucepan and bring to a boil. Cook for 5 minutes, then add butter. (Some people add apple peels to the sauce before cooking, to provide extra flavor and color. Strain the peels before pouring sauce over the apple dumplings.)

• Pour sauce over dumplings and bake at 375°F (190°C) for 35 minutes. Serve warm or cold.

Philip Pearlstein Banana Splits

In the 1960s, Philip Pearlstein was a key figure in the sharp-focus realist movement and a leader in the revival of figure painting, a traditional subject that had virtually disappeared from the contemporary art world. Here he describes his mother's unusual banana splits and divulges the recipe:

"My wife is an excellent cook. I am a can opener myself, or for more elaborate meals on my own, I can use the broiler on our stove for steaks. . . . But my really most favorite food is peanuts, in any form. A super-deluxe peanut butter spread that I made under my wife's direction has been added to one of my favorite snacks of childhood memory. My mother made what she called 'banana splits' by slicing a ripe, firm banana in half, lengthwise and spreading one half with peanut butter; then topping it was the other banana half, to make a sandwich. This new variation resulted from the acquisition of a Cuisinart machine."

Banana Splits

Serves 2–3

1 cup (150 g) shelled roasted peanuts
1/2 cup (75 g) sesame seeds
1/2 cup (120 ml) honey
2 bananas, sliced in half lengthwise

• Philip instructs: "Process in the Cuisinart, spread on sliced bananas, and you're in heaven and overweight!"

"Thank you for including my inane banana split recipe. . . .I'm not much of a cook, and certainly no one ever has asked me for a recipe before."

—Philip Pearlstein

(*Left*) Philip Pearlstein, c. 2000; courtesy Philip Pearlstein.

Jeff Koons Apple Raisin Dumplings

Jeff Koons is one of the most famous—and controversial—names in contemporary American art. He studied at the Maryland Institute College of Art, but worked as a Wall Street broker before pursuing an art career. Koons became an international art star in the 1980s for his Pop-influenced sculptures —inflatable toys cast in stainless-steel , basketballs suspended in water tanks, Plexiglas-encased vacuum cleaners—that both celebrate and satirize modern commercialism and kitsch. In a recent series of paintings, *Easyfun–Ethereal*, Koons merges media images—such as lips, eyelashes, donuts, and sandwiches—from fashion and food magazines into iconic, surreal collages.

> "I get probably more excited walking down the street and just looking at a window of a pharmacy store or a grocery . . . than I do probably from a general artistic experience, 'cause I just enjoy the world around me; it's so visual."

—Jeff Koons, from an interview on the *Egg Art Show,* 2002

(Below) Jeff Koons, *Niagara,* 2000, courtesy Deutsche Guggenheim, Berlin

(Right) Jeff Koons, c. 1996, courtesy Todd Eberle

Koons's administrative assistant, Maresa Von Rohrer, says that he "was brought up in York, Pennsylvania, in a rural area with a lot of Pennsylvania-Dutch influence. Often he would eat apple dumplings as a main course for dinner and he picked this recipe because his mother always cooked this favorite dish for him."

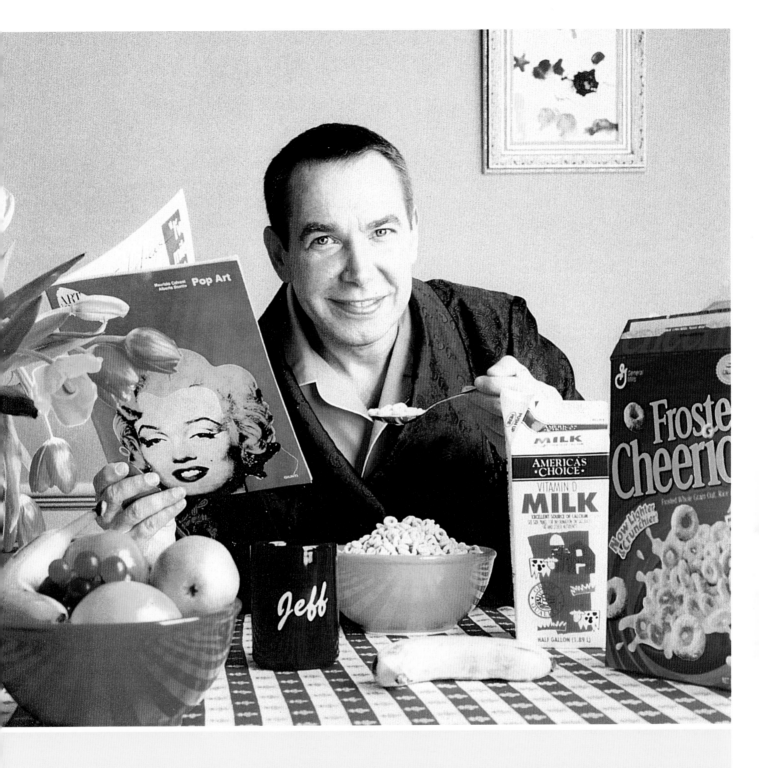

Apple Raisin Dumplings

Makes 6 dumplings

2 Jonagold or Golden Delicious apples,
 peeled, cored, and chopped

1 /4 cup (50 g) golden raisins

2 tablespoons sugar

1 tablespoon cornstarch

2 teaspoons lemon juice

1 teaspoon grated lemon zest

Pastry for two-crust (9-inch/25 cm) pie

1 large egg, beaten

1 tablespoon milk

• Heat oven to 400°F (200°C). In large bowl, combine apples, raisins, sugar, cornstarch, lemon juice, and lemon zest. Mix well and set aside.

• On lightly floured surface, roll out pastry to make six 5-inch (10 cm) rounds. Divide apple mixture evenly among rounds, mounding it in the centers. Moisten edges of pastry rounds lightly with water; fold over rounds to cover filling and meet opposite edges. Crimp edges of dumplings with fork to seal.

• Place dumplings on a lightly greased cookie sheet; cut slits in the top of each dumpling to vent steam. In small bowl, combine egg and milk, and using a pastry brush, brush mixture on top of the dumplings. Bake for 20–25 minutes or until golden. Cool before serving.

Mark Rothko Apple Pie

Abstract Expressionist Mark Rothko is best known for his powerful, deeply felt Color Field paintings, especially his soft-edged, luminous rectangles that seem to float weightlessly on the surface of the canvas. Christopher Rothko, the artist's son, shares his mother's recipe for his father's favorite "quintessentially American dessert," which was served to Rothko every year on his birthday:

"My father, who was otherwise known for eating almost anything with considerable gusto, apparently detested cake. So, every year . . . my mother would bake him an apple pie on his birthday. I'm not sure what we did for candles? . . . I find it striking that my immigrant father chose this quintessentially American dessert as his favorite. Perhaps doing so was an expression of his ready embrace of his adopted home. Then again, perhaps the apple pie brought back fond memories of the *yablekes* (apples) of his Russian, or more accurately, Latvian youth."

Birthday Apple Pie

Serves 8 | Adapted

For the Crust:
1/2 lb (225 g) butter (or margarine if you must)
2 cups (250 g) flour, plus more as needed
2 tablespoons sugar
1/8 teaspoons salt
1/4 cup (60 ml) cold water

For the Filling:
6 semisweet apples such as Fuji or Macintosh peeled, cored, and sliced thin
1/4 cup (25 g) raisins or currants
Grated rind and juice of 1 lemon
1 egg yolk, beaten
2 tablespoons finely chopped walnuts

• Combine the butter, flour, sugar, and salt in a food processor. Blend well, adding water slowly. When a ball of dough forms, split it in half, wrap each half in wax paper, and refrigerate 1 hour until firm.

• Combine apples, raisins or currants, lemon juice, and rind in a bowl. Mix well.

• Preheat oven to 350°F (175°C). On a lightly floured surface, roll out one ball of dough and press into a 10-inch (25-cm) pie plate. Fill with the apple filling. Roll out the second ball of dough and cover the pie. Use the tongs of a fork to seal the bottom and the top crust . Make several holes in the top of the crust with the fork. Using a pastry brush, brush the top of the pie with the beaten egg yolk and sprinkle with the nuts. Bake for 40–45 minutes, or until top is golden brown.

"Apple pie became a very seasonal family tradition on my father's September birthday."

—Christopher Rothko

(*Left*) Portrait of Mark Rothko in his studio, undated; courtesy Christopher Rothko

Ben Nicholson Brown Bread Ice Cream

Brown Bread Ice Cream

Makes 4 | Adapted

3 oz (75 g) (about 3 slices) whole wheat bread
1 1/2 cups (350 g) heavy cream
2 tablespoons super-fine sugar
1 tablespoon orange juice
1/2 cup (120 ml) clear honey

• Dry bread in an oven set at 200°F (95°C) for about 30 minutes. Crumble the dried bread in a food processor or with a rolling pin until fine. In a bowl, whisk together the cream, sugar, and orange juice until sugar is dissolved. Chill in the freezer for 30 minutes. Meanwhile, warm the honey and stir in the bread crumbs. Refrigerate until chilled. Fold the honey mixture into the cold cream. Pour into a freezer-safe container with a lid and freeze until firm.

Considered one of Great Britain's most innovative abstractionists, Ben Nicholson began his career as a landscape painter. After a period of experimention with wood reliefs in the early 1930s, he returned to landscape painting in the late 1930s, but continued to further develop his abstract reliefs. At about the same time, Nicholson met Piet Mondrian, whose Neo-Plastic style would influence his later work. In the next decade Nicholson turned from reliefs, once again, in order to focus on linear, abstract painting. An early advocate of public art, Nicholson painted many murals and wall reliefs, including one a mural commission for the London Time-Life Building, in 1952.

At right is an excerpt from a quote by Nicholson, where he listed what inspires him to paint. His favorite dish, Brown Bread Ice Cream, could be added to that list.

"Some of the things which have made me want to paint, outside of other paintings, are American wood and iron work of the past, Civil War and skyscraper architecture, the brilliant colors on gasoline stations, chainstore fronts, and taxicabs, the music of Bach . . . 5 & 10 kitchen utensils . . . "

—Ben Nicholson, from "Cube" Essay

(Top left) Ben Nicholson, *Abstract Painting,* 1945

Mary Cassatt Caramels au Chocolat

In 1874, the talented thirty-year-old American painter Mary Cassatt left Philadelphia to study art in Paris, where she was greatly influenced by the work of her new friend, Impressionist Edgar Degas. She often asked Degas to correct her artwork; although at times he would presumptuously correct paintings unasked, he greatly admired her work, once stating: "I will not admit a woman can draw like this"—and she went on to become the only American artist invited to exhibit with the Impressionists.

Cassatt and her family shared a house in Paris, where they lived a privileged life, enjoying good food and the best wines, and frequenting the finest restaurants. They also shared treasures sent by Cassatt's brother, Alexander, from America, as seen in this excerpt from a 1891 letter from her mother, Katherine, to Alexander, from *Cassatt and Her Circle: Selected Letters* (1984):

"My dear Aleck,
Though we have no letter from you we take it for granted that it is to you we are indebted for the good things we received yesterday evening and which we have been enjoying today. I think you would have laughed had you seen your father and Mary lunching on the oysters, which were excellent—they ate so many that they had to wait between the plates full. . . . Your father and Mary join me in thanking you for all those good things."

Cassatt also delighted in entertaining collectors and young students at her Paris home. Curried chicken was a specialty of chez Casatt, and a favorite of both Cassatt and Degas (although later in life she became a vegetarian due to complications from diabetes). Sadly, no written recipe exists for this dish. But Cassatt also had a sweet tooth for delicious chocolate desserts, and a recipe does exist for her *Caramels au Chocolat*, which was usually prepared by Mathilde Valet, her longtime housekeeper. Cassatt recommended "paying careful attention to the cooking because a successful outcome depends on it."
The recipe originally appeared in *Miss Mary Cassatt: Impressionist from Pennsylvania* (1966) and was translated from the French by Keelin McDonell.

(Top right) Mary Cassatt, *A Cup of Tea*, c. 1880

Caramels au Chocolat
(Chocolate Caramels)

Makes about 3 dozen candies | Adapted

1/2 cup (125 g) powdered sugar
5 tablespoons honey
6 tablespoons grated bittersweet or
 semi-sweet chocolate

3 tablespoons fresh unsalted butter

1 cup (240 ml) cream

• Put all the ingredients in a saucepan.

• Place the pan on a burner at medium, stirring until the ingredients are well blended. It is very important to stir the mixture the entire time it is heating since the success of the entire recipe depends upon bringing the ingredients to the proper temperature without burning them. Cook for 10 minutes, while stirring constantly, until mixture is very thick. Once all ingredients have blended together and the consistency of the mix has thickened, pour about a spoonful of the chocolate into a bowl of cold water. If the chocolate forms into little balls, it has reached its proper consistency and can be removed from the heat. Pour into candy molds, or pour into a 9-inch (23-cm) square grease pan, allow to cool, and cut into squares.

Note: If desired, add a little vanilla extract to the mixture while it is heating.

Alphonse Mucha Cokoladovna Bublanina

Although Alphonse Mucha was born in a small town in what is now the Czech Republic, it was in turn-of-the-20th-century Paris that he achieved recognition with his distinctive Art Nouveau style. Following his 1894 creation of *Gismonda,* a theater poster for the world-famous Parisian actress Sarah Bernhardt, Mucha quickly became a household name, sought after by every salon and lionized wherever he went. In his memoirs, Mucha describes his hectic life in Paris and shares his secret of how he found time to both work and eat:

"I had breakfast from a quarter to nine and at half-past-twelve I had a light lunch, consisting of a cup of tea and a slice of bread and butter, which enabled me to work right through till four o'clock, when I had my real lunch. In this way I made use of midday when no one interrupted me because everyone was eating. Then I could let them wait a little, which meant that I received visitors from half-past-five to half-past-six. After that supper; and by eight o'clock I was again at work until eleven, when I took some light refreshment and worked on as long as was necessary, usually until one or two. On most days I managed to keep to this routine. The worst problem was invitations to dinner. I solved it by going to them all at once. For instance, on Wednesday I went to five or six dinners, one after the other, staying at most half an hour at each. Even so, I was delayed in my work and had to make up the time at night. In the end, the only solution was to disappear to friends in the country and take my work with me."

Mucha's grandchildren, John and Sarah, asked their mother, Geraldine (daughter-in-law to the artist), for his favorite dessert. Mucha's French cook, Louise, adapted many of his favorite Czech recipes for him. This is a version of Bohemian Bubble Cake, made with chocolate instead of fruit.

Cokladovna Bublanina (Chocolate Bubble Cake)

Serves 6 | Adapted

6 tablespoons butter, plus more as needed
3/4 cup (175 g) sugar
3 eggs
1 cup (125 g) self-rising flour, plus more as needed
2 tablespoons cocoa powder
One 12-oz (350-g) package semisweet
 chocolate chips

• Preheat the oven to 350°F (175°C). Butter and flour a 9-inch- (23-cm-) square baking pan.

• In a large bowl with an electric mixer, cream the butter and sugar together until fluffy. Add the eggs, one at a time, mixing well after each addition. Slowly add the flour and cocoa powder, mixing until just combined. Pour the mixture into the prepared pan and spread it evenly with a spatula. Sprinkle the chocolate chips evenly over the surface. Bake for 25–30 minutes or until firm.

• Transfer the cake to a cooking rack and cool completely in the pan before cutting.

(Left) Alphonse Mucha in front of one of his famous posters for the Parisian actress Sarah Bernhardt, undated.

(Right) Alphonse Mucha, poster for *Cacao Schaal,* c. 1900; both courtesy Mucha Trust.

Charles Demuth Spice Cake

A pioneer of modernism who brought a highly polished, elegant touch to his art, whether he was painting flowers or industrial landscapes, Charles Demuth—"Deem," as good friends called him—was born in Lancaster, Pennsylvania, where he created most of his art. Plagued by illness all his life, Demuth nevertheless created over a thousand works of art, many of them inspired by the garden his mother tended, and which could be seen from his small, second-floor studio. Corinne Woodcock, Director of the Demuth Foundation, offers a fond account of the artist and his mother, Augusta, along with a recipe for Demuth's favorite cake from his mother's handwritten cookbook:

"For Charles Demuth (1883–1935), food played a unique role in sustaining his life. Diagnosed with diabetes in 1921, the disease demanded the persistent attention of his mother, Augusta. Her devotion to his care and perfectionism are evidenced by the accounts of several of Charles's friends. Fellow artist and friend Marsden Hartley pointed out Augusta's selectivity at the Mennonite market (a few blocks from the Demuth family home). He wrote: 'She bought this or that of her special Mennonite . . . and the greens were so precious looking they seemed more like corsages than edibles, and a basket of them would have set a chef of the Cordon Bleu to gloating with culinary glee. . . . ' In the midst of this rich domestic milieu Charles was reared, and when he was at home he liked it thoroughly, as when he was abroad he liked the usual variations of such character."

Augusta's Spice Cake

Serves 8–10 | Adapted

2 1/2 cups (300 g) all-purpose flour,
 plus more as needed
2 teaspoons cinnamon
1/2 teaspoon ground cloves
1/2 teaspoon ground nutmeg
2 teaspoons baking soda
10 tablespoons butter, softened,
 plus more as needed
2 cups (300 g) light brown sugar
2 large eggs at room temperature
1/2 cup (120 ml) buttermilk
1 cup (120 g) confectioner's sugar
3 tablespoons milk

• Preheat the oven to 350°F (175°C). Butter and flour two 9-inch (25-cm) cake pans or one jelly roll pan and set aside. In a medium bowl, stir together the flour, cinnamon, cloves, nutmeg, and baking soda until well combined.

• In the bowl of a standing mixer or with a handheld mixer, cream the butter and light brown sugar together until light and fluffy. Add the eggs, one at a time, mixing well between each addition. Add the flour mixture and buttermilk alternately, mixing well between each addition.

• Pour the batter into the prepared pans, smooth with a spatula, and bake 35–40 minutes or until a toothpick inserted in the center of the cake comes out clean.

• Cool the cakes in the pans on a rack for 10 minutes, then invert and cool completely.

• For the icing, whisk the confectioner's sugar and milk together until fluffy. When the cake is cool, glaze each cake with the icing and layer on a serving plate.

(*Left*) Charles Demuth, *Pink Tulips*, c. 1930

(*Right*) Charles Demuth, *Self-Portrait*, 1907; both collection of the Demuth Foundation, Lancaster, Pennsylvania

Norman Rockwell & Grandma Moses

I have joined two famous storytellers, Grandma Moses and Norman Rockwell, because they were good friends, and both artists created iconic images of pure, old-fashioned Americana, rendered with loving attention to detail. In order to find out more about Rockwell, the peerless illustrator, I contacted expert Linda Pero, curator of collections at the Norman Rockwell Museum, in Stockbridge, Massachusetts. She sent in a recipe for oatmeal cookies (which will fill your kitchen with a scent evocative of simpler times) and this essay on Rockwell's diet and the importance of food in his art:

"Norman Rockwell was an admitted dessert lover. This oatmeal cookie recipe, one of Rockwell's favorites, was created by Nellie Strodulski, who cooked for the Rockwell family from the mid-1950s to the mid-1960s. Baked thin and delicate, they were perfect for crumbling over ice cream, as Rockwell often chose to eat them. Rockwell's daily routine included a bottle of Coca-Cola midmorning and one in the afternoon. This no doubt helped to fuel his terrific artistic output of almost 4,000 works. Despite a regimen of what he called 'three squares a day' and his calorie-rich soda breaks, Rockwell remained thin throughout his life. His culinary choices were simple and quintessentially American. He was a self-described meat-and-potatoes man. In 1948, the *Sunday Boston Globe* quoted Rockwell as saying, 'Plenty of meat and potatoes, plus a tip-top dessert is my idea of fodder.'

"Rockwell's most famous painting involving food, *Freedom from Want,* was painted in 1943 after he heard Franklin Delano Roosevelt's State of the Union address on the freedoms America was fighting to preserve. It expressed for Rockwell not just the absence of hunger, but rather an ideal of a satisfying life—an American Thanksgiving dinner. Though ridiculed by Europeans at the time for its portrayal of overabundance, with the implication that Americans were unable to empathize with deprivation, the painting of the turkey dinner may not challenge today's viewers to see a discrepancy between its menu and our basic necessities. In moments of interview witticism, Rockwell often cited this painting as the one with the model he painted and then ate.

"*Freedom from Want, Saying Grace, The Soda Jerk, The Runaway, After the Prom,* and *Boy in a Dining Car* are a few of Rockwell's well-known images set in restaurants or dining rooms. The rituals and the physical and social ambiance associated with food cannot be discounted as a vehicle for the artist's ideas about the human condition. Rites of passage, such as a boy's first fight for independence suggested in *The Runaway*

Norman Rockwell's Oatmeal Cookies

Makes 3 dozen | Adapted

1 1/2 cups (175 g) all-purpose flour
1 teaspoon salt
1 teaspoon baking soda
10 tablespoons butter
1 cup (150 g) light brown sugar
1/2 cup (100 g) granulated sugar
1 teaspoon vanilla extract
2 large eggs, at room temperature
1 cup (80 g) quick-cooking oatmeal

• Preheat the oven to 375°F (190°C). Line a baking sheet with parchment paper and set aside. In a bowl, sift together the flour, salt, and baking soda.

• Cream the butter and sugar together until light and fluffy. Add the eggs, one by one; beat well after each addition. Add dry ingredients and mix until well combined. Stir in the oatmeal. ▷

(Above) Normal Rockwell oatmeal cookie recipe, sent to a Miss Bauer in 1966, courtesy Norman Rockwell Museum.

(Far right) Grandma Moses and Norman Rockwell cut a cake for her 88th birthday; originally printed in *McCall's,* October 1949. Courtesy Grandma Moses Properties Co., New York, and the Norman Rockwell Museum.

or the young couple discovering their political differences in *Breakfast Table Argument* and teenagers cooing over each other and a frothy soda-fountain drink in *The Soda Jerk,* were all framed in settings that relate to eating—at once a very personal and universal activity. Often a subject of Rockwell's famous *Post* covers, food was not always a source of comfort in his own life. During his adolescence and early childhood, Rockwell's family lived in a succession of boardinghouses and neighborhoods just north of New York City, where he was born and raised. Taking their meals around a communal table, young Norman experienced firsthand some of the eccentric personality types that he would one day, therapeutically and cathartically, work into his magazine covers. A nuclear family surrounding a dinner table rarely appears in Rockwell's artwork.

"In 1977 . . . *Lifestyle Magazine* gained access to several celebrity refrigerators, including those of Dave Brubeck, Howard Cosell, and Norman Rockwell. An inspection of Rockwell's refrigerator revealed: margarine, roast beef, sherry, a quarter of a cherry pie, cracked wheat bread, cinnamon buns, cinnamon twist, brown sugar, lettuce, carrots, zucchini, eggplant, milk, club soda, Coca-Cola, eggs, Dolly Madison French vanilla ice cream, croissants, asparagus, a half-gallon of Vermont maple syrup, two jars of strawberry topping, Spanish olives, stewed prunes, quince jelly, grated Parmesan cheese, Crisco, half a soufflé, a crock of cheddar cheese, and camera film."

"She's a white haired girl of the U.S.A. who turned from her strawberry patch to painting the American scene at the wonderful age of 80."

—Gimble's Department Store, 1940, for a Thanksgiving Grandma Moses art show

The "Grandmother of American Folk Art" was a farmer's widow whose full name was Anna Mary Robertson Moses. She was born in 1860, painted the world around her with love and sweetness, and lived to the ripe old age of 101. The simplicity of her tapestrylike renderings of the countryside— farms, fields, and sleigh rides—display how America once was seen. Her unfettered outlook on life can be summed up by her statement that "Life is what we make it, always has been, always will be." This recipe for one of Grandma Moses's favorite desserts was obtained from her family.

• Drop by rounded teaspoonfuls onto the baking sheet. Bake for 8–10 minutes or until golden. Allow the cookies to cool on the pan for 5 minutes, then transfer to a rack.

Grandma Moses's Old-fashioned Macaroons

Makes 6 dozen | Adapted

1 lb (450 g) blanched almonds
9 egg whites
1 cup (200 g) sugar
Nutmeg and mace to taste

• Preheat the oven to 250°F (120°C). Line 2 baking sheets with parchment.

• Grind the almonds in a food processor until fine; set aside. In a large bowl, beat the egg whites with an electric mixer until frothy. Gradually add the sugar in a slow stream while beating. Increase the mixer speed to high and beat until the whites hold a firm peak. Gently fold in the almonds and spices. Drop by rounded teaspoonfuls onto the lined baking sheets. Bake for 1 hour or until golden. Store in an airtight container.

Hans Richter Crème Caramel

Painter, sculptor, and filmmaker, Hans Richter, was born in Berlin in 1888. His pioneering abstract films—created with cinematographer Sergey Eisenstein and Constructivist artist Kasimir Malevich, both from Russia—are considered rare cinematic masterpieces today. This great Dadaist, along with his friends and colleagues Marcel Duchamp, Max Ernst, Kurt Schwitters, Jean Cocteau, Naum Gabo, and Hugo Ball of the Cabaret Voltaire, helped to form modern art as we know it today. The director of the Hans Richter Archives in Germany, Marion Hofacker, tests her memory about Richter's favorite dessert at the famous Posta Restaurant in Locarno, Switzerland:

" I've tried to muster up memories of Hans Richter's favorite food. What remains vivid was his love of frequenting the local Posta Restaurant in Locarno at noon, where a table was permanently reserved for him. The walls were hung with pictures of the artists' colony living nearby: Ben Nicholson, Hans Arp, Remo Rossi, and Richter, to name a few. Richter most often ordered the specialty of the house, a piece of tender veal, topped with a sage leaf, fried in butter. As a starter there would be some sort of freshly made pasta (this is the Italian part of Switzerland), and dessert was always his favorite caramel pudding (I think there is a fancier name for it, maybe crème caramel?"

The Posta Restaurant is still in business, and still creating the artist's favorite dessert, just as they did 30 years ago. Here is their recipe:

Crème Caramel

Makes 10 custards | Adapted

2 cups (400 g) sugar
2 tablespoons water
1 quart (1 l) milk
1 vanilla bean, split lengthwise
8 eggs

• Preheat the oven to 325°F (160°C).

• Put 1 cup (200 g) of the sugar and water into a medium saucepan and place over medium high heat. Cook, without stirring, until sugar is golden brown, about 7 minutes. Pour about 2 tablespoons of the caramel into each of ten 6-oz (170 g) ramekins, swirling the ramekin to completely coat the bottom.

• Heat the milk and vanilla in a saucepan over medium heat until boiling. In a large bowl, whisk together the eggs and remaining sugar until smooth. Pour about 1 cup (225 ml) of the boiling milk, while whisking, into the eggs until combined. Whisk in the remaining milk. Strain the mixture, then divide among the ramekins.

• Put the ramekins into a very large roasting pan. Pour hot water into the pan until it reaches half-way up the sides of the ramekins.

• Bake for 45–50 minutes, or until just set. Allow to cool completely at room temperature, then refrigerate until cold. To serve, run a knife around the edge of the ramekins to loosen the custard, then invert onto dinner plates.

(Top left) Hans Richter at an exhibition in Zurich, 1959; courtesy Hans Richter Archives

Larry Rivers Mrs. Delicious's Rugelach

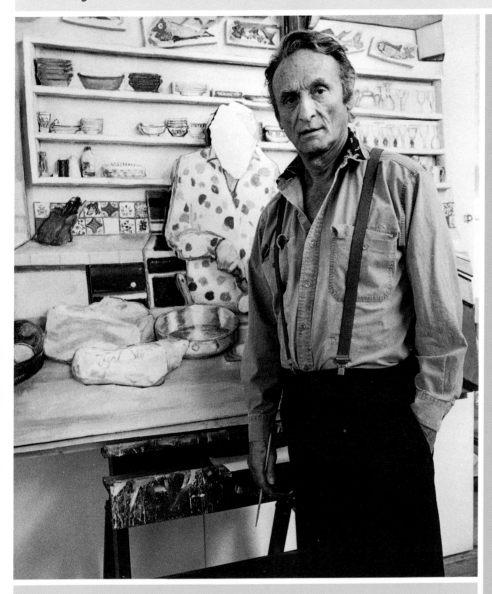

Mrs. Delicious's Rugelach

Makes 3–4 dozen cookies

16 tablespoons sweet butter, softened
1 cup (225 g) cream cheese softened
2 cups (250) all-purpose flour, sifted
Raspberry or apricot jam
1 teaspoon cinnamon
1/2 cup (60 g) walnuts finely chopped
1 2/3 cups (250 g) dark raisins
1/3 cup (70 g) sugar

• Mix together butter, cream cheese, and flour. Divide into 4 balls and wrap in aluminum foil. Refrigerate for at least 6 hours. Roll out each ball to 1/4 inch (6 mm) thick, until it is about 10 inches (25 cm) in diameter or more. Cut each circle into 10–12 wedges. Spread wedges thinly with jam. Mix cinnamon, sugar, raisins, and walnuts together. Spread over jam on each wedge. Roll gently from wide part to point of wedge. Place on lightly buttered and floured cookie sheet. Sprinkle any remaining sugar and cinnamon on top. Bake at 375°F (190°C) for 30 minutes or until golden brown.

A major figure in contemporary American art, Larry Rivers was born Yitroch Loiza Grossberg in the Bronx. His Ukranian, Jewish parents, as with many immigrants, believed that studying music was necessary, so at age 7 he began piano lessons. At 18 his name was Americanized to Irving, he took up the sax, and started performing with a small jazz combo at clubs. One night, an emcee improvised the group's introduction, calling them "Larry Rivers and the Mudcats," a name he decided to adopt for life. In 1945, Rivers joined the Hans Hoffman Art School in New York. His prolific artistic explorations have always seemed accompanied by the jazz riffs of Miles Davis or Charlie Byrd, a marriage of music and art that has left an indelible mark on the world. Larry loved the ethnic comfort food of his childhood; "Mrs. Delicious" was an affectionate nickname for his mother.

"I thought of a picture as a surface the eye travels over in order to find delicacies to munch on; sated, it moves onto the next part, in whatever order it wishes. A smorgasbord of recognizable, and if being the chef is no particular thrill. It was as much as I could cook up."

—Larry Rivers, *Art News*, March 1961

(Top left) Larry Rivers in his studio, undated

Grant Wood Strawberry Shortcake

With Thomas Hart Benton and John Stuart Curry, Grant Wood represented the painters of "The American Scene," also known as the school of Regional American Landscape. Wood was an ardent promoter of homespun American values, whose iconic images of lush, midwestern vistas and humble small-town folk made him famous during the Depression. Wood's *American Gothic*, which was first displayed in 1930, is considered one of the most recognizable and best-loved images in the world. Nan Wood Graham, the artist's sister, and Wood's dentist, Dr. Bryon McKeeby, were the models for the famous couple in the painting, who the artist portrayed as a farmer and his unmarried daughter. Here Nan gives an account of Grant's cooking, and divulges his "out of this world" strawberry shortcake.

"On occasion he would go into the kitchen and show his prowess at cooking. In no time at all, he could turn out the best potato salad I have ever tasted. He was also noted for his strawberry shortcake. Once when mother and I were away, and unexpected company arrived, Grant rose to the occasion, and whipped up a strawberry shortcake that the guests described as 'out of this world.'

Strawberry Shortcake

Serves 4–6

4 quarts (2.3kg) fresh ripe strawberries, washed and hulled
1/2–1 cup (100–200 g) sugar
Butter (approximately 1/3 stick, softened)
Heavy, rich cream (see Note)

For the Biscuit Dough:
2 cups (250 g) sifted flour
3 teaspoons baking powder
1 teaspoon salt
6 tablespoons shortening
1/4 cup (60 ml) milk

• Place strawberries in a bowl and bruise and chop with a silver spoon. Cover with sugar to suit (1/2–1 cup/100–200 g) and let stand at room temperature to bring out juice.

Preparing the Biscuit Dough
• Sift dry ingredients together, cut in shortening. Add milk and mix lightly, the less the better. Spread out in a greased pie tin. Bake in hot oven, 425°F (220°C) until done (12–20 minutes). Carefully break biscuit into two layers, using a fork to separate it. Lay top layer to one side (remove with a pancake turner if necessary). Add strawberries to bottom layer. Butter the top layer and put back over the strawberries. Cut into huge slices and serve with lots of rich country cream.

Note: You can substitute heavy cream, crème frâiche, or whipped cream.

In telling mother and me about it, Grant said in a surprised tone of voice, 'We could actually eat it!' After hearing it described as 'out of this world' Grant never dared to try making the shortcake again for fear of ruining his reputation as a cook."

"We could actually eat it!"

—Grant Wood

In the process of obtaining this recipe, author and good friend of the Wood family, Joan Liffring-Zug, remarked: "After completing the book *This Is Grant Wood Country* in 1978, Grant Wood appeared to me in a cloud of steam, as I was taking a hot bath. 'Preserve my strawberry shortcake,' he said, and I did!" One year later, in 1979, the recipe was published in *The American Gothic Cookbook*.

(Top left) Nan Wood Graham and Dr. Bryon McKeeby in front of a portrait of Grant Wood's *American Gothic,*

(Far top left) Grant Wood in Paris, 1920

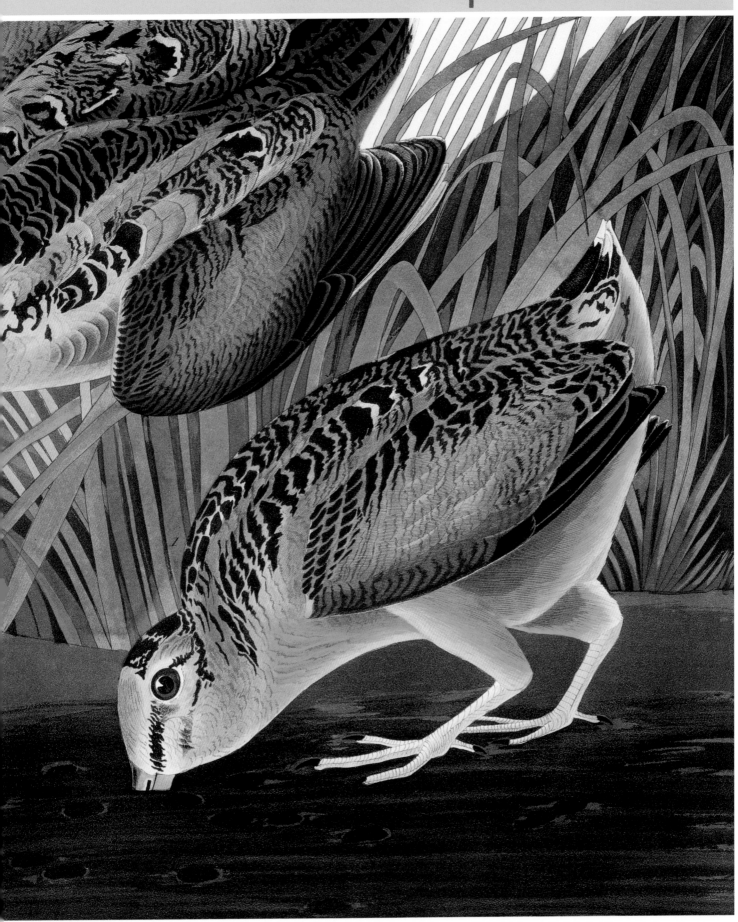

Edward Hopper supported himself as a commercial illustrator until he was recognized in the mid-1920s as the central exponent of American Scene Painting. Hopper's paintings are marked by his mysterious yet precise depiction of the solitude inherent in interiors, the open countryside, urban landscapes, and human relationships.

The Frank Rehn Gallery in New York discovered Hopper in 1924, and was his exclusive dealer for his entire career. Peter Ornstein, who spent 17 years as codirector of the Frank Rehn Gallery, recollects a surprise lunch he shared with Edward and Jo Hopper:

"It was in 1964 or 1965 that John Clancy, Director of the Frank Rehn Gallery, sent me on a special errand. Apparently, a thief managed to cut Edward Hopper's wallet out of his back pocket, as he rode the Fifth Avenue bus. Among the items lost was a check from the gallery in the amount of $15,000.00. I was sent to his home to deliver its replacement.

"I arrived at his home on Washington Square North. The stone building was picturesque, marred only by its lack of elevators. The Hoppers, naturally, lived on the top floor. I was greeted at the door by Jo Hopper. Her greeting segued immediately into a cheery monologue, which I struggled to follow as she led me through their main room. I nodded as she spoke, trying to gather the full effect of this room. The floor and walls of this room were covered with Jo's paintings—some framed and hanging, some leaning in convenient corners, some lying flat or nearly so. I gathered that this room served as a living room and as Jo Hopper's showing room. But, as she led me through the doorway to the next room, I felt as if I were passing into a different world. This space, also bright, was still and simple. The room held little: an etching press, a print cabinet, an easel with a cloth covering a canvas, and also a tall man, slightly stooped. I was standing with Edward Hopper in his studio.

"Mr. Hopper greeted me cordially. Our transaction went quickly; the task was too simple to drag out, and he was not a man to be drawn out. The sheer quiet about the man precluded any thoughts of small talk. I quickly suppressed my desire to ask about the canvas under the cloth (which I later learned was *The Comedians*, his last complete painting).

My Lunch with Edward Hopper

Serves 2

1 can Campbell's tomato soup
1 can water
1 sleeve Nabisco saltine crackers
2 cups fresh brewed Sanka coffee

• Open can of tomato soup, place in pot. Add 1 can of water, cook slowly over low heat until hot. Serve in a bowl with a fan of crackers on the side plate, accompanied by a hot cup of Sanka coffee.

(Above) Edward Hopper, undated

(Opposite) Edward Hopper, *Nighthawks,* 1942

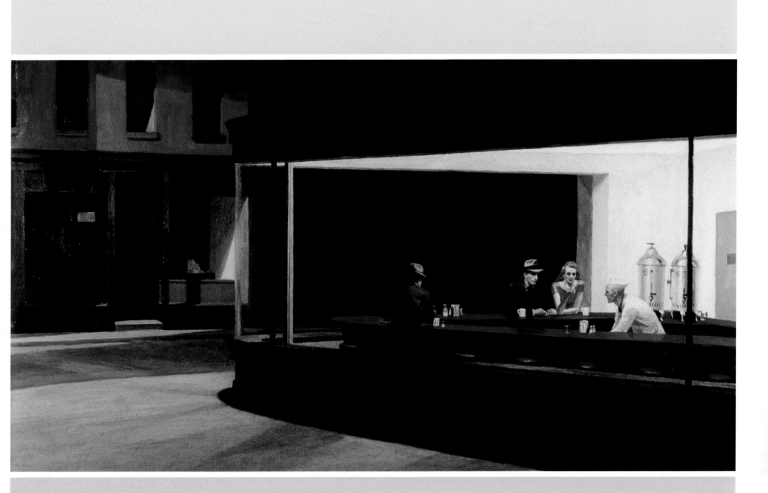

"It was a meal straight out of the *Nighthawks*: Campbell's tomato soup, Nabisco crackers, and coffee. "

—Peter Ornstein

"My delivery done, they showed me back to the main room—the wife talking with vigor, the husband silent. It appeared that my encounter with the Hoppers was ending. But, just as I was about to take my leave of them, Jo asked me if I would like to join them for lunch. I accepted the invitation quickly (lest they think better of it); the food came nearly as fast. It was a meal straight out of the *Nighthawks:* Campbell's tomato soup, Nabisco crackers, and coffee. I couldn't have known at the time, but the Hoppers were not gourmands; Mrs. Hopper didn't cook, and Mr. Hopper didn't care. I couldn't have cared less myself, seated at their table. That meal will remain in my memory—vivid as any four-star meal I've ever eaten—because I shared it with an American legend and his gracious and gifted wife."

The Swiss artist Paul Klee was born to musically gifted parents in Münchenbuchsee, Germany, near Bern, Switzerland. Klee also loved music, but instead pursued the study of art at the Munich Academy; from 1920–31 he taught at the famed German art school, the Bauhaus. An inspiration to Surrealists, Abstract Expressionists, and Expressionists, Klee's paintings and drawings encompass elements of all of these, but express one of the most original visions of the 20th century. Abstract geometric shapes and figurative imagery, color and line, were all mastered by Klee and transformed into dreamlike, witty, and fantastical creations.

I was intrigued to learn that Klee was an avid diarist, daily inscribing in a *taschenkalender* (pocket diary) his reflections on the many concerts, galas, and other events he often attended; his thoughts on the art world; and detailed notes of what he ate. Heidi Frautschi, director of Rights and Reproduction at the Paul-Klee-Stiftung Kunstmuseum Bern, graciously went into the archives to photograph several of Klee's 1935 diary pages, which are reproduced here for the first time. There was not a day noted in his diary that does not list his meals and their preparation. The menu reproduced here is a selection of those dishes that Klee wrote about most often. Klee liked fresh fruit for dessert, and usually concluded with "the inevitable Turkish," or coffee. The richer, the better.

Taschenkalender Menu

Sun-Whirl Salad

Bacon-Spiced Roast Beef with Burgundy Sauce

Gerstotto (a Dutch/German Version of Risotto)

Cauliflower with Gouda Cheese

Fresh Fruit

(Above) Paul Klee, c. 1930

(Top left) Opening page for Paul Klee's 1935 diary

(Opposite) The double-page entry for Paul Klee's 1935 diary, dated January 10 and 11, lists the dishes that Klee ate on those days, in addition to the ingredients and several recipes. Included on the left page is a recipe for goulash, made with tomato purée, red wine, and "small amounts" of "finely chopped" onion, garlic, celery, leeks, and apple, all accompanied by a cauliflower salad. Klee noted at bottom "this time no marjoram." Diary pages collection of Paul Klee Family Estate, deposited at the Paul Klee Foundation, Museum of Fine Arts, Berne.

Sun-Whirl Salad

Serves 4

2 heads curly endive
2 heads radicchio
1 bunch fresh rosemary
1 bunch basil
A few sprigs thyme
A few bay leaves
Juice of 1/2 lemon
2 red bell peppers
1 pink or ruby red grapefruit, in segments

For the Vinaigrette:

2 tablespoons whole-grain mustard
2 tablespoons Dijon mustard
1 shallot, finely chopped
1 clove garlic, finely chopped
4 tablespoons red wine vinegar
3 tablespoons honey
Salt and pepper

• Break up endive and radicchio and mince all herbs. Slice red pepper in thin lengthwise strips. Arrange salad [lettuces and herbs] on plates with red pepper slices and grapefruit segments fanned out on top. Sprinkle with vinaigrette [and lemon juice].

Gerstotto

Serves 4–6 | Adapted

1 cup (175 g) dried barley or other grain
4 tablespoons butter
1 medium onion, diced
2 cloves garlic, minced
2 stalks celery, diced
3 cups (700 ml) water, boiling
1 teaspoon salt
1/2 cup (50 g) grated Parmesan

• Rinse the barley in a strainer and drain. Melt the butter in a large saucepan over medium heat. Add the onion, garlic, and celery and cook until soft, about 10 minutes. Add the barley and cook for 10 minutes more, stirring constantly. (If needed, add 2–3 tablespoons of water to keep from scorching.) Add the boiling water and salt, cover, and reduce heat to medium low. Cook until all of the water is absorbed, about 35–40 minutes. Remove from heat, stir in the cheese, and serve.

Bacon-Spiced Roast Beef with Burgandy Sauce

Serves 6 | Adapted

2–3 lb (900–1350 kg) beef shoulder
1 lb (450 g) thickly sliced pancetta
4 cloves garlic, chopped
12 black peppercorns
1 quart (950 ml) red wine
Salt and pepper, to taste
2 cups (475 ml) beef stock
1 teaspoon tomato purée
7 tablespoons butter
4 tablespoons flour
Freshly grated horseradish

• Deeply score the beef and press slices of pancetta into the openings. Place in a bowl or heavy plastic bag and pour the garlic, peppercorns, and wine over it. Marinate, refrigerated, for at least 12 hours.

• Preheat the oven to 325°F (160°C). Remove the meat from the marinade, and strain the marinade into a large saucepan and reserve. Season the meat generously with salt and pepper, place on a rack in a roasting pan, and roast in the center of the oven for 1 1/2–2 hours or until desired temperature.

• Add the beef stock and tomato purée to the reserved marinade and bring to a boil over medium-high heat. Continue cooking until reduced by half, about 10 minutes. In a bowl, mash the butter and flour together into a paste. Whisk pieces of the butter-flour paste into the simmering sauce until dissolved and sauce thickens.

• Serve the meat sliced with the gravy and fresh horseradish.

Cauliflower with Gouda Cheese

Serves 6 | Adapted

3 tablespoons olive oil
1 head cauliflower
Grated Gouda cheese [to taste]

• Heat the olive oil in a non-stick skillet over medium-high heat. Break up the cauliflower into florets, add to the skillet, and stir-fry until slightly tender. Add 1 cup (225 ml) water and steam for an additional 7–8 minutes. Transfer to a baking dish and cover with grated Gouda cheese. Bake for 20 minutes at 325°F (160°C), watching to see that cheese does not burn.

James Rosenquist Three Meals and a Bottle of Wine

The Pop Art master James Rosenquist began his career as an industrial sign painter, creating enormous illustrated billboards for Times Square in New York. Today his paintings are represented and prized in every major museum and important collection in the world. I first asked him for a recipe in 1996, but he always seemed to be busy with one project or another. In 2002 I received a letter from the artist containing not one, but three recipes, and inside information on his private, limited edition of Blinkity Blank d'Blanc white wine.

"You've asked me for years for recipes for your cookbook. I am not a chef but I like to eat and I like to cook and I've always been interested in hand-me-down recipes and things that never came out of a cookbook.

"My father, Louis, was born in 1908. He told me as a farm boy in the 1920s that a chef ran away from a railroad gang in Minnesota and they asked him to cook for the workers in a cook car. One of these early recipes was to brown a large center-cut ham in butter, peel the potatoes and halve them, brown them, and put them on the top of the ham and cover the whole thing in milk. Put it in the oven for 20 or 30 minutes. The ham flavors the potatoes and it's a delicious simple dish.

Ham and Potatoes

Serves 4 | Adapted

Two 1-lb (450-g) center-cut ham steaks
2 tablespoons butter, plus more as needed
2 large russet potatoes, peeled, halved, and sliced
5–6 cups (1.3 l) milk at room temperature

• Preheat the oven to 375°F (200°C).

• Melt the butter in a large skillet over medium heat. Cook the ham steaks until browned, turning once, about 5 minutes per side. Transfer the ham to a deep, large baking dish. Add the potatoes to the skillet, and more butter if necessary, and cook until brown, stirring frequently to prevent burning, about 10 minutes. Add to ham in the baking dish.

• Pour enough milk into the dish to cover completely and bake until potatoes are cooked through, about 30 minutes.

Pasta Fish Sauce

Serves 4 | Adapted

8 tablespoons (1 stick) butter
1 tablespoon dried thyme
1 large onion, chopped
3 tomatoes, chopped
2 cups (475 ml) dry white wine
8 oz (225 g) grouper filet, cubed (or any other
 firm white fish)
8 oz (225 g) sea or bay scallops
8 oz (225 g) crab meat
Salt and pepper to taste

• Melt the butter in a large saucepan over medium-high heat. Add the thyme and onion and cook until softened, about 5 minutes. Add the tomatoes and wine and simmer until wine is reduced by half and sauce is thickened, about 20 minutes. Season with salt and pepper and add the fish. Reduce the heat to medium and simmer until fish is cooked through, about 5 minutes.

Serve over cooked spaghetti or fusilli.

"Last night, for an Italian photographer, Gian Franco Gorgoni, I made a pasta fish sauce. In a large frying pan you put 1/4 pound of butter, about a tablespoon of dried thyme, add one large chopped onion and about 1/2 pound of grouper, 1/2 pound of scallops (either sea or bay), and 1/2 pound of crab meat. Sauté and add three chopped tomatoes and about two or three cups of white wine. Cook until tasty. This is the sauce for spaghetti or fusilli. No garlic is added. If you remember Sweets Restaurant (the fish restaurant) on South Street in NYC, you'll remember it said, 'We serve no garlic.'

> "I crushed the grapes, fermented the grape juice in a barrel for seven days, and put it in a nice oak barrel for six months. On the waning of the moon I tasted it and much to my amazement, it tasted like wine."
>
> —James Rosenquist

"My first and most influential teacher, Cameron Booth, was a WWI veteran who was always '10 years older than the year.' He had a recipe that came from Europe. He was always afraid of gastrointestinal problems because he was gassed in WWI. So he always ate on time and very well. The recipe is to brown six lamb chops, put three of them on the bottom of a deep casserole dish. Peel and slice one large eggplant, soak in salt water for a few minutes, dip in egg batter, and then dip in Italian bread crumbs and deep fry. On top of the lamb chops put slices of onion tomato, green pepper. On top of that, slices of eggplant again, and three lamb chops, sliced onion, tomato, and green pepper on top of that, more eggplant, salt pepper each layer. Add a cup of water. On the very top you could add some grated Parmesan cheese. Put in oven at 400°F for about 30 minutes. It goes good with homemade wine.

"I made wine three years in a row with Ed Giobbi. The grapes came from California to Prospero Wine Distributors in Pleasantville, New York. I crushed the grapes, fermented the grape juice in a barrel for seven days, and put it in a nice oak barrel for six months. On the waning of the moon I tasted it and much to my amazement, it tasted like wine. Eddie and I took the wine out, washed out the barrel, and put the wine back in. Three months later I bottled it and Eureka! I had a nice petit syrah. Next year with beginner's luck, I had a not bad cabernet sauvignon. The last year I got to Prospero too late and didn't get good white grapes because of the increasing demand in winemaking. I now have 100 bottles of terrible white wine. I call it, 'Blinkity Blank d' Blanc.'"

Lamb and Eggplant Casserole

Serves 2–3 | Adapted

1 large eggplant
Salt and pepper, to taste
2 eggs, beaten
1 cup (100 g) Italian-style bread crumbs
Extra virgin olive oil, for frying
6 lamb chops
1 small onion, thinly sliced
2 medium tomatoes, thinly sliced
1 large green pepper, thinly sliced and
 seeds removed
Grated Parmesan cheese, optional

• Preheat the oven to 400°F (200°C).

• Peel the eggplant and cut into 1/4-inch-thick (.5-cm) slices. Immerse the eggplant in a large bowl of heavily salted water and soak for 10–15 minutes. Drain and blot dry. Put the eggs in a shallow plate and the bread crumbs in another. Dip each eggplant slice in egg, then in bread crumbs to coat. Pour olive oil into a heavy-bottomed skillet to a depth of one inch and heat over medium-high heat. Fry the eggplant until golden, turning once, about 1–2 minutes per side. Transfer to a paper towel-lined plate to drain.

• In a heavy skillet, heat about 2 tablespoons of the oil that the eggplant was fried in over high heat. Season the lamb chops on both sides with salt and pepper. Sear the lamb chops on both sides until browned.

• Lay the lamb chops in the bottom of a small baking dish. Cover the chops with the onions, then tomato slices, then green peppers. Season with salt and pepper and Parmesan, if using, as you go. Finally, top the casserole with the fried eggplant slices and sprinkle with Parmesan.

• Bake for 30–35 minutes, until lamb is cooked through and vegetables are cooked.

Note: Serve all meals with homemade or store-bought wine.

pani dua

un bochal di vino

una aringa

tortegli

una salata

quattro pani

un bochal di tondo

un quartuccio di bruscho

un piattello di spinaci

quattro a la c...

tortelli

sei pani

dua minestre di finochio

una aringa

un bochal di tondo

Michelangelo Grocery List
re-created by Master **Chef Mario Batali**

A painter, sculptor, architect, and poet, Michelangelo Buonarroti had one of the most astounding creative minds in the history of art and, with Leonardo da Vinci, was the greatest artistic force during the Italian Renaissance and a lasting influence on Western art. Although he was born in the small town of Caprese and spent much of his adult life in Rome—where he worked on the Sistine Chapel and other papal projects—he considered the city of Florence as his true home.

The Life of Michelangelo is a biographical account of the master's life, written in 1553 by Asconia Condivi, Michelangelo's student, assistant, and close confidante. Condivi's book tells intimate stories about Michelangelo, including his dedication and total surrender to his art, and his lack of interest in self-comfort. Michelangelo lived piously, sleeping in his clothes, eating little. The piece of bread mentioned in the below excerpt would occasionally be graced with slices of raw onions and a glass of red wine.

"He was very frugal in his lifestyle, eating more out of necessity than enjoyment, especially when working, and at these times he has been happy with a piece of bread, eating it while working. . . . and just as he has eaten little food, so he has slept little. According to him, sleep gives him a headache, and too much sleep gives him indigestion. When he was stronger, he often slept with all his clothes on and his breeches on his leg, which he wears for cramp, which has always bothered him. Sometimes, he has left his breeches on so long that when he removed them, the skin has come off too like a snake."

Even when he wrote to his brother, Lionardo, of his appreciation for a gift of cheese, Michelangelo's eye focused more on their sculptural forms: "I received twelve little cheeses some days ago and not only were they delicious, but good to look at. I thank you for them." Although Michelangelo did not eat a lot, he did need sustenance for his Herculean creative sessions, and kept meticulous track of his food expenses. The "expense report" reproduced here, both a treasure and an insightful look into Michelangelo's daily life, was sent to me by documentary filmmaker Perry Wolff (Michelangelo, Restored, 1977). To interpret the ingredients on the list, I approached world-renowned chef Mario Batali, who has four restaurants in New York—Babbo, Lupa, Esca, and Otto— ▷

(Left) Michelangelo, *Three Different Lists of Foods Described with Ideograms,* 1518, collection Casa Buonarroti, Archivio Buonarroti, Florence

Three Different Lists of Foods Described with Ideograms

Michelangelo traced these three menus for three meals of varying size while he was quarrying marble in Pietrasanta, on the back of a letter sent to him on 18 March 1518 by Bernardo Nicolini: in other words, he used the first sheet of paper he could get his hands on, as was often his custom. The grocery list corresponds to a scrupulous intention to register the expenses and events of his day-to-day life; it offers proof of Michelangelo's frugal customs, pointed out and praised by his biographers. The note in this case might have been meant for the sculptor Pietro Urbano, an assistant of the artist: Michelangelo's administrative papers from this period, in fact, include notes in Pietro Urbano's handwriting regarding everyday expenses. On the other hand—and first to point this out was Tolnay when he published the sketches on this page—the power and confidence of the mark make these utilitarian notes a characteristic manifestation of the genius of a great artist.

—**Lucilla Bardeschi Ciulich**, *from* **Costanza ed evoluzione nella scrittura di Michelangelo,** *catalog of a 1989 exhibition at Casa Buonarroti, Florence*

Following are the items on Michelangelo's list, with translation by Dolores Holt:

Pani dua **(bread rolls with grapes)**
Un bochal d[i] vino **(one carafe of wine)**
Una aringa **(one herring)**
Tortegli **(tortelloni)**

Una 'nsalata **(one green salad)**
Quarto pani **(a selection of four breads)**
Un bochal di tondo **(one carafe of mellow wine)**
E un quartuccio di bruscho **(a quart of sour wine)**
Un piattello di spinaci **(small plate of spinach)**
Quarto alice **(four anchovies)**
Tortelli **(tortellini)**

Sei pani **(a selection of six breads)**
Due minestre di finochio **(two fennel soups)**
Una aringa **(one herring)**
Un bochal di tondo **(one carafe of mellow wine)**

Michelangelo Grocery List

re-created by **Chef Mario Batali**

Halibut in a Cool Summer Gazpacho, based on Michelangelo's Grocery List

Serves 4

Four 6-oz (175-g) halibut steaks
Salt and pepper
4 quarts (4 l) chicken stock
1 cup (230 ml) white wine
4 large ripe tomatoes, finely chopped
4 carrots, peeled and cut into chunks
2 bulbs fennel, trimmed, cored, and cut into chunks
2 onions, cored and cut into chunks
4 slices peasant bread, cut into 1-inch
 (2.5-cm) chunks
2 tablespoons plus 4 tablespoons extra
 virgin olive oil
1 yellow squash, cut into julienne strips
1 zucchini, cut into julienne strips
1 yellow bell pepper, cut into julienne strips
1 red pepper, cut into julienne strips

• Season fish with salt and pepper. In a fish poacher or pan with high sides, combine chicken stock and wine, bring to a simmer, and add fish. Poach steaks 20 minutes, until cooked through. Remove from liquid and set aside.

• Line a large strainer with cheesecloth or a coffee filter and place over a large bowl. In a separate bowl, toss tomatoes and a few tablespoons of salt (1 tablespoon = 18 g) and place in strainer. Let sit 1 hour, stirring occasionally to facilitate draining.

• Run carrots, fennel, and onions through juicer and combine resultant juices with tomato water. Season with salt and pepper and set aside.

• Preheat oven to 450°F (230°C). Place bread cubes on a baking tray and toast in oven 5–10 minutes, until bread is golden brown.

• In large sauté pan, heat 2 tablespoons olive oil over high heat. Season poached fish with salt and pepper and sear on both sides 1 minute. Place 1 piece of fish in each of four shallow bowls. Divide bread cubes evenly among bowls, pour in the vegetable juices, drizzle 1 tablespoon olive oil over each piece of fish, and top with julienned vegetables. Serve immediately.

and hosts two programs on the Food Network: *Molto Mario* and *Mario Eats Italy*. His knowledge of the history and customs of regional Italian cooking is unsurpassed, and this dish is one that Michelangelo would have enjoyed not only looking at, but—during a break from work—eating, too.

> "I hardly have time to eat what I need to keep going; so I do not want anybody to bother me, for I just couldn't take it all."
>
> —Michelangelo, from a letter to his brother, Lionardo, during the painting of the Sistine Chapel

(Above) Michelangelo, *Bacchus,* 1700, Museo de Uffizi, Milan.

John James Audubon Perfect Meal

Don Boarman, curator of the John James Audubon Museum, kindly offered this fascinating profile on the renowned artist and ornithologist, whose *Birds of America* (1827–38) is an unsurpassed masterpiece of natural science.

"John James Audubon, (1785–1851), born in Haiti, raised in France, came to America at the age of 18 to operate a farm near Philadelphia that his father had purchased for investment. Since childhood, Audubon had a fascination with birds, and was obsessed with the desire to paint a picture of a bird that looked alive. After marrying Lucy Bakewell, who lived on a neighboring farm, the Audubons moved to Louisville and then to Henderson, Kentucky. As a result of the depression of 1819, they lost everything, and Audubon turned to his art as a way of making a living. He is best known for his monumental work, *The Birds of America,* four enormous volumes with 435 life-size, hand-colored illustrations. Accompanying these were five volumes of letterpress, containing Audubon's observations of the lives of the birds, and stories of the American Frontier.

> ## "Pies, puddings, eggs, milk, or cream was all I cared for in the way of food."
>
> —John James Audubon

"Audubon wrote much about food; in a great many of his descriptions of individual birds, he would advise the reader as to the food quality of the various species, from sparrows to eagles. In his ear, this was a valuable bit of information, when the local markets displayed the morning harvest of every form of wildlife for the buyer's lunch or dinner. Some of his advice was a little comment that 'the flesh of this bird has a strong, fishy taste' while with others, he became more detailed. In his description of the purple grackle, he tells us 'the flesh of the Purple Grackle is little ▷

(Top right) Nicola Marschall, *Portrait of John James Audubon,* 19th century; courtesy of the Kentucky Department of Parks, John James Audubon Museum

Perfect Meal

The following two recipes for woodcock [and quail] came from a very old cookbook called Kentucky Housewife, *compiled by Mrs. Lettice Bryan, originally published circa 1835. The recipes are those used in Kentucky during the time Audubon lived there. These would be close, if not the same, as used by his housewife.*

—Don Boarman, curator, John James Audubon Museum

Roasted Woodcock

"Pluck them carefully, touch a slip of paper to a blaze of fire, and hold them immediately over it, to singe off the little hairs that adhere to the skin, wash them very clean in cold water, and if practicable, let them lie in sweet milk and water for at least an hour before they are cooked.

"Season them inside and out, put in each a lump of butter, rolled in breadcrumbs and seasoned with a little pepper, rub them over with butter, and roast them before a brisk fire, which will cook them in a few minutes, then serve them up, garnish with a little mounds of ripe, soft peaches, having them mashed fine, add to drippings or trail some drawn butter, chopped asparagus or parsley, and pepper, and serve it in a boat, to eat with the birds." ▷

better than that of a crow, being dry and ill-flavored, notwithstanding, which it is frequently used, with the addition of one or two Golden-winged Woodpeckers or Redwings, to make what is called potpie.'

"In his little autobiography *Myself,* he informs the reader that while he lived on his father's farm in Pennsylvania, he had a finicky appetite, and refused many dinner invitations: 'Pies, puddings, eggs, milk, or cream was all I cared for in the way of food.' His journals reveal much more about his eating habits later in life, when he was anything but finicky. One time, all he had for food was a supply of apples and bread, another he had cold raccoon for breakfast. We learned that in 1843, while in Montana, he preferred bison over beef, and learned that dog was 'most excellent.' On the same trip, he wrote home to Lucy, 'My last upper tooth fell out of my mouth the other day, now I must soak my biscuits.'

"The nearest entry in Audubon's writing, to a recipe, is his descriptions of the American Woodcock. 'How comfortable it is, when fatigued and covered with mud, your clothes drenched with wet, and your stomach aching for food, you arrive home with a bag full of woodcocks, and meet the kind of smiles of those you love best, and which are a thousand times more delightful to your eye, then the savory flesh of the most delicate of birds can be to your palate. When you have shifted your clothes, and know that on the little round table, already spread, you will ere long see a dish of game, which will both remove your hunger and augment the pleasure of your family when you are seated in the midst of the little group, and now see someone neatly arrayed, introduce the mess, so white, so tender and so beautifully surrounded by savory juice, when a jug of sparkling Newark cider stands nigh, and you without a knife or fork, quarter a Woodcook, ah reader!'

"The following recipe for Woodcock came from a very old cookbook called *Kentucky Housewife,* compiled by Mrs. Lettice Bryan, originally published circa 1835. The recipes are those used in Kentucky during the time Audubon lived there. This would be close, if not the same, as used by his housewife."

Grilled Quail

"Pluck and draw them carefully as soon as they are killed. Split them open on the back, and rinse them in cold water. Season them with salt and pepper, and broil them hastily on a clean and greased gridiron over coals, turning them occasionally, and basting them with very little butter. When they are done, which will be in a very few minutes, serve them up immediately, sprinkle over them a handful of grated bread, and pour on a few spoonfuls of melted butter, seasoned with lemon juice and pepper."

These next two recipes have been adapted from the originals with ingredients readily available today:

Roasted Poussin with Peach Sauce

Serves 4 | Adapted

**2 poussin or Cornish game hens, about 1–1 1/2 pounds (450–675 g) each
Salt and pepper, to taste
1/4 cup (50 g) butter, softened
2 tablespoons dried bread crumbs
2 large peaches (about 6 oz/175 g each) pitted and sliced
1 tablespoon chopped parsley
12 oz (350 g) asparagus. woody ends trimmed**

• Preheat the oven to 425°F (220°C). Rinse the poussin well and pat dry. Season generously inside and out with salt and pepper. Cut 2 tablespoons of butter into slices and roll in the bread crumbs. Place one butter slice and any remaining bread crumbs into the cavity of each bird. Rub the remaining butter all over the exterior of each bird.

• Lay the sliced peaches in 2 mounds in a large, greased roasting pan. Put a poussin on top of each mound and roast until golden and a meat thermometer inserted into the thigh registers 170°F (75°C).

• Transfer the poussin to a serving platter and cover to keep warm. Pour the contents of the

roasting pan into a saucepan and bring to a simmer over medium low heat. Meanwhile, season the asparagus with salt and pepper and put into the roasting pan. Return the pan to the oven and roast until asparagus are tender, about 8–10 minutes.

• Use a wooden spoon to mash up any large pieces of peach remaining in the sauce. Taste and season accordingly. When ready to serve, stir in the parsley. Lay the roasted asparagus neatly on a serving platter. Top with the roasted poussin, and pour the peach sauce over each or serve it on the side.

Grilled Quail

Serves 2 | Adapted

4 quail, backbone removed, rinsed and patted dry
Extra virgin olive oil
Salt and pepper, to taste
1/4 cup (50 g) butter, melted
2 tablespoons fresh squeezed lemon juice
2 tablespoons bread crumbs

• Prepare a fire in a charcoal grill or heat a gas grill to medium heat.

• Rub the quail all over with olive oil and spoon generously with salt and pepper. In a small bowl, combine the butter and fresh lemon juice.

• With a long basting brush or with tongs and a kitchen towel, carefully oil the grill grate generously with oil (stand back, it can flare up) and place the quail, breast side down, on the grill and cook until charred, about 4 minutes. Turn the quail, baste with the lemon butter, and cook until done, about 4–5 minutes more.

• Transfer the quail to a serving platter. Drizzle the lemon butter over each and sprinkle with breadcrumbs. Serve warm, with remaining lemon butter to dip the meat into.

(Above) John James Audubon, American Woodcocks, c. 1830s, courtesy of the Kentucky Department of Parks, John James Audubon Museum

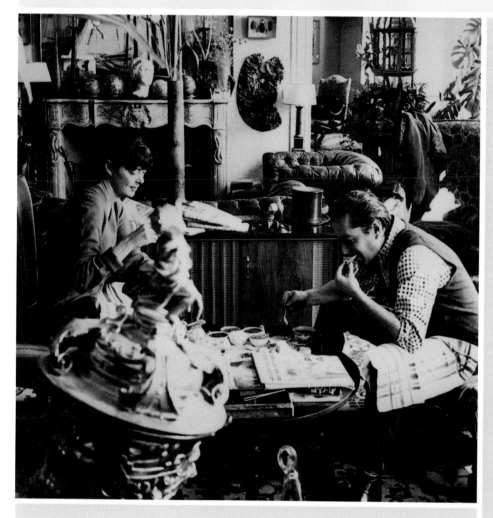

Buffet's Buffet

Frog's Legs with Garlic Purée and Parsley Sauce

Sauteed Sweetbreads with Truffled Mashed Potatoes

Warm and Light Apple Tart

Frog's Legs with Garlic Purée and Parsley Sauce

Serves 4 | Adapted

12 oz (350 g) garlic (approximately 5 heads)
1/4 cup (60 ml) milk
1 large bunch (about 4 oz/125 g) flat-leaf parsley,
 stems removed
1/4 cup (60 ml) goose fat or olive oil
4 tablespoons butter
All-purpose flour, for dredging
Salt and pepper, to taste
48 frog's legs, 2.2 lbs (1 kg) (usually available
 frozen and ready to cook)

Garlic Purée
• Break apart the heads of garlic with palms of your hands. Put them in a saucepan and cover with water. Bring to a boil and cook for 5 minutes. Drain, cover with water, and boil again for 5 minutes. Repeat the process a third time. Drain. Remove the skins and germ of each clove. Cover the cloves with water in the saucepan and boil for 10 more minutes and drain. Allow to cool slightly, then purée the garlic in a food processor with the milk until smooth. Set aside.

Parsley Sauce
• Wash the parsley and pat dry. Cook in salted boiling water for 4–5 minutes, and then shock in cold water to stop the cooking process. Drain well in a colander and then purée in a food

French painter Bernard Buffet's monochromatic palette and dark spiky lines captured the angst-ridden, existential mood of post–World War II Europe, catapulting him to international stardom in the late 1940s. Buffet's paintings explore themes ranging from Paris and portraits to still lifes and landscapes; his haunted scenes of the horrors of war, the Passion of Christ, and melancholy clowns, are especially powerful. In 1991, he became the first living artist to have simultaneous retrospectives at the Hermitage and Pushkin museums in Russia. There are two Buffet museums in Japan, and his work continues to be among the most admired and collected in the world.

Mr. Hugues Alexander Tartaut, president of Societé des Amis de l'Ermitage in Paris, graciously put me in touch with the artist's wife, Annabel Buffet, to obtain some information on Buffet's favorite recipe. When I received a letter from Mrs. Buffet, I found not one but three of Buffet's favorites: a literal "buffet."

(Top) Bernard and Annabel Buffet having tea in their castle at Château l'Arc, near Aix-en-Provence, France, c. 1960s, courtesy Galerie Maurice Garnier.

processor. Strain the purée through a sieve into a saucepan. Add a little water to achieve the consistency of a coulis (thick purée or sauce). Set aside.

Frog's Legs

• Cut off the ends of the frog's legs. Season with salt and pepper, then dredge in flour. Heat the fat (or oil) and butter in a frying pan until very hot and golden brown. Working in batches, place the frog's legs in the pan, browning 3 minutes on one side, then cooking 1 minute on the other side. If necessary, add more oil between batches to prevent burning. Once they are cooked, lay them out on paper towels to absorb the excess fat.

Presentation

• While the frog's legs are cooking, heat and season both the garlic purée and the parsley coulis. Coat the bottom of the plate

Preparing the Sweetbreads

• Blanch the sweetbreads in boiling water for 20 minutes, then put them into iced water to cool. Remove the surrounding membranes from the sweetbreads. Pat them dry and refrigerate until ready to use.

Truffled Mashed Potatoes

• Peel, wash, and chop the potatoes. Put in salted cold water, bring to a boil, and cook until tender, about 20 minutes. When cooked, drain them, and then lightly dry them in the oven. Put them through a food mill or mash by hand to make a smooth purée. Add the milk and 2 table-spoons of the softened butter to the purée, gently mixing it in with a spatula. Mix in the diced truffles, truffle juice, and 2 tablespoons of the truffle oil. Allow the flavor to develop for a few minutes, while keeping it warm.

Warm and Light Apple Tart

Serves 4 | Adapted

7 oz (200 g) pastry dough (equivalent to amount for a single-crust pie)
All-purpose flour for rolling
3 Golden Delicious apples
3 tablespoons sugar
2 tablespoons butter

• Preheat the oven to 375°F (200°C). Dust a work surface and rolling pin with flour. Divide the dough and roll each half into a thickness of about 1/8 inch (.25 cm). Using a small plate or bowl as a guide, cut each dough round into two 6-inch (15-cm) circles. Transfer the dough circles to a parchment-lined baking sheet and pierce all over with a fork. Refrigerate them until ready to use.

"Painting—we do not talk about it, we do not analyze it—we feel it."

—Bernard Buffet

with parsley sauce. Put a spoonful of garlic purée in the center. Arrange the frog's legs around the purée.

Sautéed Sweetbreads with Truffled Mashed Potatoes

Serves 4 | Adapted

4 sweetbreads, each 4 1/4 oz (120 g)
2 1/4 lbs (1 kg) of Bintje potatoes (substitutes: Yukon Gold or Yellow Finn)
4 tablespoons butter
2 tablespoons milk
1/2 oz (15 g) black truffles, diced, and their juice from the can
3 tablespoons black truffle oil
2 tablespoons goose fat or olive oil
Salt and ground black pepper

Cooking the Sweetbreads

• Heat the goose fat and 2 tablespoons of butter in a frying pan. When the butter is very hot, brown the sweetbreads. Season with salt and pepper. When the sweetbreads are evenly colored, cook for about four more minutes, then remove from pan. Degrease and then deglaze the pan with a little water. Allow the cooking juices to simmer for 2–3 minutes, then pour through a fine strainer. Add the remaining truffle oil and a little potato purée to thicken the sauce. Season with salt and pepper.

Plating

• Put a high dome of mashed potatoes on the plate. Coat the bottom of the plate with sauce. Place the sweetbreads on top of the sauce.

• Peel and core the apples, then slice them very thinly, about 1/16 inch (1.5 cm) thick. Arrange the apple slices in concentric circles on the tart dough. Sprinkle the tarts with sugar and dot each with about 1 tablespoon of butter cut into small pieces.

• Bake for about 25 minutes, until golden brown and apples are cooked through.

Max Beckmann Plaza Feast recreated by **Chef Roberto Hasche**

The German Expressionist Max Beckmann created some of the most profound and brutally insightful paintings of the 20th century—from phantasmagoric scenes of mythology and war to scathing portrayals of German high society, cabarets, and portraits. Beckmann studied art in Weimer during the early 1900s and soon won acclaim, but his career was interrupted by a stint as a medical corpsman during World War I, his first encounter with the horrors of war. After the war, Beckmann continued to create canvases with his trademark style of thick paint, dark outline, and intense color, becoming Germany's most honored artist. When the Nazis took power, all Expressionist art was deemed "degenerate." Hundreds of his artworks were confiscated, and he fled to Amsterdam in 1937, where he worked in exile for ten years.

> "Art is also an intoxication. Yet it is a disciplined intoxication. We also love the great oceans of lobsters and oysters, virgin forests of champagne . . ."
>
> —Max Beckmann, from "Letters to a Woman Painter," 1948

Beckmann emigrated to America in 1947. He was intrigued by the theatricality of hotel lobbies, where interesting-looking strangers came and went. He often visited the Plaza Hotel lounge to sip his favorite drink—champagne—and watch the passersby. His granddaughter, Mayen Beckmann, reported that "he did like champagne, he did comment on too much cabbage and potatoes during the war, and loved to go to have food, like it used to be served in the Oak Room of the Plaza Hotel." Lobster, which figures strongly in his writing, must have been a favorite. A recipe that he would have savored is offered below by Chef Roberto Hasche, former executive chef at the Oak Room, along with one for a classic champagne cocktail.

Plaza Feast

Serves 2

Seared Lobster and Porcini Mushroom with Chervil Butter Cream Sauce

One 2 1/2–3 lb (1–1.5 kg) lobster
8 tablespoons butter
2 large porcini mushrooms, sliced
1/2 cup (125 ml) white wine
4 tablespoons shallots, chopped
1/2 bunch chervil
2 cups (450 g) heavy cream

• Cut the lobster in half lengthwise. Place the halves shell side up in a large saucepan with 2 tablespoons of butter and the mushrooms. Sauté the lobster and mushrooms until the shells turn bright red, about 5 minutes. Set aside.

• In a separate saucepan, add the wine and shallots and boil over medium heat until reduced by half. Add the remaining butter, the chervil, and the wine/shallot reduction to a blender, and blend until smooth. To serve, remove the lobster meat from the shells and place on a bed of the sautéed mushrooms. Pour the sauce all around.

Champagne Cocktail

2 sugar cubes
Angostura bitters
1 bottle Champagne

• Place 1 sugar cube each in the bottom of 2 champagne flutes. Add a few dashes of bitters to each cube, and then fill flute with champagne.

(Right) Max Beckmann, *Still Life with Pears and Orchids,* 1946

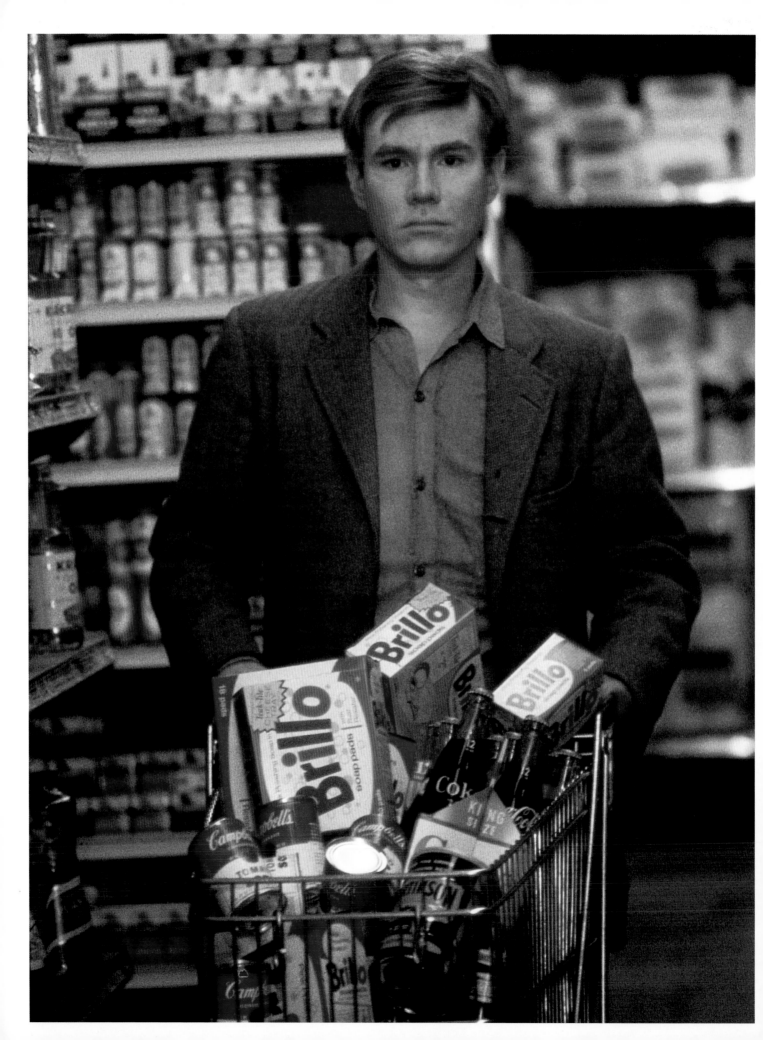

American artist Andy Warhol simplified his choice of subjects in art when he said: "Pop Art is liking things": from Campbell's soup cans, Heinz Ketchup bottles, Brillo boxes, dollar bills, to Elvis, Marilyn, Mao, Mickey Mouse, and Mick Jagger. But his culinary tastes proved more difficult to determine. It seems the undisputed king of Pop Art did not cook much. The Warhol Foundation had no information, and the artist's brother, John Warhola, confirmed that Andy was a man of simple tastes when it came to food also. The only thing he could remember Andy cooking was lamb chops. When asked for a recipe he said, "Well, I just put them in the oven!" Help came from Nena Bugarin, Andy's maid and housekeeper from 1975 until the artist's death in 1987. Nena sent in these recipes for what she said was his favorite meal; she served it to him every Thanksgiving and reported that this was exactly how Andy liked his Turkey Day meal cooked, and that he really loved it.

> ## "Bad taste makes the day go by faster."
> —Andy Warhol

Andy Warhol's Thanksgiving Dinner

Stuffed Turkey

Gravy

Green Beans

Sweet Potatoes

Cranberry Sauce

Serves 4–6

Stuffed Turkey

One 10–12-lb (4.5–5.5-kg) turkey

For the stuffing:
2–3 stalks of celery, chopped
2 green apples, diced
1 medium onion, chopped
1 bag Pepperidge Farm Bread Cubes for stuffing
Chopped boiled giblets and turkey insides
1 cup (125 g) dried cranberries

• Mix all of the stuffing ingredients together and stuff the turkey. Roast the turkey in a pre-heated oven at 350°F (175°C) for about 3 1/2 hours, depending on the size of the turkey, basting often. Use turkey drippings for gravy.

Gravy

Turkey drippings
2–3 tablespoons flour

• Skim the fat off of the turkey drippings and pour it into a saucepan. Add the flour and simmer until thick, stirring constantly to avoid bumps. Add seasoning to taste.

Green Beans

1 lb (450 g) green beans
Salt and pepper to taste
1 11-oz (300-g) can cream of mushroom soup, optional
1 cup (150 g) cashews, chopped, optional

• Simply boil the green beans until tender, then add salt and pepper to taste. For a tasty difference, add a can of cream of mushroom soup and chopped cashews to the green beans, stirring until warm.

Sweet Potatoes

4–6 sweet potatoes (1 per person)

• Wash the sweet potatoes and then boil them until they are easily punctured by a fork. Then peel and slice them, and put in a baking dish. Sprinkle with brown sugar and butter. Bake in the oven at 350°F (175°C) for 10 minutes or until brown. Garnish with fresh orange slices.

Cranberry Sauce

Adapted

1 12-oz (350-g) bag fresh cranberries
1 cup (200 g) sugar
1/4 cup (60 ml) freshly squeezed lemon juice
1 small orange sliced into very small wedges

• Put all of the ingredients into a large saucepan over medium heat. Cook, stirring frequently, until cranberries are completely broken down and orange rinds are very soft, about 15–20 minutes. Cool completely before serving.

Note: serve this meal with a hearty red wine.

Frédéric-Auguste Bartholdi first thought he might be an architect, and later, a painter, pursuing studies of these arts in his native France and the Middle East. Instead he became a sculptor, applying his engineering skills to building some of the most colossal sculptures of the 19th century. His most famous work is the monumental, enduring symbol of freedom: the Statue of Liberty. Barry Moreno, librarian and historian of the Statue of Liberty Monument, and author of *The Statue of Liberty Encyclopedia,* shares detailed information about the artist, his culinary background, and the banquet organized at the inaugural fund-raiser on November 6, 1875. The entire menu of that lavish feast has been re-created here by the brilliant chef David Féau of Lutèce New York and Las Vegas:

" Although Frédéric-Auguste Bartholdi was one of the most popular French sculptors of the latter half of the 19th century, producing a wide range of works of art, including statues, bas-reliefs, sculptural groups, medallions, busts, fountains, and tombs, he has achieved immortal fame in the eyes of the world with but one work alone, the colossal statue of *Liberty Enlightening the World.* This monument, standing on a small island in New York, has come to symbolize universal freedom and democracy for people throughout the world for over a hundred years. The Statue of Liberty, as the monument is popularly known, casts on its sculptor the unique role as the artist credited with the contemporary world's most revered icon.

"Bartholdi was a native of the French province of Alsace, an area noted for its delicious wines. Although he lived most of his life as a Parisian, he returned to his native Alsace often, and was well-acquainted with a wealth of food traditions. While in his hometown of Colmar, Bartholdi would have enjoyed dining on such Alsacian dishes as *choucroute, baeckeoffe, kougelhopf, and waedele*, while the local wines included such classics as . . . Sylvanar, a dry Muscat d'Alsace, or a rich, full Gewurztraminer.

"In 1871, Bartholdi, who had already won a measure of success with patriotic sculptural works, was commissioned by Edouard de Laboulaye, a prominent scholar and politician, to sculpt the goddess Liberty; Laboulaye planned to give it to the United States to commemorate the historic relations between the two nations at the time of America's centennial anniversary of independence. The iconography of the monument was based upon French and Roman models. It was to take the form of the Roman goddess Libertas, which had long been a symbol of freedom in Europe. . . . Laboulaye approved Bartholdi's clay study model for the statue in 1875, and then he inaugurated the Franco-American Union, which was to have full responsibility for the monument and the raising of money to pay for its construction. One of the great fund-raising events in the pains to

Lady Liberty Banquet

Serves 6

Potage Pritanier—Mock Turtle à l'Américaine

Hors d'Oeuvres variés

Turbot à la Hollandaise—Croustades à la Washington

Buissons d'Écrevisses de la Meuse (Sauce à la truffle noire)

Filet de Boeuf Lafayette

Cotelettes d'Agneau aux petit-pois

Poularde Caroline

Faisan et Perdeaux Bardés

Salade de chicorée

Haricots verts à la Mâitre d'hotel

Turbans d'Ananas au Kirsch

Parfait glace au café

Dessert assorti
Wines: Marsala, Bordeaux en Carafon, Haut-Sauternes, Cos d'Estournel 1865, Chambolles 1858, Clos Vougeot 1868, Veuve Clicquot extra sec, Clicquot superior

Café et Liqueurs

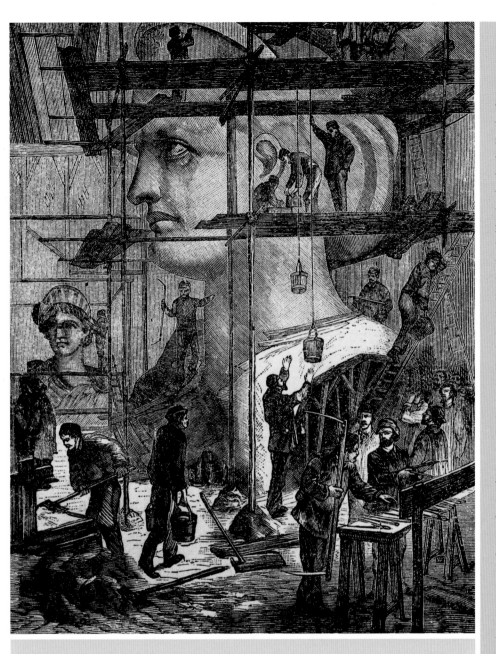

Potage Pritanier—Mock Turtle à l'Américaine (Mock Turtle Soup)

1 onion
1 carrot
2 leeks
1 turnip
1/2 celery root
1 parsnip
1 celery stalk
3 oz (75 g) bacon
1 bunch parsley
1 thyme bouquet
1 bay leaf
2 heads garlic
12 1/2 cups (3 l) cold water
Salt
1 tablespoon black & white peppercorn
1 tablespoon olive oil

• Peel all the vegetables. Cut the onions in *brunoise* (small dices). Finely slice the leek and celery. Cut the turnips, celery root, parsnips, and carrot into 1/2-inch (1-cm) triangles. In a large shallow pan, sweat the celery, onions, and leeks with the bacon and olive oil. Add the turnips, carrot, celery root, and parsnips along with the water, garlic, thyme, peppercorn, and bay leaf. Season with salt and cook. Keep the vegetables *al dente*. Remove the bacon and vegetables and reduce the broth (if necessary). If not, adjust the seasoning. Add the vegetables, dice the bacon and put it back in the soup. Put the soup in the soup bowl, and sprinkle the chopped parsley on top. Serve immediately.

Hors d'Oeuvres variés (Assorted Hors d'Oeuvres)

2 red beets
2 bay leaves
Salt
3 artichoke hearts, fresh
2 carrots
1 celery root ▷

build the Statue of Liberty was its kick-off banquet given at the Hotel du Louvre on Saturday, November 6, 1875, by the Franco-American Union. . . . The event was a glittering affair of some 200 guests, which included such distinguished names as French president Patrice de MacMahon, U.S. ambassador Elihu Washburne, descendents of Marquis de Lafayette . . . also present were prominent liberals Victor Borie, Louis Wolowski, and Henri Martin. The event, which raised 40,000 francs, was thus enormously successful both financially and socially. Based on newspaper reports, the banquet was described in Hertha Pauli's 1948 classic volume, *I Lift My Lamp: The Way of a Symbol:* 'The splendid dining room of the Hotel du Louvre was decked out in the red, white, and blue colors of the American and French republics. Two hundred guests, French and American (all male; the affair was strictly stag) sat at three tables forming a large U. At the end a gorgeously colored transparency depicted the proposed work. Its arms seemed to rise from the sea.' The dinner was at once scrumptious and symbolic. Its leading dishes were specially named for the occasion."

(Near top left) An etching of workers modeling the head ot the Statue of Liberty in the workshop of Moudinet and Becher, from *Frank Leslie's Popular Monthly,* c. 1880.

(Far top left) Frédéric-Auguste Bartholdi; both collection National Park Service, Statue of Liberty National Monument, New York, c. 1886

1 cucumber

1 head lettuce

1/2 head white cabbage

6 eggs

2 avocados

Juice of 1 lemon

1/2 bunch parsley, chopped

1/4 bunch chives, chopped

2 shallots, chopped

2 cups (475 g) tarragon mayonnaise (see below)

2 cups (470 ml) vinaigrette (see below)

For the Vinaigrette:

2 tablespoons vinegar

1 teaspoon Dijon mustard

6 tablespoons olive oil

Salt and pepper to taste

For the Mayonnaise:

2 egg yolks

1 teaspoon Dijon mustard

1 1/2 cups (360 ml) grapeseed oil

Lemon juice

1 tablespoon tarragon

Salt and pepper to taste

To Prepare the Vegetables and Eggs

• Wash the beets with cold water. Place them on a large piece of aluminum foil with the bay leaf and salt, and seal foil together to make a packet. Bake in back of a 325°F (160°F) oven for about 2 hours, depending on the size of the beets.

• Cook the artichokes with salted water and lemon juice. Clean the artichoke and keep only the heart. Peel the carrot, celery root, and cucumber, and cut them into julienne separately. Remove the first leaves of the lettuce and white cabbage, and chop finely.

• Cook the eggs in the salted water for 10 minutes and allow them to cool before taking off the shells and quartering them. Clean the avocado, dice it, and mix with lemon juice and salt. In a large oval tray, put the chopped lettuce in the center and garnish with chopped parsley, chives, and shallots all around, and finish decorating with the quartered eggs. Serve the 2 dressings on the side.

To Make the Vinaigrette

• Put the vinegar and mustard in a bowl and mix with a fork. Add the oil, season, and serve in a *saucière* (gravy boat).

To Make the Mayonnaise

• In a bowl, mix all the ingredients and season the mixture with salt and pepper.

Turbot à la Hollandaise
(Turbot in Hollandaise Sauce)

One 4-lb (1.8-kg) turbot (1 fish)

Salt and pepper to taste

2 stems thyme

3 oz (75 g) clarified butter

1 lb (450 kg) baby spinach

1 tablespoon olive oil

1 head garlic

Saffron

For the Hollandaise Sauce:

4 egg yolks

4 teaspoons water

2 cups (470 ml) clarified butter

Salt and crushed black peppercorn to taste

1 teaspoon lemon juice

• Clean the turbot [or have the fishmonger clean it], reserving the bones of the fish [to freeze for future use in making stock]. Season the fish inside and outside with salt and pepper. Put the thyme inside, pour the clarified butter on top, and roast in the oven at 400°F (200°C).

To Prepare the Hollandaise Sauce

• Place the egg yolks in a stainless steel bowl with the water. Put the bowl in a hot bath and mix the eggs until they become very smooth, slowly adding the clarified butter (heated to 90°F/32°C). Season with salt and pepper, finish by adding a tablespoon of lemon juice.

For the Presentation

• Wash the spinach and drain very well. Take a garlic clove and prick it with a fork. Put the olive oil in a very hot sauté pan and sauté the spinach,

and stir using the fork with the garlic on it, and season with saffron. Cut the turbot into 6 portions. Arrange the spinach with the turbot over it on 6 plates. Spoon some sauce around, and sprinkle some salt and black pepper on the turbot. Offer the remaining sauce on the side.

Buissons d' Écrevisses de la Meuse
(Sauce à la truffle noire)
(Crawfish in Truffle Sauce)

36 live crawfish

For the Broth

1 carrot, peeled and sliced

1 onion, peeled and sliced

1 bouquet thyme

1 teaspoon each black and white peppercorn

2 cups (470 ml) white wine

2 cups (470 ml) white vinegar

12 cups (2.8 l) water

1/3 bunch parsley

2 stems basil

Salt

For the Sauce:

18 crawfish shells

2 tablespoons fresh butter

5 shallots

1 carrot

1/4 cup (60 ml) brandy

3 oz (75 g) fresh butter

4 cups (950 ml) water

1 leek

1 teaspoon black peppercorn

1 thyme bouquet

3 oz (75 g) heavy cream

3 oz (75 g) black truffles, diced

1 cup (240 ml) truffle juice

1 bunch watercress

To Prepare the Crawfish:

Remove the little piece of shell at the end of each tail (in the center). Add the broth ingredients to a large pot, and cook over medium heat for 15 minutes. Poach half of the crawfish in the broth, and remove their shells when they are cooked.

To Prepare the Sauce:

• Sauté the shells with fresh butter. Peel and dice the shallots and carrots, add them to the pan with the sautéed shells, and caramelize them a bit. Deglaze with brandy and butter and add the water. Clean and wash the leek, dice it, and put it in the sauce as well as the pepper and thyme. Reduce the sauce by half, add the heavy cream and reduce by half again. Strain the sauce, add the diced black truffle and the juice. Cook for 5 minutes, add the butter and season the sauce with salt and pepper. Keep the sauce warm in hot water bath. Clean and wash the watercress, and divide it in the center of 6 plates.

• Reheat the broth *(nage)*. Pull the crawfish's claws back, push them into their tails and poach them. Strain, and arrange them nicely around the watercress with their heads meeting in the center. Reheat the 18 crawfish tails in the broth, strain well, and put them between the crawfish. Glaze the crawfish with the sauce, and serve it hot.

Filet de Boeuf Lafayette (Filet of Beef)

For the Croustades champignons (Mushroom-stuffed Pastry):

Mix of wild mushrooms:

 1/4 lb (100 g) canari (yellow-knight)

 1/2 lb (225 g) yellow-foot chanterelle

 1/2 lb (225 g) black trumpet

1 teaspoon olive oil

Water

1 teaspoon fresh butter

Salt to taste

1 tablespoon all-purpose flour

Six 6 x 6 inch (15 x 15 cm) puffed pastry squares

3 egg yolks

For the Beef:

2 lbs (900 g) beef tenderloin

Salt and white pepper to taste

1/4 lb (125 g) fresh butter

6 golden endives

1/2 bunch tarragon

For the Sauce:

3/4 cup (180 ml) Bourdelaise sauce reduced

To Prepare the Croustades

• Clean and wash the mushrooms. Chop the canari then sauté them with olive oil. Cook the yellow-foot chanterelle and the black trumpet with a little bit of water, fresh butter and salt. Strain them, and save the liquid. Mix the mushrooms and season them with salt and pepper. Sprinkle a little bit of flour on the table and lay out the puffed pastry squares. Put some mushrooms in the center of each square, and fold the four corners into the center of each.

• Mix the egg yolks in a bowl with 1 pinch of salt and water. Using the brush, glaze the 6 mushroom croustades with the mixture. Preheat oven to 400°F (200°C). Place croustades on a half-sheet pan before cooking them and prick them with a knife to allow steam to escape while they bake. Cook the croustades for 20 minutes.

To Prepare the Beef

• Clean the tenderloin and season it with salt and pepper. Chop the endives, and chop the tarragon leaves, saving half for later. In a hot sauté pan, sear the beef on both sides with fresh butter, add the endives, tarragon leaves, and cook in the oven at 450°F (230°C) for 20 minutes. Baste it and mix the endives.

• When the beef is cooked, wait 5 minutes before slicing. Reheat the croustades in the oven at 350°F (175°C) for 5 minutes. In the pan, reduce the mushroom jus and add the bordelaise sauce. In a long tray, arrange a bed of caramelized endives topped with the sliced tenderloin and spoon the sauce around. Serve the sauce on the side. Sprinkle the chopped tarragon over the beef and serve.

Cotelettes d'Agneau aux petits-pois (Rack of Lamb with Peas)

3 lbs (1.4 kg) English peas

Salt

12 baby carrots

2 teaspoons fresh butter

1 teaspoon crushed black peppercorn

3 racks of lamb, 6 bones each

White pepper

2 teaspoons olive oil

1 big bouquet of thyme

2 oz (50 g) prosciutto, diced

2 pieces garlic

1/2 bunch basil, chopped

2 cups (470 ml) lamb sauce

2 heads garlic, peeled

1 pinch sugar

• Clean the peas and cook them in a pot of the salted water, then cool them down with ice water and strain. Peel and cook the baby carrots with a little water, salt, black peppercorn, and a teaspoon of butter. Season the rack of lamb with salt and white pepper, and sear them with olive oil. Cut the garlic in half and add to the rack of lamb. Pick and sprinkle the thyme leaves over the lamb and cook in the oven for 14 minutes at 450°F (230°C).

• Sear the prosciutto in a pan with 1 teaspoon of butter, add the garlic, peas, 1 tablespoon of water, and the baby carrots. Glaze the peas with the sugar. Reheat the lamb sauce and add the fresh basil. Take the meat off the bone without separating the rack. Place the bones in a long tray. Slice the meat and fan it over its original place on the bones. Drizzle 2 tablespoons of sauce over meat. Serve the remaining sauce on the side with the English peas and the baby carrots.

Poularde Caroline (Roast Hen)

1 5–6 lb (2.25–2.7 kg) *poularde* (roasting hen or chicken

1 big bouquet of thyme

Salt

White pepper

1 cup (225 g) clarified butter

For the Pâte à Choux (Cream-puff Pastry):

1/2 cup (120 ml) water

2 tablespoons (25 g) fresh butter

1/2 teaspoon salt

1 pinch nutmeg, grated

5/8 cup (75 g) flour

2 egg whites

For the Stuffing and Sauce

4 oz (125 g) foie gras

Salt and pepper to taste

1 teaspoon brandy

4 shallots, peeled and diced

1 stalk celery, sliced

2 tablespoons fresh butter

1 quart (1 l) chicken stock

1 cup (225 g) crème fraîche

To Prepare the Hen

• Stuff the hen with thyme, and season the inside and outside with salt and pepper. Preheat the oven to 450°F (230°C). ▷

Frédéric-Auguste Bartholdi Lady Liberty Banquet

Re-created by **Chef David Féau**

Preheat the oven to 450°F (230°C). ▷
Place the hen in a roasting pan, pouring the clarified butter on top. Cook for 45 minutes and baste it every 10 minutes.

To Prepare the Pâte à Choux

• Mix the ingredients for the pâte à choux in a bowl. Line a half-sheet pan with Silpat (non-stick silicone baking mat). Place the dough in a pastry bag and pipe golf-ball size dollops onto the Silpat. Glaze them with brush the egg yolk and cook those 12 minutes at 375°F (190°C).

To Prepare the Stuffing and Sauce

• Mix the foîe gras in a Kitchen Aid with salt, pepper, and the brandy. When the choux are cool, make a hole in the bottom, and stuff them with the foîe gras. Sauté the shallots and celery with fresh butter, deglaze with chicken stock. Reduce the stock by three-fourths, add the crème fraîche, and let it simmer for 20 minutes more. Season and strain the sauce. Keep it warm for 10 minutes at 350°F (175°C). Place the poularde on a large tray, drizzle some sauce around and garnish with the warm choux. Serve immediately with the remaining sauce on the side.

Faisan et Perdreaux Bardés (Pheasant and Partridge)

3 female pheasants, 2 lbs (900 g) each
3 partridges, 1 lb (450 g) each
5 oz (140 g) foie gras
4 slices white bread, toasted and diced
3 lbs (1.4 kg) pork fat
6 pieces fresh bay leaves
3 oz (75 g) polenta
6 1/2 oz (190 ml) reduced chicken stock
6 1/2 oz (190 ml) milk
1 teaspoon mascarpone cheese
Salt and white pepper to taste
1 teaspoon white truffle, chopped
1 cup (125 g) green apple, diced
 1/4 inch (6 mm)
1 cup (125 g) celery root, diced 1/4 inch (6 mm)
2 cups (470 ml) brown game stock

1 piece onion, peeled and diced
1 teaspoon apple brandy
20 pieces white truffle, sliced
1 tablespoon fresh butter

To prepare the game:

• Clean the game and remove the nerves from the pheasant and partridges, stuff each game with foie gras and white bread. Cut 12 squares of pork fat and place them on the breast of each game with a bay leaf, and tie with a string.

• Cook *à la brioche* (see Note) in the oven at 150°F (65°C), 10 minutes for the partridges and 30 minutes for the pheasant. Place a tray in the bottom of the oven to save the fat. Cook the polenta with the chicken stock, milk, mascarpone cheese, and season it with salt and pepper. Add the chopped truffle, mix, and cover with plastic wrap. Sauté the apple and celery root separately and allow them to cool. When the game are cooked, let them rest for 10 minutes in the half-sheet pan, and remove the bay leaves. Debone and place them nicely, breast and legs, in a long tray. Cut the bones in little pieces, then sauté with the game's fat. Add the onion and caramelize it a bit. Deglaze with the apple brandy, game stock, and butter, and reduce the jus and strain it.

• Reheat the game and place the diced apple and celery on the top of the game. Spoon the sauce nicely over the game and serve the rest on the side. Serve the polenta in a deep dish on the size with the game. Top the game with the slices of white truffle and serve.

Note: For the à la Brioche method, you can use an outdoor grill with the rotisserie attachment.

Salade de chicorée (Chicory Salad)

1 head chicory

For the Dressing:
Salt and white pepper to taste
1 tablespoon sherry vinegar
1 teaspoon Dijon mustard
1 tablespoon shallot, finely chopped

3 tablespoons olive oil

• With your hands, separate the chicory into little leaves. Wash a few times. Prepare the dressing. Place and mix the chicory in the large bowl with the dressing and serve. This salad can be accompanied with a nice cheese selection.

Haricots verts à la Mâitre d'hotel (Green Beans in Butter Sauce)

1 lb (450 g) young haricot vert beans
2 oz (50 g) salt
12 1/2 cups (3 l) water
Ice cubes
3 tablespoons fresh butter
1/4 lb (125 g) fresh butter
1 tablespoon garlic, finely chopped
1 1/2 tablespoons finely chopped parsley
Salt and white pepper to taste

• Cut both ends of the beans. Cook them in the salted water a few minutes and cool them in the iced water. Sauté the haricot vert with fresh butter, season with salt and pepper. Add the garlic but do not let it brown, then add the parsley, and sauté. Place the beans inside a deep dish to serve.

Turbans d' Ananas au Kirsch (Pineapple and Kirsch Pastry)

1/2 cup (125 g) sugar
1/2 cup (120 ml) water
1 loaf brioche
Pineapple

For the Syrup:
1 tablespoon kirsch
1 quart (950 ml) orange juice
1 tablespoon lemon juice
1/2 cup (125 g) sugar
2 vanilla beans

For the Flan:
1 cup (200 g) sugar
6 whole eggs
1/3 cup (50 g) flour

2 cups (470 ml) dark rum
1 cup (150 g) pineapple, diced
1/2 cup (120 ml) apricot glaze
1 teaspoon fresh mint, sliced julienne
1 cup (225 ml) kirsch
1 1/2 quarts (1.4 l) pineapple purée (see below)

Note: Prepare and cook the day before serving this dessert.

• Cover the bottom of a terrine with a layer of caramel made using sugar and water. Cut nine 1/2-inch (1.25-cm) slices of brioche (without the crust), 2 inches wide x 3 inches long (5 x 7.5 cm). Fan the slices along the bottom of the terrine. (Use half of a brioche slice for the first, then full slices to cover the rest of the bottom.)

Poaching and Puréeing the Pineapple
• Remove the rind and core from the pineapple. Poach ten 1/3-inch (8.5-cm) thick slices for about an hour. Purée the poached pineapple together with the poaching liquid. Chill and reserve this for the flan (should yield about 1 1/2 quarts/1.4 l).

Preparing the Flan
• Preheat the oven to 400°F (200°C). Whisk together all of the ingredients. Pour the mixture into the terrine lined with caramel and brioche. Place in a water bath with a towel underneath terrine. Lower oven to 350°F (175°C) and bake for 50 minutes.

Parfait glace au café
(Coffee Ice Cream Parfait)

6 egg yolks
3/4 cup (150 g) sugar
1 cup (240 ml) espresso
2 1/3 cups (275 g) whipped cream
1 cup (240 ml) coffee liqueur
cocoa powder

For the Coulis (Purée):
1 lb (450 g) pears
1/4 cup (60 ml) water
1 vanilla bean
4 1/2 tablespoons sugar
1 tablespoon lemon juice

The day before you want to serve:
• Place the egg yolks in a mixer bowl and whip them.

• Prepare the cooked sugar by mixing 3/4 cup (150 g) of the sugar with the espresso; cook at 110°F (40°C) (sugar thermometer) or using a fork with the syrup in cool water. You can feel the consistency between your fingers.

• When the sugar is cooked, add it little by little to the egg yolks. Whip the sabayon until it's cooled off. Fold in the whipped cream and add the coffee liqueur. Fill 6 stainless-steel ring molds and place them in the freezer.

The Coulis
• To prepare the coulis, peel, core, and dice the pears. Place them in a pan with the water, vanilla, and sugar, cook covered with lid. Remove the vanilla beans.

• When the pears are cooked, place them in a blender, and mix until the purée is smooth. Add the lemon juice and some cold water if the coulis is too thick. Remove the parfaits from the freezer, remove the ring molds, and sprinkle the tops with some cocoa powder. Place them in a round dish. Serve the pear coulis on the side.

Roasted Apple Pie

8-inch (20-cm) circle of puffed pastry
3 golden apples
8 tablespoons melted butter
2 tablespoons all-purpose flour
1/2 cup (125 g) sugar

• Keep the puffed pastry in the refrigerator. Peel the apples, cut them in half, and core them. Slice the apples finely.

• Take a half-sheet pan and sprinkle the flour on it, placing the puffed pastry in the center. Dress the apple slices nicely on the dough, brush the apple slices with the melted butter, and sprinkle them with sugar. Cook the apple tart for 30 minutes at 400°F (200°C), but add butter and sugar every 7 minutes. When cooked, allow the tart to cool down and cut it into 12 slices. Serve at room temperature.

Financier Cookies Amandes
(Almond Financiers)

2 tablespoons melted butter for
 12 financier ring molds
1/2 cup (50 g) all-purpose flour
1/2 cup (50 g) almond powder
1 1/4 cups (150 g) confectioner's sugar
6 tablespoons fresh *beurre noisette*
 (brown butter)
4 egg whites
1 pinch salt
7 teaspoons vanilla sugar

• Brush 12 financier molds with the melted butter. Mix the all-purpose flour, almond powder, and confection sugar. Put the warm brown butter on the dry mix and whip slowly. Whip the egg whites with salt and vanilla sugar; when you obtain a meringue mix into the batter. Fill the molds and cook 8 minutes at 375°F (190°C). Arrange the financier over a napkin on the tray and serve warm.

Cannelé (Bordeaux Pastry)

2 tablespoons butter (for ring molds)
2 whole eggs
2 egg yolks
1 1/4 cups (250 g) sugar
3/4 cup (100 g) all-purpose flour
2 tablespoons (56 g) butter, melted and cold
1/2 quart (470 ml) milk
2 cups (470 ml) rum

• Brush 12 cannelé molds with melted butter. Whip the eggs and egg yolks together. Combine sugar and flour in a separate bowl and then mix with the eggs. Whip until the batter is smooth and add the melted butter, milk, and rum. Fill the molds and bake for 12 minutes at 375°F (190°C). Serve warm with the financier.

Alan Sonfist Natural Dinner

In the 1960s, Alan Sonfist was among the first artists to base his work on ecological and environmental elements. Sonfist uses the land and native flora to recreate natural landscapes all over the world, especially in or near cities, where the contrast between nature and the urban environment is especially poignant. In Greenwich Village, New York City, in 1965, Sonfist created *Time Landscape,* the first urban forest to feature pre-Colonial plants. He has recreated an apple orchard that once existed in the Riverdale section of the Bronx and a seven-acre landscape in Tampa, Florida, which is now considered the area's "Central Park."

As a small child Sonfist found safety from the world at the top of a tree:

" I grew up in the south-central Bronx, next to the Bronx river, where there was one special oak tree—my sanctuary, and a way to understand the environment. . . . We always have choices in our lives, and I made the choice that this tree, this environment, was the most important aspect of my childhood."

Consequently, Sonfist began his career as an artist by creating numerous drawings of himself and the oak. Many years later in 1993, he paid homage to his old friend and protector, the oak, by creating a stone-walled Viking ship in Denmark. It was the size of a football field, with a seedling oak forest planted inside its borders. Sonfist said, "The ship form protects the endangered forest . . . and the oak is the heart of the piece."

In the 1980s, one of Sonfist's most ambitious projects (it took three years to complete) involved an installation in the gardens of the Fattoria di Celle, a private estate near Florence that is dedicated to the creation of site specific art. There, as it does everywhere, Sonfist's work tells an unforgettable story about the interaction between human culture and natural habitats, while awakening our lost relationship to nature, and the oak.

The artist warns us that "PLANTS SHOULD ONLY BE COLLECTED BY EXPERTS OR SOMEONE KNOWLEDGEABLE OF NATIVE PLANTS!"

Natural Dinner

Beverage
Salad
Main Dish
Dessert

Beverage:
Staghorn sumac *(Rhus)*
2 cups (250 g) red sumac berries
1 gallon (3.8 l) water

• Slightly mash red sumac berries and cover with boiling water. Let stand until cool. Strain out berries and serve the juice.

Salad:
1 cup (25 g) live forever *(Sedum)*, only using the inside of the leaves
2 cups (125 g) prickly lettuce *(Lacutuca)*, only the tender greens
1 cup (125 g) salsify *(Tragopogon)*
1/2 cup (50 g) wild onion *(Allium)*
1/4 cup (16 g) wild ginger *(Asarum)*

• Cut into small piece. Serve in a large bowl.

Salad Dressing:
1 cup (125 g) rose hips *(Rosa)* chopped
2 cups (300 g) blueberries *(Vaccinium-gaylusscia)*, liquefied

• Pour over salad.

Main Dish:
2 cups (320 g) wild rice *(Zizania)*
4 cups (950 g) water
4 cups (600 g) acorns *(Quercus)*

• Cook rice in water until tender. Roast acorns

on a slow flame for 1 hour. Serve without shells. If acorns are slightly bitter, they can be buried in swamp mud for a year.

1/2 cup (50 g) serviceberries *(Amelanchier)*
Maple syrup

• Wash and mix all berries in bowl, then cover with syrup.

Dessert:
1/2 cup (75 g) strawberries *(Fragaria)*
1/2 cup (75 g) elderberries *(Sambucus)*

(Above) Alan Sonfist, holding one of his ecological pieces, undated

Le Corbusier Two Feasts for Ozenfant re-created by **Chef André Soltner**

The renowned architect, designer, artist, and writer who later adopted the name Le Corbusier, was born in 1887 as Charles-Edouard Jeanneret, the son of an engraver from La Chaux-de-Fonds, Switzerland. Stephane Potelle, Archivist and Project Manager at the Josef and Anni Albers Foundation, has translated a letter from Le Corbusier, pictured at right, that contains a menu he specially prepared for his close friend, the French painter and theorist Amédée Ozenfant. Mr. Potelle also provides a glimpse of Le Corbusier's life in Paris during World War I:

"This letter is dated the 6th of March 1918. Paris is still under the German bombs. Charles-Edouard Jeanneret, not yet Le Corbusier, moved to Paris in 1917. He met Amédée Ozenfant with whom he founded a new artistic movement, Purism, in reaction to the excesses of Cubism in its last years. Jeanneret appeared unconscious of the danger, but he spent a lot of time in caves to protect his life against bombing. It was a time of war, but Jeanneret and his contradiction [*sic*] mind did not want to give up Paris's art of life. He dared to overcome all of the difficulties regarding food and beverage shortages, and wanted to offer to his best friend the best dinner! A kind of tour de force and a direct expression of the incredible personality of Le Corbusier. We don't know how he found all these foodstuffs. At this time he also had no money.

"He added a touch of humor by calling himself Vatel, or Marie Whistler, two famous French chefs. He really wanted to make the best for his friend. In Ozenfant, Le Corbusier found a kind of aristocratic standing and allure. So he tried to make his dinner with all of the noble package [*sic*]. For this he used old French language forms.

"Later in this letter Le Corbusier complained of the fact that the wines weren't Burgundy but some Saint Emillion. Chops or ribs were also remarkable, according to him. He was also amused by Ozenfant's reactions to the sweet peas. What was most important for Le Corbusier during that night: Harmony. He didn't have enough money and access to the black market to get the good foodstuffs. He settled on some Greek pottery for the table, fruits in baskets, sugar in Daum bowls, flowers, good wines, and candles: the 'Art of Life.' For him the table was a still life, composed as a painting, with a theatrical meaning. It was a good time. They had a rich conversation; they forgot the war and the bourgeois.

> "A room and a good meal were important to him. He also thought that somebody needed to eat and drink all the goods on Earth."
>
> —Stephane Potelle,
> Archivist and Project Manager,
> Josef and Anni Albers Foundation

3/ des affaires tout en faisant son œuvre. Il
écrit bien; il peint très bien. Il est aussi
pour la liberté des mers. Nous dînons souvent
ensemble dans un petit bouibouis parsou le
soir à mon bureau. Les bombes lui ont ravi
ses clients. Toutes ces grandes et belles dames ont
filé sur Nice ou tout autre motif plausible. Il
aurait un cafard noir, s'il ne réagissait
avec toute la ténacité de son aïeule face de
Mohican. Voici le menu que je ferai suivi
par les soins de mes dix doigts demain soir.

EN L'HOSTEL D'ADRIENNE LECOUVREUR.
SUR LES JARDINS AUTHENTIQUE DE LA DITE
DÉCOR: AHÉMONES DE NICE.
ÉVENTUELLEMENT: ORQUESTRE DES GOTHAS et
DIVERTISSEMENT EN LES SOUS-SOLS
RÈGLES PAR LES CONCIERGES DU
QUARTIER.

HUITRES PORTUGAISES
GRAVES.
SAUCISSON DE MENAGE
COSTELETTES DE PORC AUX ŒUFS POCHÉS.
PETITS POIS AU BEURRE.
VINS DE BOURGOGNE.
FROMAGE DE BRIE –FAÇON.
MARMELADE DE POMME A LA SACHARINE
FRUITS DU DÉSERT
DATTES ET FIGUES
CAFÉ SANS SUCRE.
CALVADOS VIEUX.
MAUVAIS CIGARES.
LE TOUT, ET SPECIALEMENT LES BOISSONS, SERA SERVI EN ABONDANCE.

"Le Corbusier needed very few things to live. A small place to write and paint, like his *cabonon* (cottage) in Cap Martin on the French Riviera. He also had simple tastes in food and beverages. During his journey to Italy (1907) and to the East (1911), he especially enjoyed the Italian and Turkish food. But in his daily life he used to have simple meals and a glass of red wine. He and his wife from Monaco, Yvonne, had the habit of taking an aperitif every day at 5:00 PM—a glass of Pastis. Even if Le Corbusier was in a work meeting, he had to stop and respect this custom. He liked the idea of simple meals . . . During his youth, he liked to have small portions of foods, like a monk. He tried to discipline his body and mind like a friar. When he built a monastery for the Dominican monks in La Tourette, France, he liked to share their meals, always with a glass of wine. Le Corbusier was fond of his wife's cooking and was always anxious about food during his nonstop travels. A room and a good meal were important to him. He also thought that somebody needed to eat and drink all the goods on Earth. Many times with these experiences, he was drunk, but confessed it very openly."

Translation, by Stephane Potelle:
In the mansion of Adrienne Lecouvreur [18th-century actress, buried on banks of the Seine], on the genuine gardens of the [city].

Décor: Anemones of Nice

Eventually: Orchestra of the Gothas [Germans, i.e., German composers] and Entertainment in the basements ruled by the janitors of the district [party was to move underground if Paris was bombed].

Portuguese Oysters

Graves
(wine from Graves region of Bordeaux)

Common Sausage

Pork chops with Poached Eggs

Sweet Peas with Butter

Burgundy Wines

Brie Cheese—Façon

Stewed Apples with Sugar

Dessert Fruits

Coffee without Sugar

Old Calvados

Bad Cigars

All, and especially the beverages, will be served in abundance.

(*Above left*) Letter and menu from Le Corbusier to Amédée Ozenfant, Paris, March 6, 1918; courtesy Le Fondation Le Corbusier, Paris

(*Far top left*) Le Corbusier, c. 1960

Two Feasts for Ozenfant

re-created by Chef André Soltner

Chef André Soltner has conceived of two distinct but related menus to celebrate the feast that Le Corbusier prepared for his friend Ozenfant. The first menu, below, is based on Le Corbusier's March 6, 1918, letter and its list of dishes; it ingeniously incorporates ingredients that Le Corbusier may have—with some luck—been able to secure during the war. The second menu, to the right, represents what Chef Soltner calls the "Dream of Le Corbusier." It is also based on Le Corbusier's letter, but with its more luxurious components and elaborate preparations represents what Le Corbusier might have prepared today—if he had unlimited access to ingredients, and, perhaps, Chef Soltner to inspire him. Each recipe is identified as belonging to Menu One or Menu Two.

Menu One: 1918 Feast

Huîtres Portugaises
Portuguese Oysters

Served with Graves

Saucisson à l'Ail
Garlic Sausage

Cotelettes de Porc aux Oeufs Pochés
Pork Chops with Poached Eggs

Served with vin de Bourgogne

Petits Pois à la Française
Sweet Peas with Butter

Fromage de Brie et Marmelade de Pommes
Brie Cheese and Stewed Apples with Sugar

Dates and Figs

Menu Two: Dream of Le Corbusier

Huîtres Pochées en Gelée
Poached Oysters in Jelly—cold

Served with Graves sec Lafitte

or

Huîtres Glacées sur Julienne de Poireaux
Poached Oysters on Leeks—hot

Served with Graves Imperial sec

Cervelas Truffé en Brioche avec Sauce Périgourdine
Sausage Brioche with Périgord Sauce

Served with Chateau Leoville-Poyferré (St. Julien)

Côtes de Porc à la crème aux Champignons et Oeufs Pochés
Pork Chops in Mushroom Cream Sauce with Poached Eggs

Panaché de Petits Pois et Carottes
Peas and Carrots

Served with Gevrey Chamberlin

Fromage de Brie Fermier— Pain aux Noix
Brie Cheese and Walnut Bread

Compote de Pommes Normande
Apple Compote

Tarte aux Figues
Fig Tart

Brioche de Dates
Date Brioche

Glace aux Oeufs
Vanilla Ice Cream

Menu One

Huîtres Portugaises (Portuguese Oysters)

Serves 4

24 oysters
Vinegar
Juice of 1/2 lemon

• Serve oysters raw on the half shell, with a *filet* (small amount) of vinegar or lemon juice

Menu Two

Huîtres Pochées en Gelée (Poached Oysters in Jelly)

Serves 4

24 oysters
1 cup (240) dry white wine
Juice of 1/2 lemon
Salt
Pepper, fresh ground
1 scant tablespoon gelatin (or one envelope)
1/2 lb (225) seaweed
8 sprigs cilantro, chopped fine

For the Julienne:
2 tablespoons unsalted butter (1 stick)
2 medium carrots, trimmed, peeled, washed, and cut into very fine strips
1 leek (the white part only), washed and cut into very fine strips
3 celery stalks (or a very small knob of celery), peeled, washed, and cut into very fine strips
Salt
Pepper, fresh ground

Note: Inedible seaweed is used in this recipe and the next; it turns an attractive green color when boiled and chilled.

• Open the oysters and remove the meats from the shells, taking care to keep the liquid. Retain the 24 bottom halves of the shells, wash them, and set aside.

• Strain the liquid through a very fine sieve, into a small pan. Add the wine and lemon juice to the liquid, very little salt, and pepper.

• Bring the liquid to a boil, add the oysters. After 10 seconds remove them and put them on paper towels. Continue to cook the liquid for 5 minutes, then reduce it.

• While the liquid is boiling, dilute the gelatin in 2 or 3 tablespoons of cold water. Add this to the boiling liquid, and continue to simmer for 2 minutes more. Let the liquid cool.

• Blanch the seaweed in boiling water for 2 minutes to give it a nice green color. Chill the seaweed in ice water. Drain and set aside.

The Julienne
• In a sauté pan, melt the butter. Add the vegetables, salt, and pepper, and stew, covered, over low heat, stirring occasionally, until the vegetables are soft—about 12 minutes. The vegetables must not brown. Set the vegetables aside to cool.

• Arrange the reserved oyster shells on a plate. Divide the vegetables into the half-shells. Then put a poached oyster on the vegetables in each shell.

• Lower the cooled liquid, in its pan, into ice water to chill it, stirring it constantly. When the liquid becomes syrupy, but before it becomes thick, stir in the cilantro. Spoon some of this jelly over each of the oysters, using all of it. Refrigerate.

Arrange the seaweed on 4 plates. Arrange 6 of the oysters on the seaweed on each of the plates.

Menu Two

Huîtres Glacées sur Julienne de Poireaux (Poached Oysters on Leeks)

The mixture of oysters and leeks is not new, but it was not until the late 1970s that it became very popular—almost every French chef was making it, each in their own style. I began serving this dish at Lutéce in the 1970s. The combination is less popular with other chefs now—the trend is over—but I still make it every now and again, as long as good oysters are available.

Serves 4

1 lb (450 g) seaweed (for presentation)
1 1/2 cups (360 ml) heavy cream

1 tablespoon unsalted butter
1 1/2 cups (125 g) leeks (the white part only), washed, cut in strips 2 x 1/16 x 1/16 inches (50 x 1.5 x 1.5 mm)
Salt
Pepper, fresh ground
24 oysters
1/4 cup (60 ml) dry white wine
Juice of 1/2 lemon
1 pinch cayenne pepper

• Salt 2 quarts of water and bring it to boil. Plunge the seaweed into the boiling water, and boil for 2 minutes. Cool the seaweed in ice water and set it aside.

• Whip 2 ounces (60 ml) of the cream until stiff. Refrigerate.

• Melt the butter in a sauté pan. Add the julienne of leeks and a moderate amount of salt and pepper. Sauté without browning over low heat until tender—about 8 minutes.

• Open the oysters and keep all of their juice. Wash the bottom half-shells and set them aside. Pass the juice through a sieve and put it in a saucepan. Add the white wine, lemon juice, and cayenne pepper. Quickly bring the liquid to a boil.

• Add the oysters and cook for 15 seconds. Immediately remove the oysters with a slotted spoon and set them aside.

• Over high heat, reduce the liquid to one-fourth of its volume. Add the remaining 10 ounces (300 ml) of the cream, and cook over medium heat until the sauce becomes velvety. Pass this sauce through a fine sieve. Then mix it with the whipped cream.

• Preheat the broiler.

• Arrange the seaweed on 4 plates. Put 6 half-shells on each plate, and divide the julienne of leeks among the half-shells. Put an oyster in each shell. Spoon the sauce over the oysters.

• Put the plates under the broiler until the oysters are golden brown—about 1 minute.

Menu One

Saucisson à l'Ail (Garlic Sausage)

This dish dates back to ancient times, and it is still a staple in and around Lyon, from where it originated. Chefs in France usually do not make their own sausage, because there are many excellent charcutiers (sausage makers). French restaurants typically buy sausages, wrap them in pastry, and then bake them. However when I first came to the New York I was not able to find sausage good enough for Lutéce (although they are available today), so I began to make my own. It is not difficult, and I still do it. This is considered a bistro food, and is best served at lunch.

Yield: 2 sausages, serves 8–10

1 lb (450 g) lean beef chuck
1 lb (450 g) pork butt
1/2 lb (25 g) fatback, cut in tiny dice
1 tablespoon salt
1 pinch curing salt (saltpeter)
White pepper, fresh ground
3/8 cup (50 g) corn starch or potato starch
1/2 teaspoon garlic, chopped very fine
2 beef middle casings (available from butchers)

• Grind the beef and pork in a meat grinder, using the medium blade.

• Put the ground meat, 1 cup (240 ml) of very cold water, and all the other ingredients (except the beef middle casings) in the bowl of an electric mixer. Mix slowly—do not over-mix—for 1 minute.

• Pack the mixture into a pastry bag, and from the pastry bag force it into 2 beef middle casings. Prick the casings in several places with a needle. Tie the ends. Leave the sausages at room temperature overnight before cooking.

• Simmer sausages in water for about 50 minutes. Refrigerate overnight, preferably longer.

Note: The sausages may be served cool with potato salad; or hot, with the casing removed, wrapped in Pâte à Brioche (see next page). ▷

Menu Two

Cervelas Truffé en Brioche avec Sauce Périgourdine (Sausage Brioche with Périgord Sauce)

Serves 8–10

For the Sausage:

Follow recipe for Saucisson à l'Ail (Garlic Sausage), previous page

For the Pâte à Brioche (Brioche Pastry)
1/2 oz (15 g) fresh yeast or 1 envelope dry yeast
1/4 cup (60 ml) water (or milk), lukewarm
1 lb (450 g) all-purpose flour, sifted
1 scant teaspoon salt
1 teaspoon sugar
6 eggs
1/2 lb (225 g) unsalted butter (2 sticks), softened

Note: Yields about 2 pounds (900 g). To make an even finer brioche, increase the butter to 3/4 pound (350 g). (This dough will be a little more difficult to handle.)

• Put the yeast in the bowl of an electric mixer (or in a mixing bowl). Add the luke-warm water (or milk) and blend the yeast and the liquid.

• Add one-fourth of the flour and stir it in well. Cover the bowl with a cloth, set it in a warm place, and let it double in volume—about 10 to 15 minutes, depending on the temperature of the room.

• Add the salt, sugar, the remaining flour, and 4 of the eggs. Mix in the electric mixer, at medium speed, until the dough starts to pull away from the sides of the bowl—about 4 minutes (about 8 minutes by hand).

• Add the remaining 2 eggs, one at a time, mixing the first egg in thoroughly before adding the second.

• Add the butter. Mix with the electric mixer at low speed for about 1 minute, or mix by hand. Cover the bowl with a cloth, set it in a warm place until it doubles in volume—about 1 to 1 1/2 hours.

• Punch the dough a few times to make it collapse. Refrigerate for 3 hours (or enclose it in plastic wrap and refrigerate overnight).

To assemble Sausage Brioche:
• Wrap a 1/3-inch- (8.5-cm-) thick layer of the pastry dough around each of the 2 sausages. Let the dough rise on the sausage, at room temperature, for 15 minutes and bake for 30 minutes in a 350°F (175°C) oven. As the sausage brioche bakes, prepare the Périgord sauce.

For the Sauce Périgourdine:
3/4 cup (180 ml) port wine
1/2 cup (120 ml) Cognac
1/4 cup (60 ml) truffle juice from a canned black truffle
2 oz (50 g) black truffle, chopped
2 cups (470 ml) demi-glacé (homemade or from a gourmet market)
4 tablespoons unsweetened butter (1/2 stick)
Salt
Pepper, fresh ground

• In a saucepan, reduce the port and Cognac by one-fourth.

• Add the truffle juice, truffle, and demi-glacé. Bring to a boil and simmer for 10–20 minutes.

• Stir in the butter. Add salt and pepper to taste. Simmer 10 minutes more. Place in a sauce tureen and serve with brioche sausage.

Menu One

Cotelettes de Porc aux Oeufs Pochés (Pork Chops with Poached Eggs)

Serves 4

4 pork chops, 1-inch (2.5-cm) thick
2 tablespoons sweet butter
Salt
Pepper

For the Wine Sauce:
3 tablespoons chopped shallots (or onions)
1/2 cup (120 ml) dry white wine
1 cup (240 ml) veal fond stock (or water)

For the Poached Eggs:
4 eggs, very fresh
1/2 cup (120 ml) white vinegar
3–4 (710–950 ml) cups water

• In a shallow sauté pan, bring the water to a boil. Add the vinegar (do not salt). Crack the eggs into the water one by one, and cook over very low heat for 4 minutes. Lift from the hot water with a slotted spoon and place in a bowl of ice water for 2 minutes. Place the eggs on a paper towel. Set aside and keep warm.

• Sprinkle the chops with salt and pepper. In a skillet over high heat, melt the butter and add the chops, cook for 6–8 minutes until golden brown. Turn the chops, cover, and cook for another 8 minutes. Remove the chops and set aside, cover and keep warm.

Wine Sauce
• In the same skillet, add the shallots and sauté for 2 minutes. Add the wine, scraping up the browned bits from the pan, and boil, reducing by half. Add the fond de veau or water. Add any juice from the plate in which the chops were set aside. Boil again until it reduces by half.

• Taste for seasoning. If needed, add salt and pepper to taste.

To assemble:
• Put 1 chop on each plate. Place the poached eggs on top of the chops and pour the sauce around.

Menu Two

Côtes de Porc à la crème aux Champignons et Oeufs Pochés (Pork Chops in Mushroom Cream Sauce with Poached Eggs)

Follow recipe for Cotelettes de Porc aux Oeufs Pochés (Pork Chops with Poached Eggs), left, except substitute this sauce:

For the mushroom cream sauce:
1/2 lb (225 g) fresh mushrooms
3/4 cup (180 ml) heavy cream
2 tablespoons Madeira
1 scant tablespoon chopped parsley

• After pork chops are removed from the skillet, add the shallots to the same skillet and sauté for 1 minute. Add the mushrooms and cook them until all the liquid is evaporated. Add the Madeira to the mushrooms, bring to a boil, and cook briefly. Whisk in the cream and simmer until the sauce thickens and becomes velvety—about 6–8 minutes.

• Correct the sauce for seasoning.

Menu One

Petits Pois à la Française
(Sweet Peas with Butter)

Serves 8

1 3/4 lb (800 g) (unshelled weight) *petits pois* (small young green peas), shelled
1 small head lettuce, shredded in fine strips
8 pearl onions
1 bouquet garni
2 teaspoons sugar
1/2 cup water
1 teaspoon salt
1 1/2 tablespoons butter, cut in small pieces

• Place all ingredients in a saucepan. Cover the pan, bring gently to a boil, and simmer for 20–30 minutes. Remove the bouquet garni and mix in the butter.

(Above) Le Corbusier, *Still Life,* 1922

Le Corbusier Two Feasts for Ozenfant re-created by Chef André Soltner

Menu Two

Panaché de Petits Pois et Carottes (Peas and Carrots)

Serves 4

1 small Boston lettuce
4 tablespoons unsalted butter (1/2 stick)
1 medium onion, peeled and sliced thin
3 small carrots, trimmed, peeled, and
 washed, and cut into 1/8-inch
 (3-mm) discs
2 lbs (900 g) (unshelled weight) *petits pois*
 (small young green peas), shelled
1 teaspoon sugar
Salt
Pepper, fresh ground
3/4 cup (180 ml) chicken stock or water
1/4 cup (60 ml) heavy cream
1 tablespoon chervil (or parsley),
 chopped coarsely

• Wash the lettuce leaves in cold water.
Drain them and then cut into 1/4-inch
(6-mm) strands.

• In a heavy-bottomed pot, heat the butter.
Add the onions and sauté for 3 minutes.
Do not brown.

• Add the carrots, petits pois, lettuce,
sugar, salt, and pepper. Cover and cook for
10 minutes over low heat. Stir a few times
during the cooking.

• Add the chicken stock or water, bring it to
boil, cover, and cook slowly for 10 minutes
more. Stir once or twice.

• Add the cream and cook, uncovered, until
the liquid begins to thicken—approximately
5 minutes. Stir once or twice.

• Put the vegetables on a serving plate,
sprinkle them with the chervil or parsley,
and serve hot.

*Note: This dish is also an excellent vegetable
garnish for squab or chicken.*

Menu One

Fromage de Brie et Marmelade de Pommes (Brie Cheese and Stewed Apples with Sugar)

Makes 5 servings

5 apples (2 lbs/900 g) peeled, seeded,
 and cut into quarters
1 heaping cup (275 g)
Juice of 1 lemon
1/2 cup (120 ml) water

• Put all of the ingredients in a saucepan.
Cover the pan, bring gently to a boil, and
cook for 30 minutes, until the apples are
in purée.

• Serve with Brie cheese.

Menu Two

Pain aux Noix (Walnut Bread)

Yield: 1 loaf, approximately 1 1/2 lb (675 g)

2/3 oz (25 g) fresh baker's yeast (preferred),
 or 2 envelopes active dry yeast
1 cup (240 ml) milk, warm
1 egg, beaten
1/2 tablespoon sugar
2 cups (220 g) all-purpose flour, sifted
1 cup (125 g) chopped walnuts
1/2 teaspoon salt
Unsalted butter for buttering the loaf pan

• In a bowl, dissolve the yeast in the milk.
Stir in the beaten egg. Add the sugar, flour,
walnuts, and salt. Stir the dough vigorously
with a wooden spoon for about 10 minutes.

• Put the mixture in a buttered loaf pan,
approximately 7 x 3 inches (18 x 7.5 cm).

• Put the loaf pan in a warm place, cover it
with a cloth or with plastic wrap, and let it
rise for 30 minutes.

• Preheat the oven to 300°F (150°C).

• Bake in the preheated oven until golden
brown—about 35 minutes.

Menu Two

Compote de Pommes Normande (Normandy Apple Compote)

Serves 4

5 apples peeled, seeded, cut into 6 parts
1/3 cup (75 g) sugar
1/3 cup (80 ml) water
Grated rind and juice of 1 lemon
2 tablespoons butter
1/2 cup (120 ml) heavy cream
2 tablespoons Calvados

• Put all ingredients except heavy cream in a
heavy-bottomed saucepan. Bring to a boil and
simmer slowly, covered, for 40 minutes. Break
and mix the pieces with a wooden spoon. If
necessary, continue cooking uncovered until
most of the liquid is evaporated. Let cool.

• When cold, whip the heavy cream and mix
into the apple compote.

Menu Two

Tarte aux Figues (Fig Tart)

Serves 6–8

Flour for flouring the work surface
3/4 lb (350 g) *pâte brisée* (pie crust)
Unsalted butter for buttering the pie pan
1/2 cup (50 g) cookie crumbs
2-1/2 lbs (1 kg) figs
1/2 cup (125 g) sugar
1 scant teaspoon powdered cinnamon
2 eggs
1/2 cup (120 ml) milk
1/2 cup (120 ml) heavy cream
3 drops vanilla extract

• Flour a work surface and roll out the *pâte
brisée* to a circle that will line a 10-inch (25-cm)
pie pan. Butter the pie pan and line it with the
pastry. Prick the pastry with a fork. Spread the
cookie crumbs over the bottom of the pastry.

• With a sharp knife, cut the figs in half.
Cut a 1/2-inch (1.25-cm) incision into one end
of each fig half, so that when the fig half is

opened a little the cut forms 2 points.

• Arrange the fig halves in concentric circles on the pastry, each piece with its cut end (the 2 points) out (the fig halves are more or less standing on their uncut ends and leaning against each other).

• Preheat the oven to 375°F (190°C).

• Bake in the preheated oven for 20 minutes. Remove the tart from the oven.

• In a bowl, beat together the eggs, three-fourths of the sugar, the milk, cream, and vanilla extract. Pour this mixture over the figs.

• Return the tart to the oven and bake 15 minutes more.

• Mix together the remaining sugar and powdered cinnamon. Just before serving, sprinkle this mixture over the tart. Serve lukewarm.

Menu Two

Brioche de Dates (Date Brioche)

Follow recipe for Pâte à Brioche on page 172, but fold 1 1/2 pounds (675 g) of chopped dates into the dough after it has been refrigerated.

Menu Two

Glace aux Oeufs (Vanilla Ice Cream)

Yield: approximately 3 pints (850 g)

1 quart (750 ml) milk
7/8 cup (200 ml) heavy cream
10 egg yolks
1 heaping cup (275 g) sugar
2 vanilla beans, halved

• Add milk and vanilla beans to a saucepan, and bring milk to a boil. Add the cream. Bring to a boil again. (Do not cook any further after the liquid has reached the second boil.)

• In a bowl, whisk together the egg yolks and sugar until the mixture is a very pale lemon yellow and a ribbon forms when the whisk is lifted from the mixture.

• Pour the hot milk and cream into the eggs, and mix thoroughly. Add the flavoring.

• Return the mixture to the saucepan. Over low heat, stir the mixture with a wooden spoon until it thickens slightly and coats the spoon—about 5 minutes. Do not boil. (The mixture is ready when you draw with your finger a path through the mixture on the surface of the spoon and the path does not close up.) Remove the vanilla beans and let cool, stirring once in a while.

• Process in an ice cream maker until firm. Store in the freezer until served.

(Below) People don gas masks in a cellar in Paris in response to a bomb alert during World War I, February, 1918.

Alexander Calder Flying Colors Menu re-created by Chef Jean-Georges Vongerichten

Pennsylvania-born Alexander Calder was one of the most innovative sculptors of the 20th century. His early wire sculptures transformed the drawn line into three dimensions, and his invention of the mobile introduced the elements of time and movement to the ancient tradition of sculpture.

In 1972, Braniff Airways commissioned Calder to paint the largest of his monumental sculptures—a DC-8-62 airplane. Eight-foot (2.5-m) models were shipped to the artist's studio in France, and with his trademark colors of red, yellow, orange, blue, black, and white, he began creating his ultimate mobile: *Flying Colors*. Braniff engineers traced the final design onto the plane; it took them days to fill in the shapes with many layers of specially formulated paint. Calder himself added the last touches. Unlike other planes, the jet did not carry the airline's name, only Calder's signature, making it a true work of art. The Calder family and other officials boarded for the debut flight in Dallas, Texas, when Braniff unveiled *Flying Colors* as the flagship of its South American fleet on November 3, 1973. Calder personally selected his favorite dishes for the menu to be served aboard the *Flying Colors* as it flew on a publicity tour to Los Angeles, Chicago, New York, Washington, D.C., and Miami, before continuing on to South America.

Calder's good friend, art dealer, and publisher George Goodstadt kindly sent in a transcription of the *Flying Colors* menu in its entirety. Calder's historic menu has been re-created by the internationally acclaimed chef, Jean-Georges Vongerichten, who has restaurants dot the globe: Vong, Jo Jo, Jean Georges, The Mercer Kitchen, in New York; Vong in London, Chicago, and Hong Kong; and Prime, at the Bellagio in Las Vegas.

"It might be fun. I'll see what I can come up with."

—Alexander Calder

(Opposite) Alexander Calder with his painted model of a Braniff 727 jet, 1975

(Bottom left) The chef on the *Flying Colors*, holding one of the dishes served during the inaugural flight, 1972; courtesy George Goodstadt

(Bottom right) Alexander Calder, *Flying Colors*, 1972, courtesy George Goodstadt

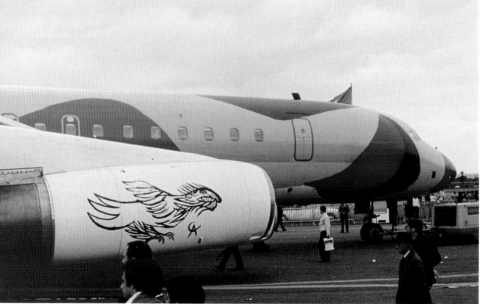

Flying Colors Menu

Serves 4

Wedding Veil (cocktail)

Liebfraumilch (sweet German wine)

Domaine de Brichot (Armagnac)

Côtes du Rhone (red wine)

Zucchini Arlesienne

Shrimp Cocktail & Spring Salad

Sirloin Steak Café de Paris

Vol au vent à la Reine

Butter-Marmalade

Semi-hard rolls & French Bread

Profiteroles aux Chocolate

Colombian Coffee

Fresh Strawberries & Cream

Sweet Rolls

French Croissants& Brioche

American Swiss Cheese & Ham

Orange Juice

Zucchini Arlesienne

3/4 lb (350 g) plum tomatoes (4–8 each)
1/8 oz (3.5 g) garlic (2 medium cloves), thinly sliced
1/8 teaspoon chopped thyme leaves (2 sprigs)
3/4 cup (180 ml) extra virgin olive oil
2 tablespoons unsalted butter
1/4 cup (75 g) kosher salt
1/2 teaspoon fresh ground white pepper
10 pieces crushed black peppercorn
1 1/2 lb (675 g) zucchini, sliced into 1/8-inch
 (3-mm) pieces (6 medium zucchini)
1/8 cup (30 ml) crème frâiche
7 medium onions, quartered and sliced into
 1/8-inch (3-mm) pieces
2 cups (480 ml) whole milk
1 1/2 cups (175 g) all-purpose flour for dredging

• Peel and seed the tomatoes, cut in half, and scoop out the seeds. Place them on a foiled, oiled cookie sheet, and sprinkle with the garlic, 2 tablespoons of the salt, and the thyme. Slow bake in a 200°F (93°C) oven for 1 1/2–2 hours, or until tomatoes have a slightly parched, dry look. Remove and cool.

• Simultaneously, place the slices from 5 of the onions in a medium-sized pot with 4 table-spoons of oil, the butter, 1 tablespoon of salt, and the peppercorns. Cook over medium-low heat for 45 minutes–1 hour to achieve a golden color and soft, marmalade-like texture. These two procedures can be done a day in advance.

• Take the remaining onions and soak them briefly in milk. Drain, flour, and deep-fry them at 350°F (175°C) until golden and crisp. Salt to taste. In a bowl, place zucchini slices, salt, pepper, and crème frâiche. Mix gently (avoiding breaking slices).

Assemble as follows:
• Lightly oil an appropriate-size gratin dish. Turn the onion marmalade into the dish. Spread evenly. Place alternating, overlapping rows of zucchini and slow-baked tomotoes until full. Bake in 350°(175°C) oven for 35–40 minutes.

• Remove and top with crisp fried onions.

Shrimp Cocktail and Spring Salad

1 small onion, sliced
1 branch celery, sliced
1 small carrot, sliced
2 sprigs fresh thyme
1 bay leaf
20 whole black peppercorns
1 tablespoon plus 1 teaspoon kosher salt
1/4 lemon
1 cup (240 ml) white wine
1 quart (950 ml) water
12 large (U-10) or 20 medium (U-16/20) shrimp,
 shells on (see Note)
1/2 cup (120 ml) tomato ketchup
1/4 cup (60 ml) prepared horseradish
1/4 cup (60 ml) sherry vinegar
4 oz (125 g) salad greens (baby mixed or mesclun)
4 silver-dollar mushrooms, peeled and
 cut into batons

9 asparagus, trimmed and peeled
1 avocado, peeled and sliced 1/4 inch (1/2-cm) thick
6 cherry tomatoes, halved
2 tablespoons chives in 1/2-inch (1.25-cm)
 long batons
1/8 cup (30 ml) extra virgin olive oil
1 tablespoon fresh lemon juice
Freshly ground white pepper to taste

Note: This is restaurant terminology for how many shrimp per pound. "U/10," stands for "Under 10," meaning there are 10 or fewer shrimp in a pound; 16/20 means between 16–20 a pound, and so on. One pound of shrimp = 450 g.

• Place the first 10 ingredients in a large non-reactive pot. Bring to a boil and let simmer for 15 minutes, uncovered. Add the shrimp to the pot, return to a light boil, simmer 2 minutes, and remove from heat. Cool in liquid. Peel and devein shrimp; chill lightly. Make cocktail sauce by mixing ketchup, horseradish, and vinegar; reserve.

To Plate Dish:
• Cook the asparagus in salted, boiling water, then cool in ice water, cut into thirds, and reserve. Divide salad greens evenly to 4 plates; top with mushrooms, avocado, and asparagus. Place tomatoes at three points around salad greens, and top with chives. Drizzle oil and lemon juice evenly over the salad, season with 1/2 teaspoon salt and pepper. Top salad with shrimp; serve cocktail sauce in a ramekin on the side.

Sirloin Steak (Entrcote) Café de Paris

2 oz (50 g) fresh parsley leaves
1/2 oz (25 g) fresh tarragon leaves
1/4 oz (10 g) fresh marjoram leaves
1/4 oz (10 g) fresh basil leaves
1/4 oz (10 g) fresh sage leaves
1 oz (25 g) shallot, medium dice (1 small shallot)
1 oz (25 g) garlic, medium dice (4 small cloves)
1 tablespoon orange zest
1/4 oz (10 g) prepared horseradish
3/4 oz (25 g) anchovies in oil, drained
 (5–6 fillets)
1 teaspoon plus 2 teaspoons kosher salt
1 teaspoon nutmeg
2 teaspoons curry powder

Pinch cayenne pepper

2 cups (450 g) unsalted butter, lightly
 chilled and cubed

1 tablespoon lemon juice

1/4 teaspoon soy sauce

1/4 cup (60 ml) cognac

3 tablespoons unscented oil (grape seed,
 canola, peanut)

4 sirloin steaks (prime or choice grade,
 8–9 oz/225 g each)

Fresh ground white pepper to taste

• Place first 14 ingredients (plus 1 teaspoon of the salt) in a food processor and process to fine chop (or hand cut). Add the butter, lemon juice, soy sauce, and cognac and whip to a fluffy consistency (or whip in a bowl first). Cut aluminum foil to approximately 14 x 18 inches (35 x 45 cm). Pour the butter/herb mixture in a line about 12–13 inches (30–32 cm) long on the foil. Roll the foil around the butter sausage-style to create a tube 1 1/2–2 inches (4 cm) in diameter. Place in the refrigerator to firm. (Alternatively, place the butter in a container and leave free form.)

• In a thick-bottomed pan of appropriate size, heat oil to medium-high heat. Season steaks with remaining salt and pepper. Cook to desired doneness (3–4 minutes per side for rare), remove from pan, and rest for equal amount of time. Plate steak. Slice the butter 1/4 inch (1/2 cm) thick and place 2 slices on top of steak or spoon butter onto steak. (butter should not be too cold). Serve with French fries or oven-roasted potatoes.

Vol-au-vents à la Reine

1 package (1 lb/450 g) frozen puff pastry

5 large egg yolks

1 teaspoon water

7 cups (1.7 l) chicken broth (preferably
 homemade)

2 small sprigs of thyme

4 chicken breasts (12–15 oz/375 g each)

5 oz (150 g) white mushrooms, peeled and
 quartered

2 teaspoons lemon juice

7 tablespoons unsalted butter

4 tablespoons all-purpose flour

1/2 cup (120 ml) heavy cream

1 tablespoon kosher salt

Fresh ground white pepper to taste

1/4 teaspoon nutmeg

6 stems curly parsley, chopped

• Preheat the oven to 450°F (230°C). Thaw pastry according to manufacturer's instructions. Unroll the pastry on lightly floured, cool work surface (only use enough pastry as required). Roll out to a thickness of approximately 1/4–3/8 inch (8 mm), and then [using a glass or cookie cutter] cut 4 individual rounds, each 3 inches (7.5 cm) in diameter.

• Score a second round cut approximately 3/4 inch (2 cm) from the outside edge of the pastry (make only a light score so as to designate the top for the vol-au-vent case).

• Place the 4 pastry rounds on a lightly buttered and floured baking sheet. Mix 2 yolks with the water and brush the mixture over the pastry. Bake in the oven for 15–20 minutes or until light golden, then remove and cool.

• Melt the butter in a small saucepan, then add the flour. Stir continuously over medium low heat for 10–15 minutes or until a roux paste is formed. Set aside and cool.

• Add the broth, thyme, and chicken breasts to a large pot, and simmer (do not boil) for approximately 20 minutes. Remove the chicken from the pot, and cut

Profiteroles au Chocolat

For the Pâte à Choux (Cream-puff Pastry)

1 cup (240 ml) plus 1 teaspoon water

5 tablespoons unsalted butter

1/2 teaspoon kosher salt

2 tablespoons granulated sugar

1 cup all-purpose flour

4 large eggs

1 egg yolk

• Bring the first 4 ingredients (using only 1 cup/240 ml) water) to a boil in a medium-size pot. Remove pan from heat. Add flour, and mix with a wooden spoon. Return to medium heat. Mix for 30 seconds to blend well. Remove from heat. Add eggs one at a time, mixing well to amalgamate. Place the dough in a pastry bag with a medium tip. Pipe dough onto a buttered and floured baking sheet to a diameter of 1 1/2 inches (3.75 cm) (should yield approximately 35 pieces). Mix yolk with water and brush over dough lightly. Place in a preheated 475°F (250°C) oven for

5 minutes. Lower temperature to 425°F (220°C). Bake for 20–25 minutes or until lightly golden. Remove from sheet to cooling rack.

For the Pastry Cream

1 1/4 cup (230 ml) milk

1/3 cup (70 g) granulated sugar

2 egg yolks

1 large egg

3 tablespoons all-purpose flour

2 tablespoons vanilla extract

• Bring milk to a boil. Set aside. Mix next four ingredients together until thick. Add hot milk little by little. Return to medium heat and stir constantly to set thickness (careful not to scramble eggs by cooking too hot—should coat a wooden spoon adequately.) remove to bowl, add extract. Cover and cool. Load into a pastry bag with small tip.

For the Chocolate Sauce:

4 oz (125 g) bittersweet chocolate (good quality)

2 tablespoons water

• Break chocolate into small pieces. Place in a small bowl with water. Place over a pot of simmering water and melt to liquid. Reserve at body temperature.

Assembly:

• Hold the profiterole in hand. Make an insertion with the pastry bag. Gently squeeze into the profiterole until full. Dip top with opening into warm chocolate. Place on platter chocolate side up. Serve.

Strawberries and cream

2–3 pint baskets (700-1000 g) strawberries
 (seasonal farm fresh preferred)

1/4 cup (60 ml) champagne

1 cup (240 ml) heavy cream

• Hull and rinse strawberries. Macerate in champagne for 10-20 minutes. Whip cream (or leave natural, as with Devon or Normandy). Distribute berries into four champagne goblets. Top with cream. Serve.

Menu

Foutimaises assorties
Puaka Oviri au four tahiti
moa Opepa Sauce Coco
roti boeuf à la française
Salade !! aita
Desserts
—
Appéritifs
Vin Colonial

Rupe farani Rupe tahiti

Paul Gauguin Tahitian Feast re-created by **Chef James Babian**

Throughout history, many poor and hungry artists have traded their drawings and sketches for meals. During the 19th century, if a Parisian hostess invited Toulouse-Lautrec or Renoir to dinner, she would expect the artist to illustrate the menu as a table decoration. And if the artist were to celebrate a sale or a gallery exhibition, he would throw a dinner party at his favorite café, with himself as guest of honor and his artwork pictured on the menu. The charismatic and pioneering French painter Paul Gauguin made use of this practice when he moved to Tahiti in 1891. Gauguin thanked one Tahitian hostess eleven times, each time with a different illustration on the menu cover. The menu, left, was obtained from Peter Morell, of Peter Morell & Company Liquors, in New York. Chef James Babian of the Orchid at Mauna Lani, Hawaii, re-created this menu, served to Gauguin by his Tahitian hostess.

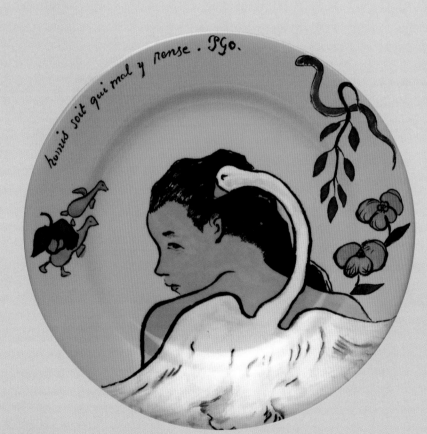

(Left) The items on Paul Gauguin's illustrated menu include roast beef, salad, desserts, appertifs, and "colonial" wine, c. 1892; collection Peter Morell, New York.

(Above) Paul Gauguin, plate illustrated with Tahitian motifs, c. 1892; collection The Musée Gauguin, Tahiti

Tahitian Feast

Wild Pig in Tahitian Oven
Snails in Coconut Sauce
Roast Beef French-Style au Jus
Haupia (Coconut Pudding)

Being a chef in Hawaii, I have been exposed to many traditional Tahitian and Polynesian cooking methods. Several of these dishes use a pit as an earth oven: A hole is dug in the ground; a fire is prepared in the center of the pit, using wood gathered locally; and large river rocks are placed on top of the wood. The wood is ignited and allowed to burn for several hours, leaving white hot rocks and embers. A pig is then rubbed inside and out with Hawaiian sea salt and hot rocks are placed inside the cavity of the pig. It is placed in the pit, covered with various layerings, including ti (banana) leaves and cooked for about 8 hours. When the pig is removed from the pit it is very tender and has a rich flavor, a hint of smoke, and is somewhat reminiscent of a confit or braised pork.

The following recipe tastes similar to the pork that would be prepared in an earth oven and is an acceptable substitute.

Wild Pig in Tahitian Oven

Serves 6–8

5 lbs (2.25 kg) pork butt, cut in thirds
1 1/2 tablespoons liquid smoke flavoring
2–3 tablespoons Hawaiian sea salt
3 cups (750 ml) chicken stock
10 *ti* (banana) leaves if available (can substitute 10 green cabbage leaves)

• Preheat oven to 350°F (175°C).

• Rub the pork with the smoke flavor and sea salt.

• Take an appropriate-size roasting pan and line the bottom with half the *ti* (or cabbage) leaves, add the pork.

• Add chicken stock, being careful not to pour it over the pork, and remove the seasoning.

• Cover with remaining *ti* (or cabbage) leaves.

• Cover tightly with the foil and roast for approximately 3 1/2–4 hours. Cook the pork to a minimum internal temperature of 165°F (75°C).

Note: When done the pork should shred easily and be very moist. The cabbage in this method tastes really good and is an excellent complement to the pork.

Snails in Coconut Sauce

Serves 4

12 oz (350 g) conch meat, cooked
2 cups (450 ml) coconut milk
1 1/2 tablespoons fresh grated ginger (juice only)
Kosher or sea salt to taste
White pepper to taste

• In a medium sauté pan, slowly warm the coconut milk to a simmer.

• Add the ginger, juice, salt, and pepper.

• Add the snail meat and warm through.

• Taste the sauce and adjust the seasonings.

• Spoon into 4 portions, garnish each plate with finely diced tomato and a cilantro sprig.

Note: Ginger varies in intensity. Taste the sauce and add more ginger if you prefer. While seasoning a dish remember that you can always add more, but you can't take out what you put in.

Roast Beef French Style with au Jus

Serves 8

5 lbs (2.25 kg) boneless ribeye
salt to taste
pepper to taste

1 small onion, diced
1/4 cup (30 g) celery, diced
Few sprigs thyme
2 bay leaves
1 quart (1 l) beef broth or stock

• Rub the beef with salt and pepper. Place in a roasting pan that has been covered with non-stick spray. Roast at 350°F (175°C) for 30 minutes.

• Lift the roast and add the vegetables and herbs. Place the meat on the vegetables and return to the oven, lowering the heat to 300°F (150°C).

• Cook to an internal temperature of 125–130°F (50–55°C). Remove from pan and allow to rest for 20 minutes.

• While meat is resting, make the jus. Pour off any excess fat from the pan. Add the beef broth or stock and reduce by half. Strain and skim off any excess fat. Season to taste with salt and pepper.

• Slice meat to desired thickness. Pour some jus over it.

Note: To make a thicker jus, add some cornstarch that has been dissolved in a little cold water.

(Right) Wooden spoon carved by Paul Gauguin, c. 1892.

(Opposite) Paul Gauguin, c. 1888; both collection The Musée Gauguin, Tahiti

Haupia (Coconut Pudding)

Yield: 14–16 two-inch (5-cm) pieces

Although roast fruit was probably served at Gauguin's feast, I am substituting here a familiar Hawaiian dessert, haupia. At every commercial luau, a thick and heavy pudding of cornstarch and coconut milk is cut into squares and served on pieces of green ti leaf. This version is a long way from the original. Coconut milk should be thickened with cornstarch or pia, the Polynesian arrowroot. Today's version is boiled in a saucepan, however, the original version of haupia was wrapped in ti *leaves and steamed.*

5 cups (1.125 l) coconut milk
6 tablespoons sugar
6 tablespoons cornstarch (or 5 tablespoons arrowroot)

• Mix cornstarch and sugar in a saucepan and gradually add coconut milk, beating with a whisk to prevent lumps from forming. Heat until just simmering, continuing to stir with the whisk until the mixture thickens.

• Pour into a 8-inch- (20-cm-) square cake pan and chill.

• Cut into 2-inch- (5-cm-) square pieces and serve.

Leonardo da Vinci The Last Supper Re-created by **Chef Mario Batali**

The last supper in this book comes from the authentic favorite recipes of the most remarkable figure of the Renaissance, and the artist who painted the most famous version of *The Last Supper*—Leonardo da Vinci. It is not known when the great Leonardo first became a strict vegetarian and great lover of animals. But his vegetarianism was well-known throughout Italy, although this practice would not be accepted for another 500 years. The Florentine traveller, Andrea Corsali, wrote of Leonardo's vegetarianism in a 1515 letter sent from Inda to Giuliano Medici in Italy: "Certain infidels called Guzzarati do not feed on anything that contains blood, nor do they permit among them any injury to be done to any living things, like our Leonardo." The artist's love for all living creatures is also told in Giorgio Vasari's *Lives of the Most Excellent Architects, Painters and Sculptors of Italy* (1550): "He always kept servants and horses, which later he took much delight, and particularly in other animals which he managed with the greatest of love and patience. And this he showed after passing the places where birds were sold, for taking them in his own hand out of the cages, and having paid to those who sold them the price that was asked, he let them fly away into the air, restoring to them their lost liberty."

On the origins of Leonardo's Eastern, vegetarian, and Humanist influences, I contacted Michael White, historian and author of *Leonardo: The First Scientist* (2000). He replied, "Indeed, Leonardo was greatly influenced by travelers he met in Florence and Milan, and he was fascinated with all things linked to Eastern culture. He probably learned vegetarianism from such sources and he was almost certain to have stumbled upon recipes from the Far East handed to him by peripatetic painters and philosophers who crossed his path."

There are references in Leonardo's notes to meat purchases, which must have been for his non-vegetarian students. Although a confirmed vegetarian, he invented a machine that could grind sausage meat, as well as an automated cooking machine for meat, which Bartolemeo Scappi describes in his book *Opera* (1570): "[Leonardo] invented a spit with a propeller that turned in the heat of fire." This automated invention was animated by the process of

Leonardo da Vinci, *The Last Supper*, c. 1495–98, Santa Maria delle Grazie, Milan

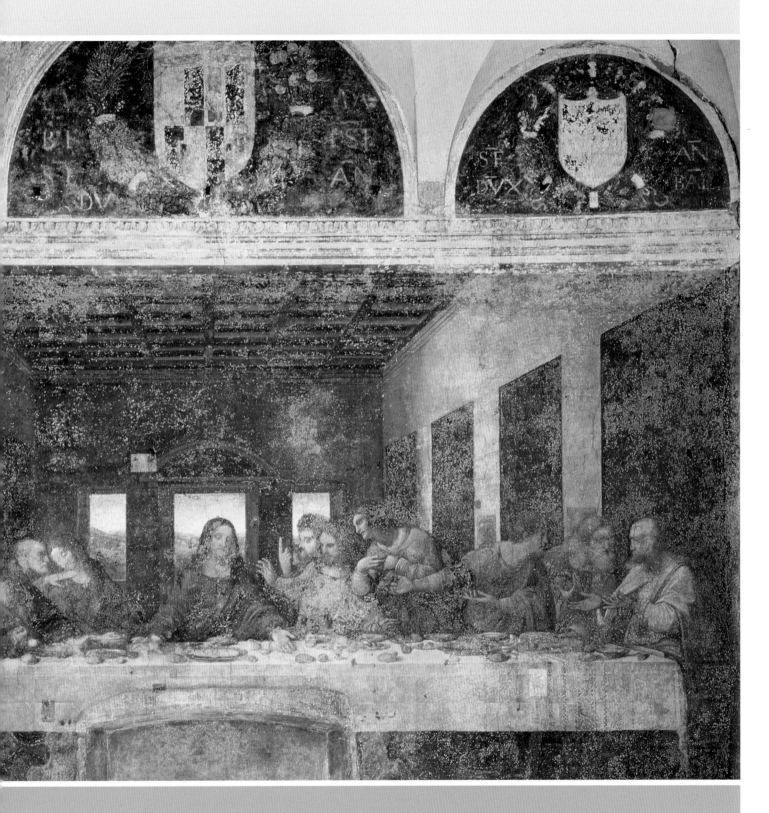

"Your life should be as well ordered as if you were a student of theology... You will eat and drink in moderation at least twice a day, taking pasta carefully prepared and modest wines."

—Leonardo da Vinci

hot air rising which turns the propellers, turning the spit. Leonardo endorsed his new automated product by saying "This is a good way to cook meat . . . since the roast will turn slowly or quickly depending whether the fire is strong or weak."

When courting royalty and religious patrons at their castles and affairs Leonardo would dine on green salads, fresh fruit, vegetables, bread, mushrooms, cereal, and pasta. He also loved chickpea soup which he called *la minestra,* and which he liked served nice and hot. While writing and drawing in his notebook, he ends a sentence with an "et cetera" and upon returning to the page he explains why he stopped, "it is because my *la minestra* is getting cold."

"If you be healthy, heed this advice, eat only when hungry, and let light fare suffice. Chew all your food well, and this rule always follow. Well cooked and simple, be all that you swallow. On leaving a table, a good posture keep, and after you luncheon, do not yield to sleep. Let little and often be your rule for wine, but not between meals or when ready to dine."

—Leonardo da Vinci

At the end of his life, Leonardo moved to Cloux, France, at the invitation of King Francis I. After his death, a cookbook containing Leonardo's favorite vegetarian recipes was found in his home library at Cloux. This was the first modern cookbook, a 1487 edition of *Platina de honesta voluptate,* written in Venice in 1475 by the Italian scholar, humanist, and Papal Librarian, Bartolomeo de Sacci. Mr. Leonardo Beck, a noted authority on *Platina,* was quoted in *The New York Times* (1986) on the relevance of the book in Leonardo's life: "If you want to know what he ate, this is the book." He explained that Leonardo "had a 1487 edition of *Platina* in his library. Book VII of that copy answers the question as to the vegetarian dishes which this our Leonardo doth feed, that he is grown so great."

Following are two authentic recipes from Leonardo's 1487 edition of *Platina.* This Last Supper has been lovingly reinterpreted by master Chef Mario Batali.

The Last Supper

La Minestra (Luis in Cecere Rubeo)
(Chickpea Soup)

From *Platina*
"Wash a pound or more of chickpeas in hot water. After being washed they should be put in a pot to simmer without water. With your hands mix half an ounce of meal, a little oil and salt, and twenty grains of coarsely ground pepper and ground cinnamon, and then put this near the hearth with three measures of water, and add sage, rosemary and finally chopped parsley roots. Let this boil so that it is reduced to eight saucers full. When it is nearly cooked, drop in a little oil; but if it is juice for sick persons, only add a little oil and spices."

From Chef Mario Batali

Serves 4

1/4 cup (60 ml) extra-virgin olive oil
1/4 cup (25 g) all purpose flour
Salt and pepper to taste
4 sage leaves finely chopped
1 tablespoon rosemary leaves finely chopped
1 tablespoon parsley leaves finely chopped
1/2 tablespoon red chili flakes
Pinch of cinnamon
6 quarts (5.7 l) water
2 cups (400 g) chickpeas

• In a large soup pot, heat oil over medium heat. Whisk in the flour a little at a time, to form an oil-based roux. Let cook 1 minute, then add salt and pepper, sage, rosemary, parsley, chili flakes, and cinnamon and whisk well. Cook another 5 minutes, until roux is browned, then whisk in water. Stir in the chickpeas and bring to a boil. Reduce to a simmer and cook until the peas are tender, about 1 hour. Add more water if necessary to keep chickpeas well covered. Adjust seasoning and serve.

Faba in Frixorio
(Fried Figs and Beans)

From *Platina*

"Put broad beans that have been cooked and softened into a frying pan with soft fat, onions, figs, sage and several pot-herbs, or else fry them well rubbed with oil and, on a wooden tablet or a flat surface spread this into a form of cake and sprinkle spices over it."

From Chef Mario Batali

Serves 4

1 lb (450 g) fava beans shelled and peeled
Salt and pepper to taste
1/4 cup (50 g) lard or 1/4 cup (60 ml) extra-virgin
 olive oil
1 Spanish onion, finely chopped
12 dried figs, coarsely chopped
4 sage leaves, finely chopped
1 tablespoon finely chopped thyme leaves
Pinch red chili flakes
High-quality aged balsamic vinegar (Aceto
 Manodori brand preferred) for drizzling

• Bring 6 quarts (5.7 l) of water to a boil and add 2 tablespoons of salt. Add the fava beans and cook 5 minutes, until tender and bright green. Drain and refresh in an ice bath. Set aside.

• In a large sauté pan, heat lard or oil over medium heat and add onion. Cook over medium-high heat until the onions are soft and golden brown. Season with salt and pepper and add figs, herbs, and chili flakes. Cook over medium heat 10 minutes until the figs are soft. Stir beans and cook another 3 minutes. Remove from heat, drizzle balsamic over, and serve immediately.

Leonardo da Vinci, *Self-Portrait,* c. 1512

Participating Chef's Biographies

James Babian
(Paul Gauguin)

The Orchid at Mauna Lani,
Hawaii

Mario Batali
(Michelangelo &
Leonardo da Vinci)

Molto Mario and *Mario Eats Italy*,
Food Network;
Babbo Ristorante e Enoteca, *Lupa*,
Esca, and *Otto Enoteca Pizzeria*,
New York

David Bouley
(Edgar Degas)

Bouley and Danube, New York

Antonio Cabanas
(Pablo Picasso)

Els Quatre Gats,
Barcelona, Spain

Mary Ann Esposito
(Amadeo Modigliani)

Ciao Italia, PBS

David Feau
(Frédéric-Auguste Bartholdi)

Lutèce, New York and
Las Vegas

Roberto Hasche
(Max Beckmann)

Formerly of the *Oak Room*, Plaza
Hotel, New York

Mark Hix
(Paul Cézanne)

Le Caprice, *The Ivy*, and *J. Sheeky*,
London

Erin Horton
(Jasper Francis Cropsey)

Top of the Falls Restaurant,
Niagara Falls

Kevin Shikami
(Isamu Noguchi)

Kevin Restaurant, Atlanta

André Soltner
(Le Corbusier)

Founder and former owner of *Lutèce*,
New York; Master Chef, the *French
Culinary Institute*, New York

Ming Tsai
(Friedensreich Hundertwasser
& Sam Francis)

East Meets West with Ming Tsai,
Food Network; *Blue Ginger*, Boston

Jean-Georges Vongerichten
(Alexander Calder)

Vong, *Jo Jo*, *Jean Georges*, *The
Mercer Kitchen*, in New York; *Vong* in
London, Chicago, and Hong Kong;
and *Prime*, *Bellagio* Las Vegas

Index

Albers, Josef and Anni, 110
Almost Fat-free Chili con Carne, 117
Alternating Slices of Marinated and Cooked Tuna, 99
Ambrosia, Nectar of the Gods, 78
Andy Warhol's Thanksgiving Dinner, 159
Antes, Horst, 82–83
Apple Compote Normande, 174
Apple Raisin Dumplings, 125
Arman, 99
Artist's Meal, 101
Audubon, John James, 140–141, 151–153
Augusta's Spice Cake, 132

Babian, Chef James, 181–182, 188
Bacon-Spiced Roast Beef with Burgandy Sauce, 145
Baked Oysters with Leeks, 64
Banana Splits, 123
Barnet, Will, 97
Bartholdi, Frédéric-Auguste, 160–165
Batali, Chef Mario, 9, 149–150, 184–187, 188
Bearden, Romare, 100–101
Beckmann, Max, 156–157
Bertha's Apple Dumplings, 122
Birthday Apple Pie, 126
Borglum, Gutzon, 68–69
Bouley, Chef David, 23–24
Bourgeois, Louise, 36–37
Bread, 70
Bread, Cheese, and Absinthe, 58
Brioche, 24
Brioche de Dates (Date Brioche), 175
Brown Bread Ice Cream, 127
Buffet, Bernard, 154–155
Buissons d'Écrevisses de la Meuse (Sauce à la truffe noire) (Crawfish in Truffle Sauce), 164
Burchfield, Charles, 122

Cabanas, Chef Antonio, 94, 96
Calçotada, 62
Calder, Alexander, 11, 176–179
Cannelé, 165
Caramels au Chocolat (Chocolate Caramels), 129
Cassatt, Mary, 128–129
Cauliflower with Gouda Cheese, 145
Caviar with Rice Crackers, 55
Cervelas Truffé en Brioche avec Sauce Périgourdine (Sausage Brioche with Périgord Sauce), 171–172
Cézanne, Paul, 5, 56–57
Cheese Hominy Puffs, 73
Cherries Jubilee, 120

Chia, Sandro, 112–113
Chiles Rellenos de Picadillo, Frios o Callientes (Peppers Stuffed with Meat, Served Hot or Cold), 116
Chiles Rellenos de Questa (Peppers Stuffed with Cheese), 114–116
Chinese Chicken Salad, 52
Christo. See Javacheff, Christo
Cokoladovna Bublanina (Chocolate Bubble Cake), 131
Coloradito (Red Mole), 48
Confetti Egg Salad, 76
Corn Soup, 33
Cotelettes d'agneau aux petits pois (Rack of Lamb with Peas), 163
Cotelettes de Porc aux Oeufs Pochés (Pork Chops with Poached Eggs), 172
Côtes de Porc à la crème aux Champignons et Oeufs Pochés (Pork Chops in Mushroom Cream Sauce with Poached Eggs), 172–173
Cottingham, Robert, 34–35
Courtyard Garden Breakfast, 19
Crème Caramel, 136
Cropsey, Jasper Francis, 44–46
Curry Oil, 88

Dalí, Salvador, 6, 10, 84–85
da Vinci, Leonardo, 184–187
Davis, Stuart, 102
Degas, Edgar, 12–13, 22–24
de Guillebon, Jeanne-Claude, 47
de Kooning, Willem, 14–15
Delvaux, Paul, 64
Demuth, Charles, 132–133

Eggs Picabia, 18
Escher, Maurits Corneille (M. C.), 16–17
Escobar, Marisol, 32
Esposito, Chef Mary Ann, 93

Faba in Frixorio (Fried Figs and Beans), 187
Faisan et Perdeaux Bardés (Pheasant and Partridge), 163–164
Féau, Chef David, 160, 161–165
Filet de Boeuf Lafayette (Filet of Beef), 164–165
Financier Cookies Amandes (Almond Financiers), 165
Finn an' Haddie, 102
Fish and Pork Chowder, 46
Flageolet Beans with Ginger and Scallion, 24
Flying Colors Menu, 178–179
Francis, Sam, 108
Frankenthaler, Helen, 106–107
Frijoles Negros (Black Beans), 74
Frog's Legs with Garlic Purée and Parsley Sauce, 154–155

Fromage de Brie et Marmalade de Pomme (Brie Cheese and Stewed Apples with Sugar), 174
Gauguin, Paul, 180–183
Gerstotto (Dutch/German Version of Risotto), 145
Glace aux Oeufs (Ice Cream), 175
Glaser, Milton, 52–53
Gogh, Vincent van, 8, 58–59
Grandma Moses. See Moses, Anna Mary Robertson
Gravy, 159
Green Beans, 159
Grilled Quail, 153
Grooms, Red, 76
Gross, Chaim, 77

Halibut in a Cool Summer Gazpacho, 150
Hamaguchi, Yozo, 120–121
Ham and Potatoes, 146
Haricots verts à la Mâitre d'hotel (Green Beans in Butter Sauce), 161
Hasche, Chef Roberto, 156
Haupia (Coconut Pudding), 182
Hearty Lamb Stew, 34
Himmel und Erde, 110
Hirschfeld, Al, 55
Hix, Chef Mark, 56
Hollandaise Sauce, 162
Holtzman, Harry, 78–79
Honey and Buttermilk Oatmeal with Crème Frâiche, Ginger, Lavender, Orange Crumble, and Honey Tuile, 20
Hopper, Edward, 7, 142–143
Hors d'Oeuvres variés (Assorted Hors d'Oeuvres), 162
Horton, Chef Erin, 46
Hot and Sour Soup, 43
Hot-Cold Chinese Noodles, 65
Huîtres Pochées en Gelée (Poached Oysters in Jelly), 170–171
Huîtres Pochées en Gelée (Poached Oysters on Leeks), 170–171
Huîtres Portugaises (Portuguese Oysters), 170
Hundertwasser, Friedensreich, 86–88

Javacheff, Christo, 46
Jeanne-Claude. See de Guillebon, Jeanne-Claude
Jeanneret, Charles-Edouard, 168–175
Juliet's Potlagel (Romanian-style Eggplant), 54

Katz, Alex, 98
Kienholz, Edward and Nancy, 65
Klee, Paul, 144–145

Koons, Jeff, 124–125
Krasner, Lee, 50–51, 70–73

Lady Liberty Banquet, 160–165
Lam, Wifredo, 74–75
Lamb and Eggplant Casserole, 147
Lamb Stew, 30
La Minestra (Luis in Cecere Rubeo)
 (Chickpea Soup, 186–187
The Last Supper, 184–187
Late Supper, 111
Le Corbusier. See Jeanneret, Charles-Edouard
Lichtenstein, Roy, 103
Linguini with Garlic and Oil, 97
Lobster à l'Américaine, 90–91

Mamelige, 77
Man Ray, 54
Marisol. See Escobar, Marisol
Marmalade of Apricots, Vanilla, and
 Orange Rind, 23
Masson, André, 25
Matelote d'Anguille
 (Eel in Brandy Sauce), 94, 96
Matisse, Henri, 40–41
Mesclagne Landais, Mère Irma, 84, 85
Michelangelo, 148–150
Milktoast, 17
Miró, Joan, 62–63
Modigliani, Amedeo, 92–93
Mondrian, Piet, 78–79
Moore, Henry, 30–31
Moses, Anna Mary Robertson (Grandma), 135
Motherwell, Robert, 111
Mrs. Delicious's Rugelach, 137
Mucha, Alphonse, 118–119, 130–131
Mushroom Gravy, 69
My Lunch with Edward Hopper, 142

Nabeyaki Udon (Japanese Noodles), 32
Natural Dinner, 166–167
New Hamachi Sashimi with Curry Oil, 87–88
Nicholson, Ben, 127
Noguchi, Isamu, 20–21

Oatmeal Cookies, 134, 135
Omelette au lard pour Monet et Pour Deux, 89
Oppenheim, Meret, 4, 19
Oxtail Stew, 36–37

Pain aux Noix (Walnut Bread), 174
Panaché de Petits Pois et Carottes
 (Peas and Carrots), 173–174
Parfait glace au café, 165
Pasta Fish Sauce, 146, 147
Pastry cream, 179
Pearlstein, Philip, 123
Pepper, Beverly, 104–105
Petit Pois à la Française
 (Sweet Peas with Butter), 173
Philadelphia Pepper Pot, 38

Picabia, Francis, 18
Picasso, Pablo, 94–96
Pickled Fish, 61
Poached Stuffed Striped Bass, 107
Pollock, Jackson, 50–51, 70–73
Pommes de terres à l'huile
 (Potatoes in Oil), 56
Pommes Frites (French fries), 78
Potage Printanier—Mock Turtle à l'Américaine
 (Mock Turtle Soup), 161–162
Poularde Caroline (Roast Hen), 163
Profiteroles au Chocolat, 178–179
Pyle, Howard, 38–39

Rack of Lamb, Roast Potato with
 a Lemon Verbena/Prune Crust, 24
Renoir, Pierre Auguste, 80–81, 89
Richter, Hans, 6, 136
Riley, Bridget, 26–27
Rivera, Diego, 114–116
Rivers, Larry, 137
Roast Beef French Style with au Jus, 182
Roasted Apple Pie, 165
Roasted Poussin with Peach Sauce, 152–153
Robert's Egg Dish, 26
Rockwell, Norman, 134–135
Rosenquist, John, 146–147
Rothko, Mark, 126

Salade de chicorée (Chicory Salad), 165
Salmon Coulibiac (Salmon in Pastry), 98
Salsa Coloradita, 62
Sashimi 101, 87
Saucisson à l'Ail (Garlic Sausage), 171
Sautéed Sweetbreads with
 Truffled Mashed Potatoes, 155
Seared Lobster and Porcini Mushroom
 with Savoy Cabbage and Chervil Butter
 Cream Sauce, 156
Shikami, Chef Kevin, 20
Shrimp Cocktail and Spring Salad, 178
Sirloin Steak (Entrecote) Café de Paris, 179
Smoked Salmon and Jicama Maki Sushi,
 108, 109
Snails in Coconut Sauce, 182
The Soft-boiled Egg with Truffle, 25
Soltner, Chef André, 170–175
Sonfist, Alan, 166–167
Spaghetti à la Roberto Barni, 83
Soupe de Poissons (Fish Soup), 41
Soy Syrup, 88, 108
Spaghetti al Limone
 (Spaghetti with Lemon), 104
Spaghetti with Broccoli Rabe, 103
Spice Cake, 132
Strawberries and Cream, 179
Strawberry Shortcake, 138
Stuffed Turkey, 159
Sun-Whirl Salad, 144–145
Szilva Gombac (Sugared Plum Dumplings), 66

Tahitian Feast, 180–183
Tamayo, Rufino, 5, 48–49
Tarator (Summer Soup), 47
Tarte aux Figues (Fig Tart), 174–175
Thiebaud, Wayne, 28–29, 33
Toulouse-Lautrec, Henri de, 90–91
Traditional Dutch Breakfast, 14
Triglie alla Livornese (Stewed Red Mullet), 93
Tsai, Chef Ming, 87, 88, 109
Turbot à la Hollandaise, 162
Turbans d'Ananas au Kirsch (Pineapple and
 Kirsch Pastry), 165
Two Hot Mexican Chiles, 114–116

Vasarely, Victor, 66–67
Vegetarian Lasagne, 113
Vol-au-vents a la Reine
 (Chicken à la Queen), 179
Vongerichten, Chef Jean-Georges, 178–179

Warhol, Andy, 7, 158–159
Warm and Light Apple Tart, 155
Wasabi Oil, 108
Wesselmann, Tom, 117
Wild Pig in Tahitian Oven, 182
Wood, Grant, 138–139

Yang, YuYu, 42–43

Zoe's Brunch, 23–24
Zucchini Arlesienne, 178
Zúñiga, Francisco, 60–61

Recipe Credits

Recipes on pages 84–85 (Salvador Dali), 101 (Romare Bearden), 107 (Helen Frankenthaler), 111 (Robert Motherwell), 117 (Tom Wesselmann), 123 (Philip Pearlstein), 137 (Larry Rivers) were reprinted from the *Artists' Cookbook: Conversations with Thirty Contemporary Painters and Sculptors*, Edited by Madeleine Conway and Nancy Kirk (Museum of Modern Art) 1977, with the permission of Nancy Kirk

Recipe on page 139 (Grant Wood) courtesy *The American Gothic Cookbook: From the Artist Grant Wood, His Family, Friends, Fans, Famous Colleagues*, Joan Liffring-Zug (Editor), Penfield Press, Iowa City (1996)

Recipe on pages 124–125 (Jeff Koons) credit: Washington Apple Commission

Recipes on pages 87–88 (Hundertwasser) and pages 108-9 (Sam Francis) reprinted from *Recipes from Blue Ginger*, by Ming Tsai (Clarkson N. Potter; 1999) with the permission of Clarkson Potter/Knopf, New York

Recipe on pages 128-29 Translated from the French and Reprinted from *Miss Mary Cassatt: Impressionist From Pennsylvania*, by Frederick A. Sweet, University of Oklahoma Press, Norman, 1966 with the permission of University of Oklahoma Press, Norman

Recipe on page 98 (Salmon Coulibiac) courtesy Culinary Institute, Hyde Park, New York

Recipe on pages 90–91 from: *THE ART OF CUISINE* by Henri de Toulouse-Lautrec and Maurice Joyant. English-language translation and notes. © 1966, 1944 by Henry Holt and Company, LLC and Michael Joseph Ltd. Reprinted by permission of Henry Holt and Company

Photo Credits

t=top, b=bottom, l=left, r=right, c=center

1 © Musée Gauguin, Tahiti; Photograph © Philip Gatward/ DK Media Library

2 © Bettmann/CORBIS

4 © Lisa Wenger Carona; Photograph courtesy Dr. Burkhard Wenger-Reister

5bl © Colita/CORBIS

5tr © Archivo Iconografico, S.A./CORBIS

6tl © Bettmann/CORBIS

6br Courtesy Hans Richter Archives; Photography by J. Bruell, Zürich

7cl © Francis G. Mayer/CORBIS

7tr © Bettmann/CORBIS

8 © Francis G. Mayer/CORBIS

11 © Paul Almasy/CORBIS

12–13 © Archivo Iconografico, S.A./CORBIS

14–15 © 2003 The Willem de Kooning Foundation/ Artists Rights Society (ARS), New York; Photograph © Elliott Erwitt/Magnum Photos

16 © Nikki Arai/courtesy Vorpal Gallery, San Francisco

17 M.C. Escher's Sky and Water I © 2003 Cordon Art B.V. – Baarn – Holland. All rights reserved.

18 © 2003 Artists Rights Society (ARS), New York/ ADAGP, Paris; Photograph © The Art Archive/Musée National d'art Moderne Paris/ Dagli Orti

19bl © 2003 Artists Rights Society (ARS), New York / ProLitteris, Zurich; Photograph © Estate of Meret Oppenheim

19tr © Estate of Meret Oppenheim/Alexis Baatsch

20 © Michael S. Yamashita/CORBIS, with permission of the Isamu Noguchi Foundation

21 © Courtesy of the Isamu Noguchi Foundation

22 © Bettmann/CORBIS

24. © Musée d'Orsay; Photograph © Phillippe Sebert/ DK Media Library

25 © 2003 Artists Rights Society (ARS), New York/ ADAGP, Paris; Photograph courtesy Comité André Masson

26 © Bridget Riley; Photograph © Prudence Cumming Associates

27 Courtesy Bridget Riley

28–29 © Wayne Thiebaud/Licensed by VAGA, New York, NY; Photograph courtesy Allan Stone Gallery, New York

30–31 © The Henry Moore Foundation, Hertfordshire, UK

32 © Marisol/Licensed by VAGA, New York, NY; Photographs courtesy Marlborough Gallery, New York

33 © Wayne Thiebaud/Licensed by VAGA, New York, NY; photograph courtesy Allan Stone Gallery, New York

34 Photograph © Charles Gold, courtesy Forum Gallery, New York

35 © Robert Cottingham, courtesy Forum Gallery, New York

36tl © Louise Bourgeois/Licensed by VAGA, New York, NY; Photograph © Peter Bellamy

36r-37 © Louise Bourgeois

39t Published by Scribner's Magazine, December 1893, courtesy Illustration House

39b Published by Harper's Monthly, December 1890, courtesy Illustration House

40tl © 2003 Succession H. Matisse, Paris / Artists Rights Society (ARS), New York

40bl © 2003 Succession H. Matisse, Paris / Artists Rights Society (ARS), New York; Photograph © Philadelphia Museum of Art/CORBIS

40r–41 © 2003 Succession H. Matisse, Paris / Artists Rights Society (ARS), New York; Photograph © 2001 by Cornell Capa/Magnum Photos

42–43 © YuYu Yang Lifescape Sculpture Museum, Taipei

44–46 © Newington-Cropsey Foundation, Hastings-on-Hudson, NY

47 Photograph Wolfgang Voltz, © Christo 1995

49 © Inheritors of the artist in support of Fundación Olga y Rufino Tamayo, A.C.

50–51 © Pollock-Krasner House and Study Center, East Hampton, NY, Jeffrey Potter Archives

52–53 © Milton Glaser

54 © Man Ray Trust

55t © Mary Hilliard, courtesy Louise Kerz

55b © Al Hirschfeld/Margo Feiden Galleries, New York

56–57 ©Archivo Iconografico/CORBIS

58tr Amsterdam, Van Gogh Museum (Vincent van Gogh Foundation)

58bl World Trademarks owned by Michel Roux

59 © Christie's Images/CORBIS

60 © Thomas Kaiser, courtesy Fundación Zuniga, Mexico

61 © Ariel Zuñiga, courtesy Fundación Zuniga, Mexico

63 © F. Català-Roca

64 © Delvaux Foundation, St. Idesbald, Belgium

65 © Nancy Reddin Kienholz

66–67 © 2003 Artists Rights Society (ARS), New York / ADAGP, Paris; Photographs courtesy Yvaral Vasarely

68 © Charles D'Emery, courtesy Borglum Archives

69t © National Park Service, courtesy Borglum Archives

69b © Rise Studio, Rapid City, S.D, courtesy Borglum Archives

70 © Pollock-Krasner House and Study Center, East Hampton, NY

71 © Estate of Rudolph Burkhardt/Licensed by VAGA, New York, NY; Photograph © BURCKHARDT RUDOLPH/CORBIS SYGMA

72 © 2003 The Pollock-Krasner Foundation / Artists Rights Society (ARS), New York; Photograph © Christie's Images/CORBIS

74t © Lou Laurin-Lam/Photograph © Adela Gallo

74b © Lou Laurin-Lam/Photograph © Pino Gallicio

75 © 2003 Artists Rights Society (ARS), New York / ADAGP, Paris/Photograph © Lou Laurin-Lam

76 © 2003 Red Grooms / Artists Rights Society (ARS), New York

77 © The Chaim Gross Studio Museum, New York

78–79 © Mondrian/Holtzman Trust, www.mondriantrust.com

79 © 2003 Mondrian / Holtzman Trust / Artists Rights Society (ARS), New York

80–81 © Francis G. Mayer/CORBIS

82 © Horst Antes/ Photograph © Ilona Ripke, courtesy Dorothee Antes

83 © 2003 Artists Rights Society (ARS), New York / VG Bild-Kunst, Bonn/© Horst Antes; Photograph courtesy Edition Volker Huber Edition und Galerie, Offenbach-Main, Germany

84 © Bettmann/CORBIS

85 © Salvador Dalí Museum, Inc. St. Petersburg, Florida USA

86 © Joram Harel, Vienna, Austria

89 © Francis G. Mayer/CORBIS

90 © Peter Harholdt/CORBIS

91 © Corbis

92 © Burstein Collection/CORBIS

93 © Bettmann/CORBIS

95 © 2001 by Cornell Capa/Magnum Photos

96 © Peter Aprahamian/CORBIS

97tl © Anne Sager, courtesy Will Barnet

97br © Scharffen Berger Chocolate Maker, Inc., Berkeley, CA

98 © Vivien Bittencourt, courtesy Vincent Katz and Alex Katz

99 © Arman/ Photograph © Vincent Cunillere/

100 © Romare Bearden/Licensed by VAGA, New York, NY; Photograph © Christie's Images/CORBIS

101 © Romare Bearden Foundation/Photograph © Maria F. Nipson

102 © Estate of Stuart Davis

103 © Bruno Hausch, courtesy Estate of Roy Lichtenstein

104 © Paul Manes, courtesy Beverly Pepper

105 © Beverly Pepper

106 © Burt Glinn/Magnum Photos

108–9 ©Margaret Francis

110 © Artists Rights Society (ARS), New York; courtesy The Josef and Anni Albers Foundation, Inc.

111 © Hulton Archives/Getty Images

112 © Vera Isler, courtesy Sandro Chia

113 © Thomas Kletecka, courtesy Sandro Chia

115 © Archivo Iconografico, S.A./CORBIS

116 © Guadalupe Rivera Marin

117 © Tom Wesselmann/Licensed by VAGA, New York, NY

118–19 © 2003 Artists Rights Society (ARS), New York / ADAGP, Paris; Courtesy Mucha Trust

120–21 © The Vorpal Gallery, San Francisco, Photograph © Muldoon Elder

122 Collection of the Burchfield-Penney Art Center, Buffalo State College, Buffalo, New York; Photograph by Herbert Appleton

123 © David C. Levy, courtesy Philip Pearlstein

124 © Jeff Koons/Courtesy Deutsche Guggenheim Berlin/Photograph by David Heard

125 © Todd Eberle, courtesy Jeff Koons

126 Courtesy Christopher Rothko/Photograph © L. Emerson

127 © 2003 Artists Rights Society (ARS), New York / DACS, London; Photograph © Christie's Images/CORBIS

128–29 ©Burstein Collection/CORBIS

130–31 © 2003 Artists Rights Society (ARS), New York / ADAGP, Paris; Courtesy Mucha Trust

132–33 Collection of the Demuth Foundation, Lancaster, PA

134 Courtesy Norman Rockwell Museum, Stockbridge, MA; with permission of Norman Rockwell Family Agency

135 Grandma Moses and Norman Rockwell cutting a cake. Reproduced courtesy Grandma Moses Properties Co., New York. With permission of Norman Rockwell Family Agency. Photograph courtesy Norman Rockwell Museum, Stockbridge, MA

136 Courtesy Hans Richter Archives

137 Courtesy Larry Rivers Studio, New York

138 From collection of Joan Liffrig-Zug Bourret

139 © Estate of Grant Wood/Licensed by VAGA, New York, NY; Photograph from collection of Joan Liffrig-Zug Bourret

140–41 Courtesy of the Kentucky Department of Parks, John James Audubon Museum

142 © Bettmann/CORBIS

143 © Francis G. Mayer/CORBIS

144tl & 145 Paul Klee Family Estate, deposited at the Paul Klee Foundation, Museum of Fine Arts Berne

144tr © Culver Pictures, Inc.

146 Photo by Kevin Helmstreet © Rosenquist

148 Collection Casa Buonarroti, Archivio Buonarroti, Florence/vol. X, f. 578 verso

150 © Arte & Immagini srl/CORBIS

151 & 153 Courtesy of the Kentucky Department of Parks, John James Audubon Museum

154 © Luc Fournal, courtesy Galerie Maurice Garnier, Paris

156–57 (c) 2003 Artists Rights Society (ARS), New York / VG Bild-Kunst, Bonn; Photograph ©Burstein Collection/CORBIS

158 © Bob Adelman/Magnum Photos

160–61 © National Park Service, Statue of Liberty National Monument

167 ©Abe Frajndlich, courtesy Alan Sonfist

168 © Paul Almasy/CORBIS

169 © 2003 Artists Rights Society (ARS), New York / ADAGP, Paris / FLC; courtesy Le Fondation Le Corbusier, Paris

173 © 2003 Artists Rights Society (ARS), New York / ADAGP, Paris / FLC; Photograph © The Art Archive / Musée National d'art moderne Paris / Dagli Orti

175 © Hulton-Deutsch Collection/CORBIS

176 © 2003 Estate of Alexander Calder / Artists Rights Society (ARS), New York; Photographs courtesy George Goodstadt

177 © 2003 Estate of Alexander Calder / Artists Rights Society (ARS), New York; Photograph © Bettmann/CORBIS

180 Collection Peter Morrell, New York

181–83 © Musee Gauguin, Tahiti; Photograph © Philip Gatward/DK Media Library

184–85 ©Edimédia/CORBIS

187 © Bettmann/CORBIS

188 All photographs courtesy the chefs pictured; Mary Ann Esposito photo © Bill Truslow; Jean-Georges Vongerichten photo © Patrick Demarchelier .

Acknowledgments

AUTHOR'S ACKNOWLEDGMENTS

Special thanks to my wife and Research Assistant Susan Fedele, who has helped make this book a reality.

At DK Publishing, I am grateful to Barbara Berger, Senior Editor, for believing in the project for the past four years and sticking with it, and for being such an important part of this book; Dirk Kaufman, Art Director, for his stunning design; Christopher Davis, Publisher, for his enthusiasm and support; and Jennifer Williams, Senior Editor; Chuck Lang, U.S. Publisher; Tina Vaughan, Creative Director; Milos Orlovic, DTP Designer; Chris Avgherinos, Production Manager; Valerie Buckingham and Sharon Lucas, Project Directors; and Katie Ziens, Editorial Assistant.

I am eternally grateful to all of the artists, chefs, and other contributors to the book. And I offer special thanks to the following individuals and institutions from across the globe:
Amy Hau, Isamu Noguchi Museum, Long Island City, NY; Cindy Hemstreet and Beverly Coe, James Rosenquist Studio; Muldoon Elder and Sandra Lupien, Vorpal Galleries, NY and San Francisco; André Emmerich, NY; Natasha O'Connor, Magnum Photos, NY; Michael White; Nancy Weekly, Burchfield-Penny Art Center, Buffalo, NY; Elisabeth Consenary, Spanish Consulate, NY; Steven Harvey, Salander O'Reilly Gallery, NY; Ellen Mazar; Linda Szekely, Assistant Curator, Linda Pero, Curator, The Norman Rockwell Museum, Stockbridge, MA; Thomas Rockwell; Diane Setoff, Mt. Rushmore Historic Society; Mt. Rushmore National Memorial; Kyle Patterson Phillips; Wifredo Lam Center, Havana, Cuba; Barry Moreno, Librarian and Historian, and Maria Antenocruz, Public Affairs Coordinator, Ellis Island Foundation/Statue of Liberty Foundation; Maria; Ellis Island Immigration Museum, Statue of Liberty National Monument; Roger Reed, Illustration House, NY; Philippe E. David; Nancy Katzoff, New York Historic Society; Heidi Frautschi, Paul-Klee-Stiftung, Kunstmuseum, Bern, Switzerland; Mexican Embassy, NY; Robert Fishko, Bonnie Meyers, Sam Seawright, Michael Leonard, Forum Gallery, NY; Peter Morell, Peter Morell & Co., NY; Alex and George Goodstadt, George Goodstadt Inc; Jon Masson, Assistant Research & Archives, Pace Wildenstein Gallery, NY; Christopher Rothko and Kate Rothko Prizel; Bernett Shepford, Staten Island Historic Society; Estate of Roy Lichtenstein; Museó Nacional Centro de Arte Reina Sofia, Madrid; Consulate General of Belgium; Sandra Ziegler, Galerie Renée Ziegler, Zurich; Luis Masson, Comité André Masson, Paris; Nachlass Meret Oppenheim, Dr. Burkard Wenger-Reister; Anthony Allen, Paula Cooper Gallery, NY; Benedicte Lesieur, Galerie Lelong, Paris; Peter Ornstein; Fotowerken Frans Claes, N.V., Antwerp, Belgium; Andrea Heyde, German Book Office, NY; Sheila Rohan, Romare Bearden Foundation, Staten Island, NY; Patrick Kirk; Helen Harrison, Director, Heather Demon, and Kathy Peiper, Pollock-Krasner House and Study Center, Easthampton, NY; Guadalupe Rivera Marin; Society of Illustrators, NY; Grandma Moses Properties, NY; Walter Schupfer Management, NY;

Eric Browner, Man Ray Trust, Hicksville, NY; John Mucha, Sarah Mucha, and Lenka Kvasnickova, Mucha Trust, London; Marion von Hofacker, Hans Richter Archives, Icking, Germany; Denise Fasanallo, Larry Rivers Studio, NY; Maria Eugenia Bermudez de Ferrer, Fundación Rufino Tamayo, Mexico City; Michael S. Yarema, Crillon Importers Inc., Paramus, NJ; Vincent Katz and Vivien Bittencourt; Perry Wolf; Nicholas Fox Weber, Executive Director, and Stephane Potelle, Archivist and Project Manager, The Josef and Anni Albers Foundation, Bethany, CT; Anne-Laure Quemeneur, French Embassy, NY; Museó Nacional de Prado, Madrid; Elisabeth Cuspinera, Cultural Advisor, Consulate General of Spain, NY; Bob Buck, Christen Conrad, K. Austin and Cynthia Garvey, Marlborough Gallery, NY; Richard Gray Gallery, NY; Ellen Mazar; Judith Jones; Alfred Knopf, Inc.; Michael Greaves, Alfred Knopf, Inc., NY; Ronald Feldman Gallery, NY; Vincent Freemont; The Andy Warhol Foundation, Pittsburgh; John Warhola; Galerie St. Etienne, NY; Elizabeth Tookey; Martin Cribbs; Sidney Janis Gallery, NY; Gary Schuster; Margot Carpenter; Elizabeth M Weisberg; Madelene Conway; Nancy Kirk; Kim Tyner; The Museum of Modern Art, NY; Kathy Peiper; Sybille Hilger; Louisa Orto; Lynn Quayle; Pora Decker; Nena Bugarin; John Szoke, John Szoke Editions, NY; Dany Schwinn and Bettina Wiebel, Volker Huber Edition und Galerie, Offenbach, Germany; Dorothee Antes; Beate Von Ploetz, Art Practica, Inc. NY; Don Boarman, Curator, John James Audubon Museum, Henderson, KY; Gert Trani, Information Services Librarian, and Christine Crawford-Oppenheimer, Librarian and Archivist, Culinary Institute of America, Hyde Park, NY; Regis Hueber, Curator, Musée Bartholdi, Colmar, France; Lucas Lackner; Maya Beckmann, Germany; Madame Mayen Beckmann; Robin Borglum Carter and James Borglum, Borglum Archives; Pouran Esrafily; Annabel Buffet; Hugues Alexander Tartaut, La Societe des Amis de l'Ermitage, Paris; Philippe R. David, Galerie Maurice Garnier, Paris; Luc Fournol; Bernard Loiseau, Paris; Gregoire de Cleen; Agnes De Shey; Pamela A. Ivinski, Mary Cassatt Catalogue Raisonné Committee, NY; Caroline Owens, Adelson Gallery, NY; Ken J. Rosa, Curator, Galerie Michael, CA; Philippe Cezanne, Paris; Alice Allen, Bridget Riley Studio; Kenneth W. Maddox, Art Historian, The Newington-Cropsey Foundation, Hastings-on-Hudson, NY; Joan R. Kropf, Curator, and Carol Butler; Curatorial Assistant, Salvador Dali Museum, St. Petersburg, FL; E. Zanardi, Instituto Italiano di Cultura, NY; Centro L. da Vinci, Collection da Vinci, Societa Leonardo da Vinci, Florence, Italy; Earl Davis; Margaret Doyle; Dr. Rebecca A. Rainbow, Department of European Paintings, Metropolitan Museum of Art, NY; W.M Brady & Co., NY; Rainbow; Cecil Cross Plummer, Family Programing, HBO, NY; Matthew Marks Gallery, NY; Amy Schictel, Collections Curator, Willem de Kooning Revocable Trust, NY; Charles van Deun and Muriell Gyns, Foundation Paul Delvaux Foundation, St. Idesbald, Belgium; Stacie Bauer Seifer and Corinne Woodcock, The Demuth Foundation/Charles Demuth Museum, Lancaster, PA; Margareth Verbakel, Cordon Art, Baarn, The Netherlands; Margaret Smith Francis; The Sam Francis Estate, Venice, CA; Arlene Estacion,

The Orchid at Mauna Lani, Hawaii; Caroline Kasparian, Ming East West; Tahiti Tourism, Paris; Charlotte Stimpson and Marla Garfield, Assistants to Milton Glaser; Louise Kerz Hirschfeld; Gail Levin; Joram Harel Management, Andrea Christa Furst, Hundertwasser Archives, Vienna; Maresa von Rohrer, Jeff Koons Productions, NY; Shannon Rodgers; Evelyne Trehin, Director, Fondation Le Corbusier, Paris; Shelly Lee, Roy Lichtenstein Foundation, NY; Chantal Dougherty; Daisy Aviles; Dott. Elisabette, Archivist, Ente Casa Buonarroti, Biblioteca Medecio-Laurenziana, Florence, Italy; The National Library of Florence, Italy; Dr. Aldo Mazzarino; Dr. & Mrs. Khoury; Margaret Reid, Assistant Curator, The Henry Moore Foundation, Hertfordshire, UK; Macdonald & Co., Ltd., London; Emma Stower and Martin Davis; Martí Català Pederson, Barcelona; Cristina Calero Fernandez, Succession Miro, Spain; Janet Goleas, Assistant to Beverly Pepper; Rudolfo Celecia, Director, Els Quatre Gats, Barcelona; Museó Picasso, Malaga, Spain; Sophie Renoir and Stephanie Barbas, Association Renoir, Essoyes, France; Venessa Lopez; Aletha Zapf, Allan Stone Gallery, NYC; Monique Hageman, Van Gogh Museum, Amsterdam; The Rijksmuseum, Holland; Cordula Bartha, Consulate General of the Netherlands; Joan Liffring-Zug, Penfield Press; James Welu, Director, Worcester Art Museum; Ariel Zuñiga, Fundación Zuñiga Laborde, A.C.

PUBLISHER'S ACKNOWLEDGMENTS

DK Publishing would like to thank the following people for their invaluable help: Frank Fedele, for sharing this important project with DK, and his tire-less dedication to bringing it to fruition; Mario Batali, for his beautiful foreword and wonderful recipes; for opening their master chef recipe files or re-creating new culinary masterpieces—James Babian, David Bouley, Antonio Cabanas, Mary Ann Esposito, David Féau, Roberto Hasche, Mark Hix, Erin Horton, Kevin Shikami, André Soltner, Ming Tsai, and Jean-Georges Vongerichten; André Emmerich, for his considerate and thoughtful quote; Wesley Martin, for his expertise in the kitchen and his patience and caring on the page; Lucas Mansell, for his excellent conversions and proofreading; Katie Zien, for her indefatiguable energy and incredible organizational skills; and Nanette Cardon, for her always-flawless index. We are also deeply grateful to these individuals for so generously donating their time and expertise: Stuart Jackman, Group Design Director, DK; Robert Panzer, Vaga; Hugh Murtagh, Artists Rights Society, Linda Pero, Curator, The Norman Rockwell Museum; Heidi Frautschi, Paul-Klee-Stiftung, Kunstmuseum, Bern, Switzerland; Jason Holtzman, Mondrian/Holtzman Trust; Marion von Hofacker, Hans Richter Archives; Helen Harrison, Pollock-Krasner House and Study Center; Kim Bush, Solomon R. Guggenheim Museum; Mark Dennis, DK Media Libary; Lynne O'Neill; Michael Schulman, Magnum Photos; Valerie Zars, Hulton Archives; Jemal Creary, Corbis Books NY; Diane Glass; Dolores Holt; Keelin McDonell; and Lacy Garrison.